Y0-CBZ-088

ART :
a matter
of context

Bernar Venet
Writings
1975-2003

Hard Press Editions
2004

ART: a matter of context
Bernar Venet
Writings 1975-2003

with a critical essay by Christian Besson

ISBN:1-889097-65-9
©2004 Bernar Venet (text)
© 2004 Hard Press Editions, Lenox, MA (complete)

Printed in Canada

All rights reserved.
No part of this book may be reproduced or transmitted in any form or
by any means without permission in writing from the copyright holders.

Bernar Venet and Hard Press Editions would like to thank all of
those who have helped to make this book possible:
Christian Bernard from MAMCO in Geneva who pub-
lished some of these texts in a French version; Gayle Wurst
and Michael Westlake for their translation services; The art
historians and critics for their permission to reproduce these
interviews; Jacki Bascom, assistant to Bernar Venet; And, we
would like to thank, in particular, Mr. Jan van der Marck
for his precious advice.

Cover photograph: Georges Véron

To my mother Adeline Baptistine Gilly

Table of Contents

Standing on Art

Bill Beckley

I have not read widely enough to know if any aestheticians have ever considered the following: That the disorderly nature of our intelligence is exactly what enables a work of art to have its strongest effects. And yet I find this hard to believe. It isn't that the experts and art enthusiasts lack for words when praising these works of art – on the contrary, I think they have too many words. But as a general rule, each one has a different opinion of each masterpiece, and no one tells the simple observer how to solve the puzzle.

—Sigmund Freud

 Once upon a time in America artists believed in the possibility of newness, in the prospect of innovation. Of course, this inventiveness is only perceptible within a defined context. As an art student in the late sixties I can remember standing on a sculpture. I didn't know it until I read a caption on the wall that indicated 144 metal plates lying on the floor was a work by Carl André. With the presumptions I carried with me, not least of which was that sculpture is usually found on a pedestal meant to extol and protect it, I was surprised that I was standing on art. Shortly after, I saw square tubes of steel stacked against one wall in the uptown gallery of Leo Castelli. The Judd created a similar jolt, but this time it was coupled with intrigue. I could attribute this shock as well as my growing pleasure to my maturation as a student, but at the same time the work was just emerging, so it was not only new to me, but also to most everyone else who saw it. When Bernar Venet arrived in New York from France in 1966, it was this minimalist aesthetic that attracted him, more so than Pop or the earlier Abstract Expressionists. Pop was figurative and Abstract Expressionism had much metaphysical baggage. When he came to New York seeking whatever America could give, he was reading the works of another Frenchman, Roland Barthes—*Mythologies*, *Writing Degree Zero*, and *Elements of*

Semiology. Barthes influenced both of us at the time, and his writings were extremely important in the development of conceptualism, much in a the way that Sartre influenced Abstract Expressionism. It was Barthes' idea that there could be a zero degree of connotation, a style devoid of metaphor. His writing provided a way out of formalist thinking to the content orientation of conceptualism, and it provided the basic underpinning for conceptualism with the idea that iconic experience is based and dependent upon verbal language, and that, in fact, language can be art.

Generally speaking, it seems more and more difficult to imagine a system of images or objects in which the signifieds exist outside of a language system. Meaning only exists where things have names and the world of signifieds is the world of language.

Dematerializing art, getting rid of the object, was certainly at issue, emanating largely from Marxist philosophy, a somewhat puritanical ideology that wished to do away with fetish and commodity. But, as Bernar writes, this attitude can also quickly degenerate into academic reductivism, and I think at least some of us knew that we were not really getting rid of objects. A photo or a piece of writing stuck on the wall is an object, albeit a very thin one. Bernar states, and I certainly agree, that the true identity of conceptual art lies with its use and acknowledgement of language—the way that each artist uses language through his or her own motivations.

But just as everything seemed fresh, the seeds of postmodernism were being sown. Pendulums swing and postmodernism barked "nothing new."

This period of growing cynicism found its way not only in the rarified atmosphere of the New York Art World, but in popular culture as well. Through the emergence of jet planes as a viable means of travel in the late '50s and early '60s, automobile tail fins—particularly those of Cadillacs— grew larger and larger to the point of absurdity. But they did seem modern. At the same time, skirts got shorter and shorter. This had the tinge of transgression and therefore the tinge of modernism. Of course, if the manufacturers of these items had taken it to the limit, there would have been no driving through the Holland tunnel, and skirt makers would have become belt manufacturers.

Consequently, with no place to go, hemlines simply grew longer, or at least it was less of an issue, and Cadillac fins—as if no one was to

notice—shrunk to nonexistence. As an adolescent all this backtracking on what I thought was progress confused me. Avant-gardism became simply a change in style, or another form of marketing.

The postmodern suspicion of progress has often been attributed to the development of the hydrogen bomb. If progress in physics brought us the possibility of annihilating all of humankind, not to speak of all plant and animal life, what good is progress? Or the suspicion may have to do with the issue of painterly space, as Dave Hickey suggests in "Prom Night in Flatland." When painterly space disappears (through the progressive usurping of pictorial space as seen in Manet, Van Gogh, Cézzane, Picasso, and Malevitch, Stella, Marden, and Ryman, etc., there is no place to go. In some ways it's similar to the dilemma concerning hemlines.

The movements of minimalism and conceptualism were the last, at least for this time being, to strive for innovation, to believe there could be something radically new. And it is possible that because of this belief something radically new did come about, much in the way that there are certainly more sightings of the Virgin Mary in southern Italy than anywhere else.

It was in this poignant moment, at the cusp of the Modern era and what we now speak of as postmodern, that I met Bernar at the opening of his exhibition at the New York Cultural Center in 1971. On the walls were mathematical theorems, art as mathematics, and of course up to that point I had never associated art with mathematics except to calculate at any given moment the minuscule income I had just made from the sale of a photograph. I was impressed by the toughness of his stand.

Bernar and I met later that year under different circumstances. I had just flown from London to Germany after ending a disastrous relationship with a married woman. Still dazed, I recognized Benar, tall, eyes glimmering, in a gallery in Cologne. I introduced myself, told him I liked his work, and we went to a pub for a drink. Then, as if already old friends, I spilled the whole story, of my coming to London with this woman, of her long wavy red hair cascading down from her head like fireworks, of her well placed freckles, of her lithe body, her dangly legs, and oversized feet. I told him of the interventions of a couple of English artists—and of their finally organizing her flight back to New York to her husband, and of my stupidity in falling into the whole trap in the first place. By the end of the story I was distraught. (I have left out a lot of details.)

"Who is this woman with the long wavy red hair cascading down from her head like fireworks?" he asked. I can't speak for impressionists, postimpressionists, cubists, fauvists, surrealists, expressionists, minimalists, or Pop artists, but I do know what it meant for a couple of conceptualists to meet and find they are in love with the same person. It is out of our mutual infatuation for life in general, and out of a mutual respect for our work, that we have been friends ever since.

But while artists may love, they may also bicycle, and painters may swim, critics may sunbathe, and dancers may dine. Some artists sunbathe (Dennis Oppenheim), ride horseback (Robert Morris), or pick daisies (Richard Long), all in the name of art. Of course Marcel Duchamp, the grandmother of conceptual art, played strip-chess as art.

Bernar Venet made mathematics his art. He first mapped equations on graph paper, and then painted them on the wall. His work is both cerebral and beautiful in the way that a solution to a problem can be beautiful in its reasoning and in the way a painting can be beautiful without any reason. As art, these equations transcend their own conclusions and become a kind of meta-language. The results of the equations are extraneous to the conclusion that they are art. He writes,

> I used mathematics in its fullest sense, as a language. The work I exhibited was not meant to be seen as such, but rather as an articulation of the semantic-syntactic structure of its linguistic system—an attempt to give the work an artistic base corresponding to a given syntax.

This, seen in the context and development of what was early conceptual art, was radical, an immediate response to what was in the air in the late '60s—both in the rarified context of the international art world, and in the radicalization of culture through the anti-war movement, the women's movement, and the desire for racial equality. But his work is not overtly political, not didactic, and certainly not pious. Simply stated, those were radical times and this was radical art. His work felt new, new to a public dedicated at the time to finding innovative art.

Those times exploded with rock and roll. There was no nostalgia for previous decades, no saying "that's very '30s," "that's very '40s."

Jimmy Hendrix, Janis Joplin, Jim Morrison, and the Rolling Stones blitzed Sinatra, (albeit, not forever.) Rock and roll was original, not cynical, and not postmodern.

But times and people change. Here in St. Tropez this summer my favorite albums are Almodovar's collection of songs, particularly *Qualsevol nit pot sortir el sol*—which might be the saddest song on earth, and I say this without even understanding its Portuguese lyrics—and Frank Sinatra's collected works. With the exception of the Rolling Stones, who have really lived up to their name, many of the musicians of the late sixties and early seventies seem frozen in time. So do the artists. Most conceptualists stuck unerringly to the style (and I say this ironically) that made their reputation.

Bernar's work has evolved and what is important is not only the contributions he made as an early conceptualist, but the way his work now sheds the shackles of conceptual art. He has dropped the formal language that was necessary at the time to support the framework of conceptualism. His sculptures have become silent while his paintings have become very colorful. Recently Bernar has layered his paintings, with theorem painted on top of theorem so they become unreadable; it is wholly evident now that the conclusions to the formulas are subservient to the visual play. Tom McEvilley described them to me as "everything in the world at once." The paintings are new—for him and therefore for the rest of us, like Gregory Isaacs' beautiful reggae reinvention of the Animal's "House of the Rising Sun" or Norah Jones' rendition of "The Nearness of You." But in this case Bernar has reengaged his own work.

And all along he has written. Unlike many first-generation conceptualists, his writing does not have the pretense of being art, but exists to show his motivations, and to see how his work responds or plays with other work out there. I find pleasure in it, and for its own sake. These essays are roadmaps to his own development, as well as to the evolution of conceptual art.

As guitarists might bicycle and accountants might sing, these brief notes are salutations from an artist who writes, to another artist who writes. They are an appreciation, with affection, from a friend to a lifelong friend.

Committing to One Direction

Bernar Venet

Committing oneself to one direction when one starts an artistic activity does not necessarily mean that one must carefully and systematically flee the opposite route. Instead, the unity of a life's work is found in its diversity, in the way it brings opposites together. And it is by remaining open to this notion of complementarity, by avoiding the creation of taboos, that a work gains richness. A work is characterized by its unity. But this unity embraces many aspects. It embraces diversity. It is well known, especially as far as artistic creation is concerned, that one man's freedom is another man's constraint. The same holds true for reason. In 1930 the mathematician Kurt Gödel demonstrated that the most logical reasoning, over time, inevitably leads to contradictions.

In this open way of thinking, "distinction" and "opposition" are no longer separate; these two notions are the same. In the wish to make things "obvious," or to be "understood," we attempt to oppose these two tendencies, but the desire to bring them together, to make them coexist, means accepting the "nature of things," for reality is the conjunction of order and disorder, as the complexity of everything that surrounds us in our daily life never ceases to prove. This way of thinking enriches the arts, for it estab-

lishes a dialogue between two kinds of logic which have the advantage of nourishing each other even while they lock in combat.

These notes have been inspired by the reactions of a public whose simplistic conceptual schemata prevent them from seizing a certain logic: that from 1966 to 1970 in particular, my work was organized on the principles of methodical, rational thought; and that today, thirty years later, I have given myself more freedom, allowing the principles of disorder and uncertainty to intervene in my work.

For a public whose approach to art is often far too formalistic, it is extremely difficult to understand these relationships. At the very most, this public perceives unity, or a unifying thread, only in the work of artists like Poliakoff, to name but one example, whose every painting mirrors the one preceding it. But this itself is nothing but a "gimmick" which the artist exploits with quasi-methodical intellectual laziness, continually returning to mine the same old vein.

Artistic production can only result from curious, open thought. It functions as a system whose richness consists of accepting, at one and the same time, the principles of harmony and conflict. It is the competition between these two elements, or givens, that creates a whole; and thus the principle of anti-organization becomes a factor in the development, the indispensable dynamism of the creative process.

The exacting artist does not work according to principles that obey the general law of least effort, taking the shortest distance from one point to another and making the smallest possible sacrifice in order to advance his work. He accepts that artistic development is dependent on unforeseeable events like all things in life, like life itself.

To constitute a life's work, to keep developing, means agreeing to explore uncertain trains of thought, reflections that may prove useless, directions that may lead nowhere, so many gestures that perhaps serve nothing at all. Rationalists have not taken into consideration the principle of waste, that which Georges Bataille has called "*la part maudite...*"

A Summary of Responses to Basic Questions, 1975

Bernar Venet

By using mathematics as a model to be explored in the field of art it became possible to introduce a new catagory that was neither abstract nor figurative.

Why the use of mathematics?

The use of mathematics is not to be confused with simple appropriation in the manner of Duchamp or the New Realists, but should be understood as the use of a model, i.e., the mathematical model, which offers to the field of art the particular qualities of its own symbolic and syntactic system.

If we refer to Jacques Bertin's table, "Systems of Fundamental Signs," we immediately see that a work employing mathematical symbols or diagrams falls outside the usual domains of art.

Up until now, figurative works in the visual arts have depended on polysemy (several signifieds per signifier), and non-figurative works have depended on pansemy (a fluctuating relationship between the signified and the signifier). The use of mathematics brings monosemy into play, introducing it to a field where heretofore it seemed impossible for it to function. The picture is neither expressive nor aesthetic, because it is structured by a mathematical code which admits no other values, and which itself is valuable only as a function.

In a work like "Parabola of the Function $y = 2x^2 + 3x - 2$", we can read the definition supported by the graph which illustrates it. In this case,

Significations Attributed to Images

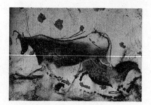

Polysemic
(The figurative image with several signifieds for one signifier)

"Red Cow and Chinese Horse"
Circa 15,000 - 10,000 B.C.
Paleolithic Mural
Axiel gallery at Lascaux, Dordogne, France

Pansemic
(The non-figurative image with a fleeting signifier/signified realationship)

Robert Delaunay
"First Disc", 1912, 53" in diameter
Private collection: Switzerland

Monosemic
(Mathematics and graphic images with only one signifier for one signified)

Bernar Venet
"La droit D'représente la fonction y = 2x + 1", 1966, acrylic on canvas, 67 x 46"
Collection of the Musée d'Art moderne, Grenoble, France

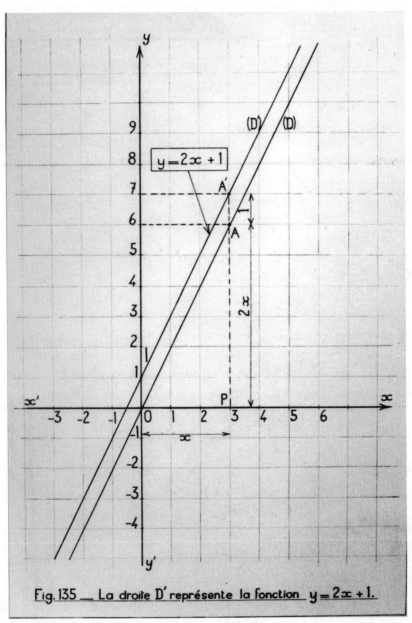

Fig. 135 — La droite D' représente la fonction $y = 2x + 1$.

"La droite D' représente la fonction y = 2x + 1", 1966, acrylic on canvas, 67 x 46"
Collection of the Musée d'Art moderne, Grenoble, France

the system of signs employed is a mathematical language added to an absolutely non-figurative graph, which allows no other possible interpretation: the semantic reference only functions in a mathematical universe; any other consideration, be it philosophical, religious, or social, is totally without a legitimate basis.

To sum up so far, it's crucial to remember we are dealing with a work that utilizes monosemic signs, which are distinguished from and opposed to the signs used in all previously produced art in that they possess a single level of meaning.

If we take into consideration its conceptual model, and remember the example borrowed from (elementary) structural algebra that served Piaget and his students as a model for the phases of mental development, and if we know that mathematical models permitted the solution of many problems in structural linguistics, and that Chomsky was able to classify many problems by relating a specifically linguistic problem (dealing with a natural language) directly to a mathematical model, i.e., a model drawn from a formalized language, we can then accept the idea that the mathematical model is not important in and of itself, but because it can be used as a "linguistic model" in different disciplines.

We can distinguish two directions in the use of mathematics in art: a "constructivist" use on the one hand, and a "linguistic" use on the other. Here we will not address the first, whose Russian heritage and its developments down to "primary structures" are well known. In linguistic use, the works of certain conceptual artists feature self-denotative phrases, texts consisting of the predicates of sentences that only refer to themselves. In such work, only the verbal form is to be taken into consideration: tautology in some cases; in others, contradiction; or in others still, a shift in level.

For those who are curious about the reasons that led me to use mathematics in the context of art, I would first like to explain my personal reactions to my sociological, historical and geographic contexts at that time. It's also important to know that beginning in 1961, I was motivated by basic considerations of restraint and neutrality, as I worked toward achieving a "zero degree style" by eliminating all "treatment" of my material.

Thus, when I arrived in New York in 1966, I initially found myself closer to the Minimalists than to Pop Art or its predecessor, Abstract Expressionism. Tired of years of lyrical European painting and the growing

redundancy of New Realism, reacting against the excesses of expressionism, I naturally opted for the kind of work that would allow me to develop the rational, as opposed to the expressive, image.

The word "expression" in its classic sense means the "representation of passions." German critics coined the term *Expressionismus* to describe painting in general, but particularly the kind where the representation of human emotions prevails over the solution of purely plastic problems. In this case, expressionist painting cannot be considered an end in itself, but rather a way for the artist to impart his psychological emotions, his personal feelings, his pathological woes, his philosophical, metaphysical or social beliefs, or even his totally individualistic visions of the universe.

In his *Essais de linguistique générale*, Roman Jakobson assigned "the poetic function" to the expressive image: "Centered on the receiver, the expressive function aims at directly expressing the subject's attitude to that about which he is speaking." According to Jean-François Lyotard,

> The problem we should consider is the relation between art and its fantasy producing capacities. If the artist is someone who expresses his fantasies, if the relationship is one of expression, his work will interest only himself or people who have similar fantasies, and hence can identify with it.

In this case, art is subordinated to a different function. The artist no longer serves painting; he makes use of it. The ability to distinguish between these two fundamentally opposed attitudes is essential.

While an expressive work of art is the result of an intuitive process, a rational work of art is arrived at deductively. It is the product of discursive knowledge. They thus represent two contradictory approaches: one immediate, the other mediate. The first remains captive to the "real" world and baseless meanings that it mistakes for reality; the second arrives at its goal by organizing its fundamental ideas within a precisely delimited field of validity.

To my knowledge, little has been written about the history of rational art, and yet it deserves serious study. To mention only a few names, the tendency begins with Malevitch who introduced the idea of a system with "*Carré noir*" (Black Square), "*Crois noir*" (Black Cross), and "*Circle noir*" (Black Circle) in 1915, followed by Rodchenko, who produced sever-

al wooden sculptures around 1920, including the famous "*Construction de Distance*" (Construction of Distance). "Arithmetic Composition", the 1930 painting by Theo van Doesburg, is also highly representative. This is followed by compositions by Vantongerloo, whose point of departure is a mathematical equation, such as "$y = x^2$".

The group of Swiss concrete artists including Max Bill, Richard Lohse, and Camille Graesser, as well as the French artist François Morellet, continued in this vein, widening its scope through rigorous theoretical research. This specifically European line was not surpassed until the '60s with the advent of American minimalists like Robert Morris, Donald Judd, Dan Flavin, Sol LeWitt, Carl Andre, Robert Smithson, with Judd, Flavin, and LeWitt producing the most rigorous works dealing with systems and mathematical progressions. The works of such artists is "rational" because they obey the laws of deductively reasoned construction in which the system of production is rigorously coded beforehand.

To explore the rational work of art more extensively, I had to leave behind formalism, which is pansemic, as shown in Jacques Bertin's diagram, and address the linguistic and graphic aspects of the mathematical model. Transcoding looses its random aspect, but obeys the laws of graphics, the only type of image to enter the domain of the monosemic. "Graphics and mathematics are similar, and make up the rational domain," Bertin writes. The use of language which continues to interest several conceptual artists has little in common with the line I followed throughout my productive period. My categorical refusal of linguistic signs found its logic in the fact that I rejected their polysemic character. Those signs generate a multiplicity of meanings that depend on context, and often produce a poetic effect. By contrast, I turned to using mathematical signs whose monosemic rigor prohibited multiple readings.

Pictorial signs, like words, have no innate meaning. They have only a use. Both lend themselves to different uses, with the exception of units of monosemic signification, which have but a single use.

In a figurative or abstract painting or text, each signifying unit can point to several signifieds, whereas in a graph or a mathematical text, each signifier corresponds to a single signified. There is one meaning per signifier, one signifier per meaning.

Major Early Contributions by Paul Klee, Theo van Doesburg and Georges Vantongerloo, all of whom used mathematics as a means to create new compositions.

Paul Klee
"Black and White Shuttle Progression", 1924, pencil and ink on paper
Reproduced from *A Pictorial Theory of Form*

Theo Van Doesburg
"Arithmetic Composition", 1930, oil on canvas, 40 x 40"
Collection of Mr. F. Witzinger

Georges Vantongerloo
"Composition y=⅗ with red", 1931, Oil on canvas, 12½ x 16 ⅞"
Collection of Kurt Seligmann

The 1970 halt in production

At the end of 1970, after having completed the program of work I'd established for myself in 1967, I decided to stop producing works of art completely. I did this for two essential reasons I here would like to define. The first was the logical consequence of the objective bent of my work. In other words, in taking the rational character of works of art to their furthermost extreme, it became impossible to interject the subjective elements that would have permitted me to develop infinite variations.

On the other hand, I'd been thinking for several years how limited artists are in relation to the length of their creative periods. These thoughts did not directly relate to the genre I was working in, nor were they the consequence of this work, but were part of my reflections on the more general aspects of the creative process.

Creation is first and foremost a historic fact. This does not mean it should be understood as a simple mechanical relationship between cause and effect, for artistic creation is a function of social milieu, personal biography, the subjective life of the artist, technical and economic resources, and many other things. We should conceive of creation (and it would be better to say "relative" creation, as opposed to the impossibility of "absolute" creation) as the production of something new by way of an original articulation of existing data.

It is impossible to measure the degree of creation, and its scale of values is constantly revised according to the evolution of political, economic and ideological ideas. Nevertheless, it does seem possible to establish the importance of an artist's contribution to what we could call the reality of the history of art.

When we analyze the production of artists in the past, it is not too difficult to situate the moment at which questioning the object of "art" gives way to making art objects.

I see the following three steps in the pictorial practice of artists: 1. informative; 2. transformative; 3. productive.

The first is the apprenticeship stage, during which the artist acquires a certain amount of information relating to theoretical knowledge and the actual practice of his chosen discipline. The second corresponds to

the moment when an artist begins to ask the question what art is really about and develops a new concept. In the third stage, artists produce variations on this concept that satisfy their pathological urge to make objects only. As far as I am concerned, this third stage is really redundant.

Thus it is that painting, like literature, dance, and music are disciplinary tools which permit their practitioners to transform and extend the field of art, within the limits of their intelligence. But the practice of such disciplines does not necessarily imply that the practitioner has made a contribution to the knowledge of art. Since 1971, I have preferred to substitute a period of logical and reflective work for this third, "productive" stage. The importance of this reflective period derived from the fact that it permitted me to analyze and codify knowledge, and thus to more rigorously formulate the scope, field, and import of my conclusions. This played a role of prime importance at the end of the discovery process, when it became a matter of communicating my ideas convincingly to others.

Psychoanalysis is another useful discipline when it comes to bringing us nearer to the true meaning of works of art, for it directly opposes the theological idealization which induces the public to worship works of art and treat them as if they were quasi-divine. It subjects works of art to the principle of demystification, and exposes fetishistic excess.

Its good is to render intelligible the "troubling" and "fascinating" effects that Freud discusses in *The Purpose of Psychoanalysis*, without recourse to aesthetic appraisal, through sheer comprehension. We must encourage art lovers to develop a rational and analytic disposition. As Freud has written:

I have not read widely enough to know if this already has been noticed: has any aesthetician ever considered that the disarray of our intelligence is the necessary condition for a work of art to produce its strongest effects? And yet I find such a condition hard to believe. It's not that experts and art lovers lack for words when they praise works of art. In my view, they use far too many of them. But as a general rule, each expert expresses, about each masterpiece a different opinion, and no one voices what would solve the mystery for the simple observer.

Far too often, biographers and critics sacrifice truth for illusion. As Sarah Koffman has put it,

Freudian demystification does away, all at once, with the theological attitude of artist worship and with narcissistic identification, treating them both as part of the same system. The religious and animistic phases must be replaced by the scientific phase, the mature phase, in which the pleasure principle is renounced and the choice of art's object is subordinated to reality.

Bernar Venet

An Interview with Ken Allan

To this day, I still have not met Ken Allan, who lives in Toronto and publishes art criticism.

He contacted me a year or so ago for an essay that he was about to publish in the Canadian magazine, *Parachute*, entitled, "Business Interests, 1969-71: N.E. Thing Co. Ltd., Les Levine, Bernar Venet and John Latham." The section on my work was entitled, "Bernar Venet: The Process of Understanding." He has since published a further essay on my poetry. I was happily surprised to see that a younger critic was aware of some of the ideas that I had developed in the '60s.

Ken sent me an e-mail asking whether we could explore some aspects of the Stock Market works. I later responded to twenty-seven of his questions…

Ken Allan: In the early '60s you had some connection with Ben Vautier in Nice. Were you personally acquainted with other European Fluxus members at that time? Fluxus did not really exist in the New York art magazines of the day, but (given your 1966 move to New York) to what extent would you say Fluxus was visible in New York in the mid to late '60s, and how much do you think it may have provided a groundwork for New York Conceptual art (which is often suggested to be more of an evolution from the practices of American Minimalism)?

Bernar Venet: Yes, it was through Ben Vautier that I met several Fluxus artists in the early '60s—most notably George Maciunas, and two other important members, Robert Filliou and George Brecht, who later settled down near Nice. In 1966, as soon as I arrived in New York, I was also in contact with Dick Higgins, Bob Watts, and Ay-O. Personally, I don't think they much influenced my work. I respected them, they were full of ideas, but I was also critical of them. For my taste, there was still too much of Dada in their work. On the other hand, I was able to perform my 1961 prostration amidst garbage bins because the Fluxus artists had generated so

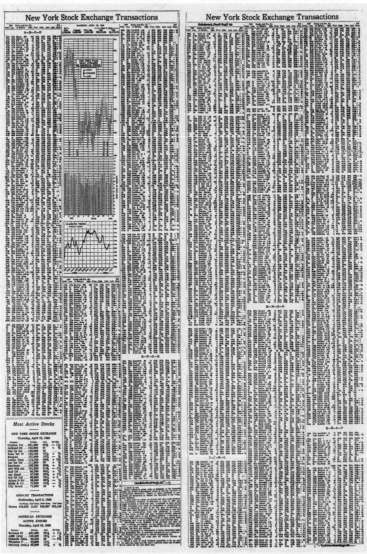

"New York Stock Exchange Transactions: April 10, 1969", photographic enlargement, 68½ x 42", Collection of G. S. Rosborough, Jr., St. Louis, MO

much creative freedom, and their "events" made my own activities easier. This doesn't relate to content, though, because this performance was very closely connected to the work I was doing back then with cheap materials like cardboard, tar, and things like that. Looking back on it now, it seems to me that Yves Klein's leap into the void was more of an antecedent to my 1961 performance, a better subject of comparison. I can't speak for other Conceptual artists, but I don't think Weiner, Kosuth, Art & Language or Ian Wilson were influenced by Fluxus either. If you're going to look for influences, you'd more likely find them in Ad Reinhardt's reductionism and in Minimalist art.

KA: One group of projects that interests me very much are the 1969-1970 newspaper subscription works that involved both The Wall Street Journal and the Frankfurt Börsen-Zeitung. I haven't seen much information on those, but have read that there were fifty copies of the business newspaper sent out to selected individuals. Could you discuss what those works involved and what your intentions were?

BV: I wanted to enlarge my range of activities by using different means to communicate the content of my work. This has always been a preoccupation of mine. Already from 1961 to 1963, in addition to painting and sculpture, I had no hesitation about turning to film, photography, performance or sound to develop the ideas I was beginning to deal with. I didn't want to confine myself to presenting "blow-ups," which were more related to my past activities as a painter and photographer. In another mode, I wanted to invite the New York art milieu to visit the New York Stock Exchange on Wall Street, as if it were an exhibition or a performance. Unfortunately, I never was able to do it because visits by groups of non-professionals were prohibited when the Exchange was in session. By introducing subjects like the stock market, I was trying to distance myself as much as possible from the subjects that had inspired artists in the past. I was searching elsewhere, in places where the atmosphere seemed totally opposed to what people conventionally call "artistic." Such nontraditional subjects could also seem unworthy of artistic treatment, because money is vulgar—or, to say the least, it's not among our more noble values. Another particularity I have to mention, something that tied this area to other subjects I was then exploring, was

its relation to calculus, analysis, and the statistics generated by economic activity. Graphs and stock exchange reports were also included in these visual materials. Although the stock market was a subject that artists still ignored at the time, I thought it should be taken into consideration because it obviously reflected certain aspects of society, and particularly the economic situation. It functions like a barometer of world events at all times, be it wars or major political developments. As a seat of power, it plays an important role in our society in the sense that for many people, it's part of their dreams, an institution at the base of the most tremendous fortunes and the worst financial catastrophes. Today, artists are interested in the stock market for the contrast between the symbolic heat it generates and the coldness of its technological environment. The photographs of Andreas Gursky (Hong Kong Stock Exchange, 1994) are one good example of this new interest.

KA: Donald Karshan wrote in the 1971 catalogue, *The Five Years of Bernar Venet*, that you yourself did not dictate the content of your Conceptual work. But is not setting the parameters of the work being responsible for the content, just as John Cage was responsible for his work in a musical sense? Karshan wrote that the use of photographic enlargements allowed you to dispense with style. He associates style with hand-craftedness. But don't the enlargements have their own stylistic consistency by virtue of the repetiveness of their sources and your standardized presentation of them?

BV: My photographic enlargements had their own visual specificity. They were distinguishable from enlargements by Kosuth or Art & Language. To me, they seemed to be the most neutral way of reproducing a chosen text. I used them just as they were. I only intervened in deciding to enlarge them. The sole function of the enlargement process was to better attract the viewer's attention. It's also important to note that I didn't always use enlargements systematically. Sometimes I also showed original pages of a photocopied text or, more directly still, the actual books themselves. I had an exhibition at the Daniel Templon Gallery in Paris where a friend of mine chose the subjects for the blow-ups. I had nothing to do with it myself. They were selected from a book on grammatical analysis that I wasn't even familiar with. To emphasize my total disengagement from the visual aspect of this work, I didn't go to Paris for the opening. I preferred to wait and see the

results a month later, after the exhibition was over. Friends of mine, scientists at Columbia University, Jack Ullman particularly, selected subjects, notably from nuclear physics, astrophysics, or mathematics. The choice was based on how important the subject was to the discipline. At the time, I didn't want to be accused of selecting the images I exhibited based on aesthetic criteria (the beauty of certain diagrams for example, or the very spectacular reproductions in books on astrophysics).

KA: What did you mean by the term "aesthetics" at the time? (Was it the study of sensory perception, prettiness, optical formalism, the philosophy of art?) There is the quote in the Karshan catalogue, "My work is a manifesto against aesthetics, against the expression of the individual's personality."

BV: I was thinking of the criteria used to judge the quality of a painting, and especially its plastic qualities (composition, balance, treatment of the medium, use of color, etc.). I wasn't interested in these things; the formalistic theories of Clement Greenberg held no attraction for me. For me, nothing counted but content and theoretical concerns. Most specifically, I was interested in introducing a new sign system, because its specifics were very different from anything we were used to seeing in art. In that phrase you brought up, the one that Karshan cites, I was insisting that I intended to distance myself from the expressive abuses that had prevailed among the preceding generation of artists, those who were working in the 1950s. The way I saw it, just expressing yourself was not enough to make art. You know what Schwitters said, "Everything an artist spits is art." I admire Schwitters, but this statement sums up everything I am against.

KA: In Lawrence Alloway's 1970 article you are quoted as saying, "I believe in nothing but one supreme value, that of 'objective knowledge.'" At the time, you spoke of the didactic nature of your project. Douglas Huebler once stated that he didn't wait for critics to explain his work, he told them what it meant himself. This seems to have been a common view of several New York Conceptualists. Would you link these objective and didactic notions to that of the monosemic which you later adopted?

BV: In fact, it was an article on my work edited by Lawrence Alloway in

the March 1970 issue of Arts Magazine that incited me to write about what I was doing, to define its interest and originality. It's always easier for an art critic to find conceptual antecedents or formal similarities with works of the past that demonstrate how a work fits into the history of art. It's more difficult to define new elements and try to make sense of them. I rejected the then current critical interpretation, and aimed to replace it with analysis. Everyone knows that this conventional discourse, the discourse of interpretation, actually tells us mostly about its author, while true analysis tries to uncover an artwork's specific characteristics. "Objective knowledge" was also the specific content of my work, which was as non-poetic, non-expressive, rational and precise as possible—in other words, which "spoke" in a scientific language. During my period of active production, although it was evident to me that my works could not be categorized as abstract (pansemy) or figurative art (polysemy), the term "monosemy" was not yet part of my vocabulary. The term obviously is tied to the principle of "objective knowledge."

KA: With the "blow-ups" of 1969-1970, what were the aesthetic relations between the phenomena of the presentations and the abstract knowledge presented, as they shifted from their hand-held newspaper or book origins to your enlarged wall panels?

BV: What interested me was this idea of context, the principle of equivalency that I talk about in my interview with Eddy Devolder. A "field of knowledge" cannot be uniquely presented as a "picture" (in this case, photographic blow-39 ups or writings on graph paper). In order not to fall into this trap, and principally to avoid public reaction to the plastic qualities of certain diagrams, I began presenting, in early 1967, non-visual work such as conference lectures recorded on tape. In May 1968, I organized performances at the Judson Church Theatre in conjunction with scientists from Columbia University. I produced a record, The Infrared Polarization of the Infrared Star in Signus, followed by another one, a single work which I considered to be more of a musical proposition, Cardiac Auscultation. I had a book on astrophysics bound with its title and my name engraved on the cover as a kind of misappropriation, a contextual shift. Then there were the cards I sent out entitled Weather Work, the financial newspaper subscrip-

tions for the Museum Haus Lange in Krefeld, Germany, during the time I was showing my work there, and One Week of The Wall Street Journal exhibited at the Paula Cooper Gallery.

KA: Would you agree that while the raw data of the stock market or of scientific information may point to one signification, the presentation of them in an art context will evoke different understandings?

BV: Of course, it can't be otherwise. We're all conditioned by our cultural references and the context in which these texts are shown. An aesthete might only see them as an arrangement of numbers and diagrams, and be particularly sensitive to their overall formal and graphic qualities. The Wall Street professional will have no problem discovering the ups and downs of the stock exchange he knows so well. Others with a taste for black and white and a preference for "cold" images will find them aesthetically satisfying. The man on the street will turn away, annoyed by numbers he can't understand and lacks the patience to read. And even the most astute professionals in the art world offer multiple readings that change with the times. The way an art lover perceived these works when they were first created is bound to differ from the way that same person will see them today, more than thirty years later. The univocity, the monosemic nature of these signs has no reality except on the level of their use as symbols. My works are not monosemic in and of themselves, but they employ monosemic signs. It is at this level that they are different from what we are familiar with in art.

KA: Robert Morgan writes in *Bernar Venet, 1961-1970*, that "the medium used to transmit the information was essentially irrelevant in formal terms. On the other hand, one cannot entirely dismiss the means by which information is comprehended from the medium used to deliver it." What is your view on the possibility that an aspect of an artwork could be considered irrelevant? Should not every aspect of possible influence be subject to consideration?

BV: It's impossible to keep visitors to an exhibition from seeing things in a work that have no importance for the artist, or in any case which he considers non-essential. Once again, our culture conditions our reactions to works

of art. We often only see what we've been taught to see. We remain blind to what is new in works of art. If the work is very radical, it's impossible for us to give it a meaning, which is normal because its meaning will only be defined little by little, as the work itself develops, as its context becomes clearer and can thus be more easily discerned. A person who was interested in the formal aspect of my diagrams in 1966, conditioned by the fact that form was an essential characteristic of art, missed the point of it all. Such a person was in the same situation as someone who'd just encountered an abstract painting by Kandinsky for the first time, and was trying to discover what it possibly could represent.

KA: In Catherine Millet's book you mention that the stock market works were provoked by a friend who worked in the area. How did that come about?

BV: In 1968, what I called *Marché des Valeurs* included the work on the stock market and the articles by Clem Morgello. With the exception of some subjects suggested by a friend of mine on Wall Street, which notably included Morgello's articles, the few works I did produce were chosen very arbitrarily and, although I may seem to contradict myself, I must confess they were also probably chosen for their visual originality. It was, in a sense, to enrich the overall variety of what I was proposing, an enrichment at the level of content of course, but I also found the technique of these images and the variety of configurations in those lists of numbers interesting in and of themselves.

KA: In his articles, Clem Morgello deals with current, changeable economic information. Your "blow-ups" of them, however, came some time after the fact, so that the audience could no longer act on the information Morgello provided. The other information that you presented was relatively stable in comparison. Could you comment on that distinction?

BV: It was with the "book presentations" in 1969 and 1970 that I started thinking that problems related to permanence and information were truly interesting subjects for reflection. You're right to mention that Morgello's articles only describe the condition of the stock market at a given moment,

without considering factors of time and updated information. Installing a television at the MoMA Information exhibition in 1970 brought up issues about the permanence of the subject, since there the information was updated every day. Turning on the television to a channel showing stock market quotes today is tantamount to discovering the follow-up to that work a couple of decades later.

KA: How did the work "One Week of The Wall Street Journal," bound in one volume, come about?

BV: As you may know, Paula Cooper invited a group of artists to exhibit at her gallery in May 1969 under the title Number 7. I don't remember exactly what motivated my decision to present One Week of The Wall Street Journal. I wasn't trying to criticize any particular economic system or glorify the American doctrine of capitalism, far from it. But it did seem to me, on the other hand, that the idea of exhibiting a week of The Wall Street Journal would work well within the framework of the program I had set myself and would amplify its demonstration. It was a "different" way of presenting my work, and probably another way of suggesting that mine were new art ideas.

KA: Did you get permission from Morgello, Newsweek, or The Wall Street Journal to reproduce the articles in your "blow-ups"?

BV: No, not at first. I reproduced several of his analyses that had, in effect, been published in Newsweek, and then one day I called him to tell him what I was doing. He seemed to know all about it. He thought it was curious, but couldn't see anything artistic in his articles. I didn't try to explain my motives to him, because we didn't speak the same language. (I didn't understand his any better than he understood mine.) In fact, if my memory serves me well, I think I called him only to say that I was missing one of the articles he'd written for a particular week in 1969. He sent it to me right away.

KA: On your page in the catalogue for the 1970 MoMA exhibition, there is this note: "During the exhibition a TV set in the gallery will be turned on whenever Stock Market and classroom programs are presented. The rest of

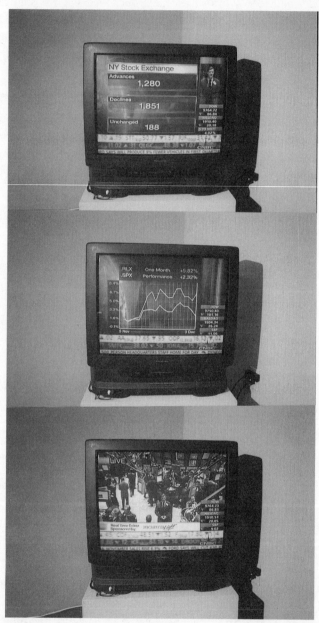

"Stock Market Channel", exhibited as part of the Information Show at the Museum of Modern Art, New York, 1970

the time the TV will be turned off." I have written on the Information show, but haven't read anything else on this piece. Could you discuss it?

BV: I'm glad you reminded me of this exhibition because it's true that I always forget to mention it as one of the ways I presented the disciplines included in the program I established in 1967. The Stock Exchange seemed entirely appropriate to me since its rates were reported on various television channels at different times of the day. I thought my non-intervention in their choice of subjects was interesting, but especially my non-intervention in the evolution of the market, its daily "ups and downs," throughout the period of the exhibition. I didn't understand anything about it, and I never did learn anything about the stock market. The area was totally foreign to me and seemed extremely abstract. Lists of numbers and the abbreviated names of companies with no connection to the natural world, to concrete reality, and nothing to do with art. Once again, it was a subject made up of analyses, numbers, calculations and diagrams, a domain where the artist's personal sentiments, emotions and metaphysical aspirations were no longer determinant factors in the conception of the work—to put it briefly, where there was an absence of expression. For this exhibition, I had a television set installed in one of the museum galleries. At certain times of the day, when programs on the stock market were presented, the set was supposed to be turned on. I remember feeling very disappointed in the exhibition. One day, I went back with some friends, and the television set was gone. My work was no longer there. I was no longer represented, and there was no trace left of my participation, no matter how temporary. I was loath to contact Kynaston McShine, the curator in charge. While this type of installation (televisions set on the floor) is very commonly used today, that was far from true at the time. Artists were not yet combining video with the plastic arts. It's interesting to note that Nam June Paik didn't take part in the exhibition, although, a year before, he was in the Art by Telephone exhibition organized by Jan van der Marck at the Chicago Museum of Contemporary Art. But it's true that his use of television sets was more oriented toward presenting abstract images, and the television set itself figured more as an object than as a means for broadcasting information. This probably explains why Nam was not part of the Information show.

KA: In 1968 and 1969 you collaborated with Billy Kluver on a project for E.A.T. at the Brooklyn Museum. Were you interested in the work being done by Robert Rauschenberg and others in Experiments in Art and Technology? Perhaps there were parallel scientific interests? What exactly were the projects that you collaborated on?

BV: I knew that numerous artists were interested in introducing technology into art. I was friends with Takis, one of the most original representatives of technology in art, as well as with some of the artists of the Howard Wise Gallery, where Hans Haacke exhibited. Of course I knew Rauschenberg's work, and the work by other E.A.T. artists, but they were not a source of inspiration for me. I had no real passion for technology. I thought that only the theoretical aspect of science, with its very specific use of language and high level of abstraction, could serve as the model for my work, which had nothing to do with the application of technology to art. It was a huge project, directed by Billy Kluver. He's the one who invited me to participate in the exhibition, using one of his own scientific texts. As you know, each work was a collaboration between an artist and a scientist.

KA: Did you have any interest in the media theories of Marshall McLuhan?

BV: I understand why you'd ask me the question. Like everyone else, I browsed through The Gutenberg Galaxy, but nothing in it was of any personal use to me. His point of view seemed interesting, of course, but it didn't influence the way I thought or acted.

KA: Did you have any contact with Daniel Buren around this time? As he is the other main French exponent of Conceptual art, could you discuss the views you have of his work and theories?

BV: His work is important and varied, and stems from a very reductivist idea. We've known each other since 1964 or 1965. Once in a while we have a long conversation, but it's rare. He's a very good artist for whom I have a lot of respect. It's interesting that you call him a Conceptual artist. You know, this is something he's always denied. His work seems more akin to Minimalism. After all, his tapes, measuring 8.7 centimeters in width and

repeated at regular intervals ad infinitum, rather refer to a formal model on which he decided long ago. Despite the richness of its variations, which are the result of deep and coherent reflection, he's no more a Conceptual artist than Sol Lewitt, whom I admire a lot. Everyone knows Sol wrote "Sentences on Conceptual Art," but his work remains strongly minimalistic. The term "conceptual" is overused, and can be adapted to just about anything, but for me, Conceptual art was above all, at its most radical, based on the refusal of everything having to do with form. It essentially favored the use of language in works of art, or simply theoretical discourse as artistic activity.

KA: You wrote: "*Mon activité de 1971 à 1976 a donc été de passer au stade du 'verbal'. Cette attitude restait dans l'esprit de mon travail antérieur puisque dans les deux cas se manifeste avec la même constance l'invariant unique: le concept d'analyse.*" (My activity from 1971 to 1976 thus consisted of moving into the 'verbal' stage. This attitude continued the spirit of my previous work, since a single invariant, the concept of analysis, consistently occurred in both.) Did that have any relation at all to the sort of work that Ian Wilson was doing?

BV: I'd known Ian Wilson since the '60s, and I found his position interesting, but I never had a real conversation with him, nothing of any substance. You have to admit, he never was very talkative. I never thought there was any similarity between his art and mine after 1970.

KA: You speak about your activity from 1971 to 1976 as a *conversion du regard*. You say:
> *Pour revenir à mon activité de 1971 à 1976, cette période de 'l'arrêt', où j'ai privilégié la réflexion au détriment de la production, ce que j'ai appelé la 'conversion du regard' m'a permis d'utiliser mes propres oeuvres comme objet d'investigation. L'avantage de ce genre d'analyse, c'est qu'il me permettait de préciser le sens véritable de l'oeuvre, de définir son contenu latent.* (To go back to my activity from 1971 to 1976, the period in which I "stopped" producing in order to reflect on my former activity, what I called *la conversion du regard* was a reorientation in vision which allowed me to use my own works as objects of investigation. The advantage of this type of analysis is that it permitted me

to clarify the real meaning of my work, to define its latent content.) You stopped making art in December 1970 and resumed in October 1976, but I'm still not clear about what exactly your activities were between 1970 and 1976.

BV: When I stopped producing works, I gave myself the time to read, study certain disciplines and write some texts with the aim of unambiguously clarifying the true nature of my work. Exhibitions of my work took place in various countries, which obliged me to travel and offered me the chance to give lectures here and there. I moved to Paris, where I lived from 1972 to 1976. During this time, I was invited to lecture at the Sorbonne. I came back to New York in September 1976, after having moved my loft from Broadway to West Broadway, and it was then, after much hesitation, that I began making art again.

KA: You said in the 1991 interview with Eddy Devolder that intuition and chance play an important role in an artist's work. Would you also apply that notion to the earlier conceptual work? If so, wouldn't that suggest something other than the analytic in the work's production and reception?

BV: Intuition and chance are certainly determinant in the process of discovery and in stimulating thought, making them essential to creation. Every day, we are subjected to unforeseeable situations that impact our intuitions, influencing our ideas as well as our reactions. We constantly have to react to unexpected phenomena full of potential. Such "accidents" allow us to revise the way we see things. They are a desirable, indispensable determinant for our development and for that of our creativity. I nevertheless must confess that during the '60s, I thought that every work of art was the logical result of all the ideas that had preceded it. I presented my work as the inescapable end result of a logic that had permitted me to develop what I called the "rational image." I won't go back over it here, but my major historic references were Rodchenko, Vantongerloo, the Swiss Art Concret movement, Morellet, Stella and Minimalism. At that point, I was able to begin another phase, passing from the formal use of mathematics to the linguistic use of the same discipline. This method was too deterministic, as I discovered at the time I ceased producing work. This criticism further permitted me to

question my decision to put a definite stop to my activity, and it was thanks to this that I was able to return to active production again in 1976.

KA: Do you see Conceptual art as part of a continuum with earlier avant-garde art of the twentieth century, or would you agree with those who claim that it represents a complete break with earlier art production?

BV: Conceptual art might never have seen the light of day if it hadn't been for the extraordinary history of the twentieth century, with its successive art movements and radical manifestos. Several artists had a liberating effect, but Marcel Duchamp and Ad Reinhardt undeniably had the greatest influence. Duchamp liberated artists from their dependence on "*la peinture retienne*," retinal painting, as opposed to an art that favored the brain. We can think of him as having opened the way for the "dematerialization" of art. This was a very compelling subject in the '60s. Two texts by Lucy Lippard, its theoretician and historian, are essential references: the first appeared in Art International in February 1968, and the second is the book she published in 1973, *Six Years: The Dematerialization of the Art Object*.

The influence of Ad Reinhardt is also undeniable. His writings on the non-relational character of his paintings were important for many artists of my generation, but especially for Minimalist artists. I don't think this was the case for me. My method of thought and deductive actions followed their own logic. We were living at a time of tremendous change, and wanted to distance ourselves from the criteria of the past.

I envision Conceptual art as more of a break with past experience. While Minimalism, despite its radicalism and importance, owes a substantial debt to geometrical abstraction, no similar comparison can be made with Conceptual art. It's a movement that opened many doors, which in my opinion introduced new ideas that recently have been exploited by artists who've been able to find more flexible or spectacular formulas than ours— formulas freed from the theoretical austerity that characterized our own work and made it so difficult in the eyes of a public often in search of the sensational, the complex and the entertaining.

KA: In Catherine Millet's book the references are often to Jacques Bertin, but also to Anglo-American analytic philosophy. Would you say, then, that

the monosemic idea, applied retrospectively, fitted the work that you had started some time before, as Christian Besson suggests? What theoretical approach were you using before that time as a method of arriving at the four-year project, or was it more intuitive? Besson says that your first published mention of Bertin was as late as 1974.

BV: Yes, it is correct that my introduction to the three essential categories drawn from Jacques Bertin's theories, polysemy, pansemy and monosemy, dates from the "hiatus" in my production. As Besson wrote, it may have been 1974 before any description of my work as "monosemic" was published. I may have used it in lectures before. That's not impossible, because I already knew Bertin's work at the time. The periodical *Communications* published his article "*La Graphique*" in 1970. I don't have a lot to say about Besson's text. His perspective is different from mine, and I find his approach enriching for the analysis of my work. I can't be very precise, but in 1967, when I established my program for the four following years, I think I was principally trying to establish a method of working in different disciplines that would not allow me to waver.

KA: In her writing on your work, Catherine Millet repeats the word "tautology" often, which was a favorite of Joseph Kosuth. Was she using his writing as a way of approaching Conceptual art in a generalized fashion, and applying that to your work?

BV: I think that her use of "tautology" can be explained by the fact that, at the time, practically no one had written on Conceptual art. There were very few texts to which one could refer. Art & Language was incomprehensible to most people and even to specialists, and furthermore, their texts certainly hadn't been translated into French yet.

KA: In your conversations with New York Conceptualists, did you discuss the work of the French theorists who were slowly being translated into English? Also, Levi-Strauss, Robbe-Grillet and Samuel Beckett were apparently quite popular among New York Minimalist and Conceptual artists. The English Art & Language artists, on the other hand, were rather hostile to French theory in the early '70s.

BV: I was close to the Art & Language artists, Ian Burn and Mel Ramsden who lived in New York, and Baldwin and Atkinson, who lived in England. We all were on friendly terms, but there was little theoretical discussion. We didn't really think in the same way, essentially because the French semiologists didn't interest them. Victor Burgin, whom I often saw because he sometimes stayed at my apartment in Paris, was the exception. I felt very isolated in the path I'd chosen. Kosuth went to war with me because I'd accused him of antedating his work. I was a little too familiar with his background, and he didn't like it. I was friendly with Lawrence Weiner, but we didn't see one another often enough. I didn't know Douglas Huebler at all, and I've known Robert Barry only for the last few years. So there was very little intellectual exchange. What our works had in common was the critique of formalism and the very direct, sober and didactic use of language.

KA: More recently distinctions have been made between "Conceptual art" and "Conceptualism." The latter has a much broader focus and is perhaps too all-encompassing. What are your views on recent attempts to redefine what Conceptual art is or was?

BV: History is constantly being written and rewritten. There are numerous interesting points of view, but it seems a shame that younger historians don't show more knowledge of what we were doing in the '60s with film, performance, video and photography. It's also true that every country has its own version of events, and analyses the facts from a point of view that greatly depends on the local culture or a specific philosophy. The English in particular have a tendency to favor their own artists.

KA: In the United States, did you find a strong nationalism regarding where significant art could then be made?

BV: In the '60s, it was very difficult for a foreign artist to make it in New York. The specialized magazines only covered what happened in the United States. The rest of the world did not exist. We had to wait until the middle of the '70s with the arrival of the Italian Trans-avant garde and German Neo-expressionists for America to discover that things were also happening elsewhere. This change

was certainly a consequence of the strong German economy and the collections being built there. It's conceivable that Ludwig and others who bought American art did a great deal to help German art to assert itself.

KA: In your book of poetry, *Apoètiques: 1967-1998*, why the initial "A" in the title? Does it indicate a wish on your part to distance yourself from the standards and general conventions of poetry, and maintain your relationship to visual art with these works? A number of Conceptual artists have presented written material that could be said to be highly poetic, yet they deny that the work is poetry. Among these artists are Lawrence Weiner, Richard Long, Robert Barry, and Ian Wilson. In the '90s you began to reformulate some of your poetic works as murals and paintings, thereby bringing the poetic material back to the art context and perhaps illustrating the slippage that had occurred historically between avant-garde art and poetry. What, in your view, is the relation between Conceptual art and poetry?

BV: The function of the "A" in the title *Apoétiques* was to relativize the poetic character of the texts I proposed. I was in the delicate position of simultaneously refusing all criteria that make it possible to call a text poetic, and trying to impose a different vocabulary and unknown grammar in this area, that of scientific language and mathematical symbols. My idea was that we should develop our aptitude for relating to different fields of knowledge in order to create new combinations. From there, my taste for interdisciplinary thinking quite naturally led me to conceive of introducing scientific language into the domain of the poetic. Once more, I relied on the concept of equivalences to demonstrate the close conceptual relationships among different disciplines. Since I'd been able to introduce "monosemy" into the plastic arts, why couldn't I apply it to the written word? I wasn't concerned whether the gurus of literature would accept this idea or not. As I reasoned, this was work that theoretically could enlarge the field of definitions of poetry. I was hoping to bring denotative scientific language, with all the strength of its rational, logical, or technical communication, to a domain that owed its poetic character uniquely to the manipulation of words and highly metaphorical phrases, rich in connotation. Things that the general public perceives as antagonistic are often, to my way of thinking, complementary. It was interesting to introduce denotation into a field where connotation had

always been the rule. This meant digging down deep and exploring all the possibilities, coming up with new hypotheses, and refusing to use alternatives or accept exclusions.

I think like you do as far as the artists you've mentioned. The texts they were writing on the walls of galleries and museums as well as the ideas which someone like Ian Wilson expresses do, in fact, have a strongly poetic character. They make this compromise through an apparent analogy with poetic tradition. Let me explain. If we take the example of Weiner's "WITH A TOUCH OF PINK / WITH A TOUCH OF VIOLET / WITH A HINT OF GREEN" (1978), or Robert Barry's "It Can Be Forgotten" (1970), one has to admit that these works are obviously of a new nature due to the originality with which they are presented: texts written on walls, they substitute for the paintings traditionally seen in spaces devoted to art. On the level of content, the selected words and phrases are strongly metaphoric. They belong to everyday language but are open to all sorts of interpretations. Their poetic nature, as you point out, seems intentional, but in reality, this is not what the artists mean. It isn't their intention. Actually, the poetry we discover in these brief texts written on walls derives from our interpretation of them within a cultural context. It is also conceivable that these texts are more like conventional poetry than "Visual Poetry," as "Visual Poetry" is a movement that is better known in Europe than in the United States. Here again, we have to accept Weiner's and Barry's position and understand that they situate themselves in the plastic arts, and in this sense are against the perception of their work as poetry. Numerous paintings rich in poetic content have been produced, like those of the Surrealists, for example, without their seeking to qualify as poetry.

My personal approach is very different from theirs in that the language I use has never been part of the fields of plastic arts or literature. It would never cross anyone's mind to read an equation and conclude it was a piece of poetry. There is nothing metaphorical or anything else to stimulate the imagination or make us dream. We're forced to admit our incompetence face to face with those incomprehensible formulas. Only a few rare, inspired mathematicians, fascinated by their high degree of abstraction and the beauty of their logic, will find anything poetic in such formulas. I don't refute this poetic aspect, and there is indeed an element of mystery surrounding these equations and complex formulas that exercise a powerful fascination

over us, even though their real sense escapes us. Yet nothing, absolutely nothing resembles what we normally expect from a poetic text.

For the first time I decided to paint an equation on the wall of my living room, "Related to: The Continuity Uniqueness Theorem," all I meant to do was to copy out something I considered to be a '60s type of poem. I wasn't aiming to create a mural painting; all I wanted to do was recopy this equation/poem in a large format—that was as far as it went. But to my surprise, the visual impact of what I'd just done started me thinking, there and then, that I could develop this idea and, with a shift in context, present such formulas as works of art.

KA: As with the "blow-ups," many of the poems are found material. Are the sources chosen by chance or do you fortuitously come upon resonant presentations of information? Are the sources chosen for their striking qualities?

BV: Obviously, I find all these mathematical texts in specialized books. That was the case in the 1960s and it's still true today for my new paintings. It's the same for my more recent "saturations." All my texts are not "ready-made," as you suggest. Some of them are, but most of the time, I construct my poems from selected words or parts of sentences that strike me as highly charged with meaning. Often, if not always, I deliberately choose them for their distance from—and total lack of relation to—poetic conventions.

Bernar Venet: Logic of the Neutral

Thierry Kuntzel

Thierry Kuntzel was a brilliant student of Roland Barthes as well as a friend. I met him in the early '70s. Knowing his mastery of semiotic hinking, I asked him to write the next two texts for issue #14 of *artpress* in 1974.

Today, Thierry is a successful video artist in Paris showing with the Yvon Lambert Gallery.

To narrow one's view of Bernar Venet's development to his post-1966 involvement with science is to grasp only the surface of a structure which is generated on another level. It is to believe, for example, that Venet's recent work is an appropriation of Science, or of an image of Science, recalling the old problem of art's receding frontiers; or else that his work has abandoned its aesthetic aspirations to suddenly and unambiguously turn informational. This limited perspective would entirely justify Jacques Henric's criticism, "...there are inevitably two ways of approaching Conceptual art, both of which are equally passive. First, that of the scientist who has actually pro-duced the work re-produced by the Conceptual artist; if a grammarian or a semiotician happens to visit the gallery, what will he read on the walls that he doesn't already know? Or secondly, that of the uninformed art-lover who, despite his best intentions, has no access to a serious analytical interpretation of the propositions offered because of their fragmented and isolated nature."

Science, Information—information about Science - are not alluded to as such: they constitute models which, when transformed elsewhere, offer the possibility of an economic "solution" (economic in the Freudian sense) to a series of "artistic" as well as instinctive problems which Venet's previous

work had already posed and begun to solve.

Stage I

1961. Tar painting. Break away from gestural painting: the canvas very soon becomes monochromatic. Black is uniformly spread over the entire surface of the canvas to avoid any effects due to color or medium.

1963. Divide the surface into rectangles. A program to cover the surface: paint the rectangles over a specified period of time (one per month), in a specified order (from left-to-right, from top-to-bottom, as dictated by the convention of Western writing) and according to methods determined by a buyer: "At first, I wanted black canvases. Then I thought that if the choice of color and format were left up to the owner of the painting, the demonstration would be clearer." [2]

1963. Cardboard reliefs. Take distance, break down the anecdote, frustrate attempts at interpretation: "The layers of lacquer which cover the surface of the cardboard hide all the markings "fragile," "top," "bottom," etc. To prevent the works from becoming Pop art, to avoid multiple meanings and anecdotal associations. "A cardboard relief is a neutral object which signifies and represents nothing." Danger of a return to aesthetics through composition: "the arrangement of the pieces of cardboard was so elaborated that it began to bother me."

1966. Tubes. Reduces the object to a volume that the buyer determines, choosing the length of the tube—a prefab industrial object.

Painting degree zero

The same issue repeats itself ceaselessly throughout all the variations of this stage: the search for a kind of painting degree zero, the most obvious characteristic of which would be its "absence of style."[3] A "painting" is a surface, a "sculpture" a volume, a form a geometric figure (Donald Judd: "The main advantage of geometric forms is that they are not organic.") The medium is chosen for its inconspicuous qualities: it must be common (tar, cardboard), it must be smoothly applied to avoid any effects due to build-up (tar,

which can vary in thickness, is spread out evenly with a squeegee), and it must be homogeneous (the glycerothalic paint "homogenizes" the cardboard reliefs). Though industrial materials fulfill these requirements, they must not be glorified as such: tubes will be fabricated in painted cardboard as well as in polyurethane. The color? Black, grey, or sometimes a color chosen by the buyer—in the same way that the object's format is chosen.

Here the radical nature of Venet's undertaking is revealed: the search for a zero degree of style cannot succeed unless the artist's presence is neutralized. Despite the elimination of treatment (the artist's style, mark, signature), certain choices—for example, color and format—continue to govern the fabrication of the objects and place the artist in the position of having to select forms and meanings. So Venet has himself programmed or programs himself (as in the case of the successfully painted rectangles).

Zero degree reading, correlative to the two previous neutralizations: the work has no subject, the symbolic codes are thwarted; it has no style, the aesthetic codes are immobilized; it is literal, the only possible reading being a denotative one.

And yet (...)

Stage II

1966. Diagrams. Eliminate any remaining ambiguities: "Adding the diagram meant that the tube could no longer be viewed as a symbolic object (for example, a phallic symbol) open to free interpretation." A series of industrial and mathematical drawings follows.

The Diagram, Definition

(...) in order to stop the flow of connotation, the object, though reduced in the manner previously analyzed, had to be accompanied by a diagram to describe it. Or, to use the distinction proposed by Hubert Damisch, to define it; even the minimal objet is open to multiple interpretations.[4] In order to suppress other possible discourses based on the object, Venet himself provides a discourse on this object as a denoted object. "The distinctive feature of definition is to state its subject in its form and material, while the aim

61

of description is simply to state the subject's qualities, often by riddle." [5]

The diagram retains none of the object's concrete qualities: it is reduced to a flat geometric representation which no longer allows interpretation.

The world of visual communications reminds us that we base our communications on codes that are strong (like language) and even very strong (like the Morse Code), as well as on very loosely-defined weak codes, which change continually and whose optional variants prevail over their distinguishing traits."[6] Venet's metalanguage sets up a definition which entails the transformation of weak codes (traditionally the domain of art) into strong codes: the diagram isolates the object's distinguishing traits and presents these alone, with a maximum conventionality of representation. [7]

"Diagram. Flat geometric representation of an object or a mathematical figure, obtained by one or more projections on one or more planes; and specifically constructed to permit univocal passage from the object to its representation, and inversely." [8] The diagram, which initially duplicates the object it denotes, is very soon accepted in its own right. The industrial drawing, however, is always a possible equivalent, as if an object (even absent) were still re-presented as if it were still possible to retrieve a real object through the code. From this standpoint, the mathematical diagrams mark a step forward in the work of the code, in the sense that what is representation no longer relies on a possible reference but on another monosemic code. [9]

Stage III

1967. Manifesto. Over a period of four years, program the various sciences which the work will take into account: "An expert will be consulted in each discipline about the subjects that should be presented (the choice being based on their importance). Thus the plastic qualities that some will find will be independent of my intentions. It is now possible to establish a program for the presentation of these works. Specialists familiar with the disciplines in question can judge which subjects should be selected, and since the process is one of photographic enlargement, everything can be done without my intervention."[10]

1967. Astrophysics. Nuclear Physics. Space Research.

1968. Computer Mathematics. Meteorology. Stock Market.
1969. Metamathematics. Psychophysics. Psychochronometry.
Sociology and Political Science.
1970. Mathematical Logic.

Displacement of Form

The diagram attains the desired zero degree: the code is finally exposed. But since it is exposed visually, it may appear to be linked to a particularly expressive material, and thus risk losing its formal coherence. The way to spot the code as such is simply to "displace" it across different materials: "the same system of differentiation (a code) can be globally transferred from one material to another while remaining more or less widely unchanged in its internal relational structure (= form in its Hjelmslevian sense)."[11] Thus, among other examples, "The Infrared Polarization of the Infrared Star in Signus" is presented equally in the form of a blow-up and a phonograph record.

Designate expressly the code: nor should the code be linked to a particular content.

Let us say that in a certain sense, formalization in logic is the implementation of a necessity implied by the notion of form. In fact, it has served as a discipline which attempted to be more and more rigorous and general as a means of attaining its formal ideal, that is, to dismiss...any reference to the content of the arguments.[12]

Mutatis Mutandis, Venet's path through the different scientific disciplines would correspond to the itinerary of the symbolization of logic which replaces individual terms with "object variables" and conceptual terms with "predicate variables," etc. Is it any accident that the program determined in 1967 should terminate in 1970 with mathematical logic?

A danger of fetishism: isolate "pieces" of Science and display them outside their original system of reference, furnish the piece as a message to be decoded without furnishing the code. Certain pieces (titles and summaries of scientific books) no longer serve any purpose but that of signaling the information (conveyed by the book which rests on a pedestal next to the "signal blow-up").

The last fetish left to be exorcised, the last myth left to be destroyed is the dogmatic illusion that scientific knowledge depends on the genius of a few great thinkers..." [13] Since the book to which the presentation refers risks being valued in and of itself, it must be considered as only an element in a vast historical whole: it is only the actualization of science in a certain state: other codes can re-assume it or run counter to it. "It is certain or very probable that in twenty years there will no longer be a reason to present Abraham A. Mole's book, *Socio-dynamique de la culture*, as the true piece, and the contrary would be a serious error because it would indicate a lack of respect for the purpose of this work. The 'work of art' is undergoing a mutation; it is no longer a frozen and irreplaceable object upon which a fetishist value is bestowed, instead it finds its identity in self-renewal.

Nirvana Principle or Passion for the Code?

Fetishism has reappeared in the last few lines for a definite reason: because Venet uses the logic of his work to block it. But the logic is what remains to be examined.

Neutral: neither one nor the other. No subject-author: the signified is chosen by others, the signifier is obtained mechanically. No subject-receiver (viewer, reader): no aesthetic-emotional investment. Strictly speaking, not even a "work": no specific form or medium. In economic terms, the logic of the neutral is subject to the Nirvana principle stated by Freud after Barbara Low[14]: the annihilation of individuality and the "tendency to reduce any excitement to zero."[15] This doesn't remove the problem of energetics but poses it in the same terms as the question of color is posed by, in white. "White is the zero level of color, of all colors, it is the place from which color emerges and to which it returns. White is a void filled by all the colors."[16] If the death wish brings to light what is most fundamental in the notion of instinct, the return to a former state and, as a last resort, the return to the absolute rest of the non-organic," then the neutral marks the degree zero of instinct, against which the pictorial practice would be played off as pleasure/displeasure.[17]

Barthes:

If writing is really neutral, if language, instead of being a cumber-

some and indomitable act, reaches the state of a pure equation, no more tangible than an algebraic equation confronted by the innermost part of man, then Literature is vanquished, the problematics of mankind is uncovered and presented colorlessly...Unfortunately, there is nothing more fickle than colorless writing...The writer who embraces the 'classic' becomes the slavish imitator of his original creation, society demotes his writing to a mere manner and returns him a prisoner to his own formal myths."[18] The neutral is fictitious: the un-marked does not exist. Without insisting on the problem of "formal myths" and "artistic" marking which reappears with the stylistic zero, the question of what takes the place of the subject in Venet's work must be answered. It is a (single) code: The Code. Thus the removal of the idealistic subject benefits another idealization and one of the system's basic fetishisms: "In fetishism, it is not the passion for things which speaks, but the passion for the Code which, by ruling and subordinating itself to both object and subject, consecrates them both to abstract manipulation. Herein lies the fundamental articulation the process of ideology: not through the projection of an alienated consciousness into the superstructure, but through the generalization of a structural code on all levels," Baudrillard again: "What fascinates us is always what radically excludes us by its logic or its internal perfection: a mathematical formula (etc.)."[19]

There is nothing more historically marked than the un-marked. Points of reference: 1964, Elements of Semiology; Barthes, in observing that "every semiological system is mixed with a language system" reverses Saussure's proposition that linguistics is a part of semiology, in order to conform significant practices other than language to the linguistic model. [20] 1971, *Discours, Figure.* [21] 1972, *L'Anti-Oedipe,*[22] *Pour une critique de l'économie politique du signe:* [23] rediscovery of the energetics and autonomy of the figure as opposed to the discourse, criticism of the linguistics of the signifier in the name of flux, dismantling of the semiotic ideology. Therefore Venet's work coincides chronologically with the short reign of "semiology triumphant," the code's ascent and domination on the theoretical level. The logic of the neutral has the same ideological implications as the channeling brought about by structuralism (the flattening of signification and even of communication) with the slight difference that the "semiological reduction,"

which normally occurs on the outside, occurs here inside the artistic practice: the visible is flattened onto the readable, the readable is flattened onto the univocity of decoding. [24]

Notes

1. Jacques Henric, "Lettre de Paris," *Art International,* Vol. XV/3 (March 20, 1971) p. 58.

2. All quotes by the artist are taken from Catherine Millet's *Bernar Venet,* (Paris: Editions du Chêne, 1974).

3. Roland Barthes, *Writing Degree Zero,* (Paris: Editions du Seuil, 1953).

4. *Si, logiquement parlant, la description n'est qu'une définition imparfaite, c'est que le des-cribere, ordonné à un object ne saurait à la difference du definire ordonné à un concept—trouver sa limite* Hubert Damisch, *Le gardien de l'interpretation, Tel Quel,* No. 44, 1971.

5. *Poétique de Boissière,* cit. By Littré, cit by Damisch.

6. Umberto Eco, "Vers une sémiotique des codes visuels," in *La Structure Absente* (Paris: Mercure de France, 1972).

7. On the idea of "conventionality" cf. Umberto Eco, *ibid.*

8. As defined by the *Grand Larousse Encyclopédique.*

9. Cf. Bernar Venet and Thierry Kuntzel, Study of Représentation Graphique de la Fonction $y=-x^3/4$."

10. Interview of Bernar Venet recorded in New York for the Archives of American Art.

11. Christian Metz, *Language et Cinéma,* (Paris: Larousse, 1971).

12. Marie-Louise Roure, *Eléments de logique contemporaine,* (Paris: P.U.F., 1967).
13. Maurice Godelier, Economie marchande, fetichisme, magie, et science, *Nouvelle Revue Française,* Number 2, (Autumn, 1970).

14. Sigmund Freud, "Au-dela du principe du plaisir," *Essais de Psychanalyse*, (Paris: Payot, 1951).

15. J. Laplanche and J.B. Pontalis, Vocabulaire de *Psychanalyse*, (Paris: P.U.F., 1968).

16. Marc Devade, interview by Catherine Millet, *Art Press*, Number 9, (February, 1974).

17. Laplanche and Pontalis, op. cit.

18. Barthes, op. cit.

19. Jean Baudrillard, *Pour une critique de l'économie politique du signe*, (Paris: Gallimard, 1972).

20. *Communications*, Paris, Number 4, 1964.

21. (Paris: Klincksieck, 1971).

22. (Paris: Editions de Minuit, 1972).

23. Baudrillard, op. cit.

24. Cf. Georges Mounin, *Introduction à la sémiologie*,(Paris: Editons de Minuit, 1970).

Study of the Graphic Representation of The Function $y = -\dfrac{x^2}{4}$

By Bernar Venet and Thierry Kuntzel

An Imaginary Piece, The Fluctuating Signification

Let us make a simple commutation by rendering here visible an imaginary piece in relation to which the real piece will take its place:

According to the cultural codes available to a receiver, we can use the following terms: diagram, mathematics, graphical representation of functions, parabolas. Besides, a careful study of the "picture" helps us to name it more precisely since parabolas are indicated by arrows which "refer" to the functions they represent: we have here a graphic representation of the function $y = -\frac{x^2}{4}$ and incomitantly—since it's represented only in dots—of the function $y = x^2$. Several denotations are therefore possible for this untitled piece, the optimum denotation requiring both a detailed analysis of the piece and some knowledge of the mathematical codes and graphic representation involved. Several denotations, that is to say a more or less precise recognition—and also several connotations. Presented in an art ambiance (museum, gallery) such a piece might be interpreted in terms of aesthetics (composition: balance, symmetry, relations between curved and straight lines etc...) or in terms of expression (which would lead for example to an analysis of the

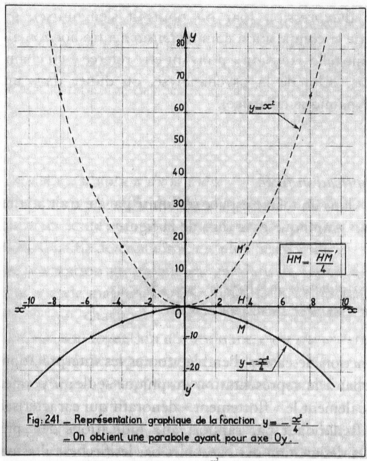

"Représentation graphique de la fonction $y = -\frac{x^2}{4}$ *",* 1966, acrylic on canvas, 57½ x 47½", collection of the artist

composition as a tension between horizontal, vertical and curved lines—such a "tension" being possibly referred to within a precise epistemological field, that of psychoanalysis, or diluted into the metaphysics of creative dynamics).

II. The Real Piece, The Fixed Signification

The real piece includes in the same space (confined by a pen-drawn line) the graphic representation and the title of the diagram:

Fig. 241 — Représentation graphique de la fonction $y = -\frac{x^2}{4}$
— On obtient une parabole ayant pour axe Oy.

This title is meant to prevent from the start any interpretation that could be related to the graphic representation alone; moreover it permits to fix in a definite way the emotional fluctuation of the imaginary piece. Redundant with regard to the indications already given in the figure (indication of parabolas by means of arrows), it asserts what Roland Barthes would call the "anchoring function":

> in all societies, different techniques for fixing the loose chain of sig-nified are being developed so as to fight the terror of uncertain signs: one of these techniques is the linguistic message...the denominative function does correspond to an anchoring of every possible meaning of the object by way of a nomenclature; the label helps me to choose the right level of perception; it allows me not only to accomodate my eyes but also my understanding.

The title might appear to be an indication of how to read the fig-ure; however, it is worth noting that it is neither unkeyed nor marginal (as a title on a label or in a catalogue would be). It is in the same frame (confined by a pen-drawn line), on the same plane as the graphic representation.

The fact that letter and figure belong to the same space is not meant to emphasize the "visibility of the letter"—which is according to Louis Martin, the object of certain paintings by Klee—nor to subvert the order of the discourse with a certain density of the figure. The inverse movement is adopted here: the letter is not to be seen, it is the "picture" that is to be read—and not even so if the reading process is conceived as an open activi-ty, an unlimited work by which codes can be located as far as the eye can see: the "picture" is to be decoded.

III. Codes, Situation of the Piece

Just as it is sufficient to know the code of language to be able to decipher its written expression, and the code of mathematics to understand

its signification, so it is sufficient to know (beside the mathematical code) the code of graphic representation involved in the figure to be able to read it. To say that the mathematical code invests linguistic and visual messages (which both "express it" each in its own way), that is the center of the piece, its focus, its determining factor, means situating the piece at the intersection of two chains (as illustrated) in relation to which it takes on a value (in the linguistic sense) in relation to which its differentiation becomes clear.

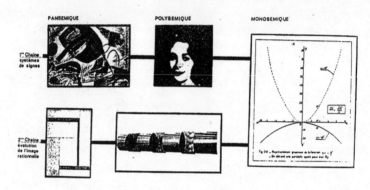

IV.　The Two Chains, Monosemy

If we refer to the diagram proposed by Jacques Bertin for the "systems of fundamental signs," this piece differentiates itself right away from the usual fields of "art" (first chain).

Degree of Abstraction, According to Jaques Bertin			
		Systems of Perception	
		Auditory	Visual
Signification attributed to signs	Pansemic	Music	Non figurative image
	Polysemic	Verb	Figurative image
	Monosemic	Mathematics	Graphic image

Whereas pictorial work had developed up to now in polysemy (several signified for one signifier) in the figurative field, in pansemy (fleeting signifiers/signified relationships) in the non-figurative field, what is at stake

here is the introduction of the monosemy in a field where its practice seems impossible: the picture avoids the expressive and the aesthetic because what structures it is the mathematical code which can be in no way invested with values, whose only value is its functioning.

Indeed has not a similar task been undertaken by Georges Vantongerloo or by Donald Judd? (second chain) Vantongerloo, in an attempt to escape from the intuitive composition of the construtivists who preceded him (the title of his work in that respect is worthy of notice; for example, in 1934: "$x^2+3x+10 = y$"), interprets rather freely for the ordering of surfaces the equation which determines his work. Judd, though building his progressions according to a mathematical order that is strictly established beforehand, remains nonetheless prisoner of a transcoding system the rules of which are not set; hence variations in shapes, materials and colors which lead to a renewed dilution of the code into "art."

It is therefore not enough to work from a monosemic code, the mathematical code, for the picture to be monosemic. Furthermore the transcoding has to be done according to a non-expressive, non-aesthetic order: i.e., logically.

Thus, the verbal message which says what it is about totally suppresses interfering connotational codes to focus on the denotative, what linguists call the function of communication—"what is defined in transformation theory as the use of a code for the transmission of a message." The writing, by the same token, tends to be neutral, its only imperative here not being aesthetics but legibility, defined by Jacques Bertin as follows: "the first and foremost property of the letter is to be non-ambiguous. It is necessary…to adopt a writing and an alphabet which make each letter come out clearly."

But, it is through the treatment of the visual message that the piece sets itself radically apart from the attempts previously evoked. The transcoding is not random anymore, it fully obeys the laws of graphs, the only type of image belonging to the domain of monosemy: "graphs and mathematics," Bertin adds, "are similar and they create the rational field." Orthogonal dimensions, graduation, the cutting of space into perpendicular lines draw the picture away from the expressive aesthetic space where it used to belong to put it into a new "rational" space devoid of any reference to any subject, author, spectator or reader—only the occasion for a code to manifest itself.

The Context of Art, Art in its Context

Questions by Seth Siegelaub

I met Seth Siegelaub at the Dwan Gallery in New York during the fall of 1967. Virginia Dwan was the owner of this very prestigious gallery which mainly exhibitied Minimal and Land Art. We had developed a friendly relationship since meeting in the south of France through Arman and Martial Raysse.

Seth Siegelaub organized several exhibitions in 1969 and 1970 that are now considered landmark events.

In 1996, he addressed a few questions to artists who had participated to those exhibitions. The answers were published in a special issue of *artpress* (No. 17: 69/96 - *Avant garde et fin de siècle—le contexte de l'art, l'art du contexte*).

For those of us who lived in New York during the late '60s, the period surely will be remembered as a time of conflict, of opposing principles confronting each other within the narrow confines of Manhattan, of grand ideological combat between art movements on display simultaneously at the same galleries (Dwan, Castelli, and Paula Cooper). Everyone had the sole aim of pushing back as far as possible the frontier of what was then acceptable.

I was no exception. All of us—the dozen artists mentioned in Lucy Lippard's article, "The Dematerialization of Art"—were seeking to develop interrogative and critical thinking, in varying degrees a risky, even reckless enterprise. Our activities had more in common with probing the limits than settling for the easy option of what we had already learned.

Thirty years later, I can only express my admiration for the profound insight that Lucy Lippard expressed in her visionary article, which even now remains a reference point. Minimalist Art, for me, was already part of history and its importance was obvious. The term "conceptual art" was not yet in circulation, and it was the Leverkusen, Germany, exhibition Konzeption/Conception which launched it internationally.

The years passed. Everyone defined his or her own trajectory, lived his or her own personal drama. Some artists—including towering figures like Judd, Flavin, and Smithson—are now no longer with us, others have lost their way, though most continue to forge ahead. The question that now should be asked is this: how many have remained open to questioning and have found solutions to enable them to advance further?

The question is an interesting one, though I will admit to being amused when I hear remarks such as, "So-and-so has remained true to himself" or "has stuck to his guns".

For someone who is asking serious questions about the direction of art activity, this type of comment can appear naive and provoke a response along the lines of "what should be understood when one speaks of artistic creation?"

When we begin to perceive in the work of some Conceptual and Minimalist artist the threat of rational desiccation, a paralysis of logic, then it is interesting to reflect on the imprisonment of artists in the intellectual systems of their own devising. To remain faithful to one's definitions is like thinking that one has discovered the truth, and can cling to certainties that would like to pass for absolute. What truth could possibly be valid, universally and for all time?

The artist is always in crisis and bears within him or herself a permanent contradiction. The artist's development is shaped by these crises, and it is in the chaos of his mind that he finds new systems to construct art. An artist's production often proceeds along a spiral path, a method that refuses simplified or logical recipes, that joins what was previously separate, that puts into thought what was hitherto inconceivable. It is by refusing tradition, conventions, habits, repetition, and uniformity, by taking a chance on not pleasing people, that an artist's work develops. The artist should take as his point of departure the obscure and uncertain, should criticize secure knowledge, indeed should criticize security itself.

The artist should remain open and be opposed to sectarianism. Naturally, he or she should be aware of everything that has been conceived within art, but his or her main activity will be to leave the confines of art. The artist should take interest in other areas of knowledge, have an openness towards the outside world that will lead to an engagement in types of work assumed inconceivable before now.

By remaining open to stimuli, the artist's vigilance and capacity to adapt will enable him or her to react and carry through change. Working on a concept means stretching it, making it understood differently. It means resituating it from its place of origin. It is the opposite of tinkering within a pre-existing set-up. It is to criticize the idea of a stable state. For the stable state is opposed to the nature of life, to the reality of the events that surround us. It's a Utopian ideal inherited from Galilean and Newtonian physics, an artificial classical paradigm that over-idealizes and fails to conform to the world in which we live. The stable state is a cultural danger, the alienation of creativity. The art endeavor should rather be seen as an open space, where nothing is certain, where everything is always engaged in a process of re-conceptualization. It's a work of interrogation, more complex than that of those artists who have found a formula and unflaggingly repeat it. Sure enough, their ideas are simple and clear, and conform to the ideas society inculcates in us. But they are closed in on themselves.

To be involved in an art activity is to accept that there is no real questioning without frequent repudiation of reason. The rational cannot be universal and the irrational cannot be excluded.

One Can No Longer Approach Art Naively

Bernar Venet

Published for the first time in the catalogue of my exhibition at the La Jolla Museum of Contemporary Art during the fall of 1976, this text is a virtual manifesto, announcing my return to artistic activity and the necessity of being in a permanent and rigorous state of questioning.

One can no longer approach art naively.

One can no longer develop it empirically.

It is necessary to apprehend art in its creative process, to rediscover its structure, not by description, but apodictically in so far as it develops and reveals itself.

The theory of art is an *a priori* not anterior to art, but in the nature of art.

Certain artists prematurely took their initial experiences as being fundamental. They organized their system of thinking on the basis of simple ideas; starting from the conception of continuous historical development they presented artistic culture as essentially " capitalizing": for them it sufficed to improve upon what was given—general and indestructible framework, an intellectual heritage. The rest of their time is spent filling in this framework and occasionally producing supplementary theories.

The artist has less need to produce art than to re-examine his concepts. He must know how to give up his pragmatic security in favor of a general interest in new ideas that often seem useless. He must move toward where one thinks more and reason seems to be in danger. His investigations

should not have as their aim confirming what he knows and consequently what he is.

All true discovery gives rise to a new method, and should negate a previous method.

Knowledge slowly stored up, patiently juxtaposed is suspect. It bears the mark of prudence, conformity, constancy, and sluggishness.
One must avoid this static coherence which corresponds to a system closed in upon itself.

Certain artists cultivate a taste for certitude, for system. They keep judging everything in terms of origins and antecedents. They are benumbed by tradition and rely on memory to produce their tautologies.

This attachment to solutions and not to the faculty of discovering new solutions is a cultural danger. To be bound by solutions of the past is, from a psychoanalytic point of view, to remain dependent on one's symbolic "father" —it is not to be adult.

Notes. Ten Years of Conceptual Art

Bernar Venet

Ten years had passed since the first public exhibitions of
Conceptual art. *artpress* #16 in March of 1978 asked artists in the
movement, myself among them, to define our positions.

THE INTRUSION OF LANGUAGE INTO ART

The historical position of conceptual art derives from two tenden-
cies that occurred at a turning point in history when many changes took
place but critical reflection was far from being considered essential. These
two tendencies consisted of calling into question certain seemingly funda-
mental experiences, on the one hand, and developing a linguistic mode of
investigation, on the other.

We were condemning the abuses of formalism as well as the ten-
dency of certain artists to believe all too naively that all they needed to do
was "express themselves" in order to make art.

Not all the definitions put forth by conceptual artists, and often the
most rigorous among them, were equally appreciated. It was not enough
merely to reject formalism and reduce the work of art to its opposite; that is,
to an idea. Pursuing the line of the "dematerialization of art," there's a sim-
plistic attitude that consists in thinking that the less there is of it, the more
conceptual it is. This amounts to academic reductivism, and is thus a for-
malistic attitude in and of itself. What was rather needed was a proposition

with valuable new definitions that could considerably enlarge the field of art. It is difficult to maintain the interest of "art as idea," and even more difficult to argue its sufficiency as a definition. Art suffered serious consequences when certain artists could claim they were calling the basis of art into question simply by advancing propositions like: "Go to such and such a place. Look right. Look left....etc."

The divergences we have witnessed over the last years often have limited a synthetic analysis of conceptual tendencies, but with time it has become evident that the true identity of conceptual art lies in the use of language—in the different, specific ways each artist exploits it, and for reasons each artist individually defines.

The use of a linguistic system of investigation, which involves questioning the limits of the formal value of works of art, was especially crucial in casting light on the importance of the semantic codes employed.

ART AND IDEOLOGY

The problem of ideology poses questions concerning the autonomy of art. Before the emancipation of the subject at the beginning of the twentieth century, art was more directly an expression of society than it is now. Today art tends to be more antagonistic to society, a position it holds by virtue of having acquired its own autonomy.

I am entirely in agreement with Jean-François Lyotard when he states, "To make the meaning of a work of art depend on its ulterior political effects is, once again, not to take it seriously, to take it as an instrument to be used for something else, or a representation of something yet to come; it is to remain in the shadow of representation, and to adopt a perspective that is both theological and teleological."

It seems to me that the ideological attitude found in the political discourse of certain conceptual artists of my generation recalls the attitude of the Russian Productivists after 1920 during an era in which creation itself seemed in crisis. Following a period of great artistic freedom that gave birth to many new developments, the next generation seemed to have difficulty renewing its vocabulary, and chose to do nothing but exploit its current one by attributing an ideological content to it.

A parallel can be seen in El Lissitzky, for example, who availed himself of Malevitch's formidable formal propositions, and then appended a political discourse to them. (See, for example, "America, Europe, Asia, Australia, Africa — Workers on every continent, unite!") It's impossible to reject this sort of work completely, and yet it's difficult not to think of it as more than ideological illustration pure and simple. In this sense, it still remains interesting, but it merits a place in the field of graphic expression only. While it's obvious that works of art have a revolutionary function, they can only be revolutionary in and of themselves, by the critical effect they produce, by the way they overturn ideas specific to the realm of art.

What is political about art is the immanency with which it opposes bourgeois society, not the position it takes in public. Any discipline that adopts the principle that it exists "for something else," admits to being subordinate; art must refuse to bend to any such principle. The end of a work of art is probably to be found in this very absence of finality.

THE CONCEPT OF ANALYSIS

In order to limit the misunderstandings which the first (sometimes favorable) written criticism of my work had caused, I decided to define more precisely, around 1970, the level of the originality and interest of my conceptual work.

As Roland Barthes puts it, "Generally speaking, it seems more and more difficult to conceive of a system of images or objects in which the signifieds exist outside of a language system. [...] Meaning only exists where things have names, and the world of signifieds is the world of language."

At the time, I was experiencing what I called "*la conversion du regard*": a visual and mental reorientation by which a work of art, formerly a theoretical model, becomes, in turn, the object of theoretical investigation.

The interest of this type of analysis is that it delivers the real meaning; nothing enigmatic remains. The purpose is to bring out the manifest meaning and the latent content.

It's interesting to see what information theory has to say about creators who, at the end of their discoveries, seek, in principle, to stick to their message: the 'force of conviction' in the messages they transmit will deter-

mine the degree of public acceptance. In this way, we see that two very different systems of communication are generally in use.

One, based on "rational constraint": used by scientists and theoreticians, it corresponds to the semantic mode of communication. It is a communication that can be decomposed into words and isolated elements of a standardized nature. This is the domain of argumentation.

The second system is used by writers and artists, who persuade through the use of seduction and the aesthetic mode of communication. A pleasing style and repeated exhibitions generate a following that triggers a fascination in art-lovers, who fancy themselves in metaphysical rapture without being able to explain it.

The first case runs counter to the second: the verbal is opposed to the active.

My activity from 1971 to 1976 thus consisted of moving from the active to the "verbal" stage. This attitude continued in the spirit of my previous work, since a single invariant, the concept of analysis, obtained with equal consistency, in both phases.

With a view to clarifying my position in relation to other conceptual artists who have worked with language, I already have written elsewhere that one cannot find a parallel between the preoccupations of other artists and my interests at the time I was producing conceptual work. Recourse to linguistic signs appeared insufficient since their meaning is established through differentiation and depends on the relationships among these signs within the linguistic chain. The term used, according to the context, offers a stratification of meaning and it is from that multiplicity that the poetic image emerges. By contrast, the vocabulary and symbols of mathematics tend to avoid polysemy completely in having a single meaning rigorously defined by the univocity of the terms employed. In aiming for monosemy, my work utilized the field of mathematics in its widest sense, in other words, as language. The painting, the object on the wall, was not to be seen for itself; its purpose was to demonstrate the semantic/syntactical structure of its linguistic system. It was to be viewed as an example of using semantics in art that unequivocally corresponded to the syntax it presented.

RECENT WORK

Conceptual art, such as it was defined at its most radical in the '60s and '70s, obviously lost its punch quite some time ago. This is a normal occurrence, though, and history shows that other major art movements of the twentieth century went through similar ups and downs. As I just explained, the position of certain conceptual artists who have opted for an ideological stance falls short when compared to my more specific work on the definition of the art object. I'm here referring to a questioning of art's content and codes, work that unfortunately we cannot yet call richly productive. Our present age will certainly be remembered as the height of minimalism gone academic.

I was motivated to clarify my personal choices when I felt that the concept of the "dematerialization of art" was beginning to be abused. When I presented works that had no tangible visual support (tape recorded conferences in 1967, or performances such as Martin Krieger's conference in 1968), my purpose was not to dematerialize art, but to stress, through the use of these (and other) media, that the originality of my work was in its content, the knowledge it conveyed, and its symbolic system, and not in its material characteristics (or lack thereof). The essential element was its new content, the monosemic code, which offered me a large field of investigation and, eventually, positioned my art at the opposite pole of minimalist reduction.

The conceptual impasse of the "little piece of typewritten paper" is a cliché that has had its day. It, too, became a new aesthetic, but looking back on it now, we see that its alleged contribution wasn't that much to begin with.

My most recent works, those I've produced since 1976, mark the beginning of a new phase. They consist of a series of drawings and paintings on canvas (horror for a conceptual artist!). Often they are composed of two distinct parts that consist, for example, of a three-dimensional pie chart from which a section has been cut and removed. The distance between the two parts depends on the dimensions of the work. A curved arrow gives the measurements of the angles in degrees. Because of the theoretical consequences I've already mentioned, I retained the essential element—the dia-

"Two Right Angles", 1978, acrylic on canvas, 94½ x 67"
Collection of the artist

gram (the angle being the most elementary geometric figure)—and yet I still wanted the physical aspect of these works to be obvious; I wanted to make "paintings" out of them, without, however, falling back into an unproductive abstract formalism.

In my previous work, and especially in the book presentations, I'd insisted on the fact that the introduction of this particular type of theme had theoretical implications in the field of art, and that the vehicle could be changed through the use of other media. Now my concerns are different. Before, the "painting" only served to convey information that was to be considered solely for its specific qualities. In my recent works, the information presented—e.g., the angle—coincides with the form of the canvas. The information is simple, and thus is instantly communicated: simultaneously, the eye is hit by the shape and the mind connects it to the content. My production is empirical, in that the canvas is made before the degree of the angle is determined. In this, the works go against the system: if their measurements were determined before the angles were realized, the paintings would be merely representations of the system. Although they are not figurative, they would have an "analogical" status.

The Line and its Definition

Responses to Questions by Catherine Millet

Once again, I am grateful to *artpress* for the December 1981 publication of this interview with Catherine Millet.

In it, I attempt to explain my new work and to compare it to my conceptual art period (1966-1970). I am entering a new and more liberated period of activity, that of the line and, more precisely, the "indeterminate line".

.

Catherine Millet: In a certain way, Conceptual art manifested "the end of art." Logically, you yourself stopped producing work.

And then you began again. Was your decision to return to making art based on any kind of self-criticism of your past work? Did it also call into question the notion of Conceptual art as the "last step"?

Bernar Venet: In fact, I never subscribed to the idea that conceptual art corresponded to the end of art itself. I rather thought that the radical character of our propositions had an unsettling effect on theory, which at the time was suffering from a real paucity of ideas, by taking art in a different direction and offering new areas of investigation.

Today, we can see two distinct consequences of this. For one, it has influenced a large number of artists who've worked with language and photography. Metro-Pictures, a cutting-edge gallery in New York, is showing a new generation of artists—Richard Prince, Sherrie Levine, James Welling, Laurie Simmons—whose conceptual preoccupations and theoretical exigencies in photography recall our own interest in a semiological approach to art. You also have to think about the impact conceptual art had on narrative, per-

formance and body art. Another effect was to paralyze, for almost fifteen years, mindless "visual" artists, who now are coming back in droves, supported by the blind-eyed strategies of the international market. You have to admit, even with a good herbicide, the weeds always manage to crop up again.

To come back to the question of why I stopped: you have to understand that my approach was theoretical, that the purpose was to question the work of art itself through the use of different types of signs, to see how these signs functioned and what the consequences would be.

It was not the kind of approach where the three-dimensional constitutes the principle area of my research.

When I thought I'd reached the end of my investigation into neutrality and rational images, there seemed to be no reason to introduce outside, subjective elements into my work, so I decided to stop.

When I began again in 1976, I was not led so much by self-criticism of my conceptual period, but rather by my critique of a certain type of conceptual art. I must say, and I've already emphasized this in *artpress*, that I find the idea of "art as idea" to be very thin. I'm talking about the genre, "Go to such-and-such a place, look right, look left….etc." All you have to do is see the dead end to which that came. Weak as well is the simplistic idea of "the dematerialization of art," as if the central idea of Conceptual art consisted of proposing quasi-invisible works whose sole interest was their non-materialness. This is academic reductivism, which is a formalistic attitude in and of itself, while the original purpose, paradoxically, was to combat formalism.

CM: In the conceptual period, your principal support was language: "paintings" made up of the written word, conferences, tape recorded texts, etc. Starting in 1976, your works played much more on their visual impact and the use of space: large-scale diagrams directly drawn on the wall, or the sculptures you're doing now. What are you looking for?

BV: It's important to understand that when I began to produce works of art again, I was no longer a "conceptual" artist; my interests were of a different sort. Just a few weeks before I started making art again, I wrote a text on the process of creation and the necessity for artists to revise their concepts, in

which I said that:

> certain artists are too quick to take their first experiences as being fundamental. Having organized their way of thinking around a few simple ideas, they start off with the conception of continuous historical development in which they treat the culture of art as money in the bank. Such artists think it is only necessary to enrich what they already have been offered: some general, indestructible frames of reference, an intellectual inheritance. The rest of their work simply consists of filling those frames, or from time to time producing ancillary theories. It's less important for an artist to produce paintings than it is for him to revise the concepts behind his practice.

I think, then, that it will be possible for me to enlarge the field of my past investigations by introducing formal considerations into my work which is still tied to the idea of monosemy. I'm not trying to do "more beautifully" the things I've already done with a certain theoretical rigor in the past, but rather to verify to what extent an elementary sign, a line for example, can function outside the traditional fields of figurative (polysemic) or abstract (pansemic) art. And this, from the moment the line has been endowed with an aesthetic purpose besides. One fundamental difference with my conceptual work lies in the fact that the works I have done these last years present subjects (angles, arcs, chords) that determine (and coincide with) their shapes. Before, the "painting" served only as carrier of an information considered exclusively for its specific qualities, for its theoretical consequences.

CM: Why this necessity to put lines in relief on a wall? Wouldn't a stroke of charcoal suffice?

BV: Simply tracing an arc or an angle on a wall in charcoal would again be just another reductive gesture that no longer interests me, given the direction my work has taken. I'll insist, repeating that I am no longer a conceptual artist, I am not a minimalist artist. Over these last three years, I've come to the conclusion that boundaries between different styles (geometric, lyrical, baroque) are no longer obstacles limiting the way a work can evolve, that it's possible to transcend these boundaries and use these different styles, side by side, as long as the basic concept is open enough to permit it. This idea

underlines my unrelenting resistance to the notion of style as a formal option—a notion that artists far too often have been satisfied to take as a guarantee of originality.

My work will never lend itself to the rigorous use of any single style or adherence to any one tendency, be it conceptual (my work from 1966 to 1970), geometric (the angles, chords and certain arcs on canvas), lyrical (the wooden arcs) or quasi baroque ("position of indeterminate lines").

This brings up an essential point concerning the choice of materials. You must realize that artists have different options in regard to getting their "information" across. I'm speaking, of course, of the content of the work. Generally, an artist will think one of these options seems ideal, and that's the one he or she will prefer to use. Malevich's "*Carré blanc sur fond blanc*" (White Square on White Background) is not just a white square on a white background. Theoretically and historically, Malevich's statement is very important, but it furthermore becomes incarnate via the plasticity of the paint application, which adds to the formal impact of the painting and gives it added force.

The same thing occurs all the more obviously with Mondrian, whose paintings cannot simply be interpreted as demonstrations of his neo-plasticist theories. Each element of the painting is taken into consideration: position, thickness and treatment of the black dividers, the direction of the brushstroke in each plane of color—only to mention the most evident ones.

So then … is an arc covered in graphite and hung on a wall less of an arc than an arc drawn in charcoal on the same wall?

CM: Why have you now abandoned measurable form and space in favor of "indeterminate lines"?

BV: From my conceptual phase on, I've been working with diagrams or graphs that by nature are made up of lines that take different forms and directions. Sometimes the lines are curved as in the case of parabolas, e.g. "*Parabole de la fonction* $y = 2x^2 + 3x—2$," 1966; other times, they're straight, "*Vecteurs égaux—Vecteurs opposés*," 1966. To give a simplified explanation to your question, since you're expecting me to give you a rational response, let's say that since 1976 I've continued to show, first in my paintings, and then in my reliefs, broken lines ("positions of angles"), curved lines ("positions of

arcs"), and straight lines ("chords that subtend the arcs of a circle").

So, I've just used three elementary variations on the line that all have the particularity of being "civilized signs" resulting from the use of tools like the ruler, the compass and the protractor. But it seemed to me that another variation was possible: I would present a "free" line, in which the gestural, the spontaneous, would take the place of the mechanical, the controlled. Theoretically, I could integrate this "scribbling," this rudimentary, seemingly "barbaric" drawing into the context of my work. First of all, because once more it is a line, and therefore a variation in terms of subject. But especially because making its definition, "position of an indeterminate line," an inseparable part of the work itself, gives it a status that connects back to my previous works. The line is indeterminate—that is to say, it isn't determined mathematically; but it's obvious that it still remains a line, thanks to the juxtapositional linguistic message which is there to insist on the non-ambiguity of the object presented.

CM: Do you consider these random lines to be expressive? How do they manage to remain true to the principle of monosemy that you have set for yourself?

BV: Images that come closest to monosemy, which is a totally univocal stage, only can use signs that possess a single level of meaning. This is why in the beginning, and until quite recently, I only used figures or diagrams belonging to the field of mathematics.

In past texts, I've explained how the definition that accompanies the diagram is of primordial importance. It was imperative to avoid connotation: the function of the definition was to prohibit it.

Consider now that in a mathematical diagram, for example, a line functions to inform, while an indeterminate line conveys nothing but its own image. It doesn't mean anything but "line," and this is true whether the line is slack or dynamic, controlled or spontaneous—and the definition is there to confirm this. In this sense, I've just answered the first part of your question: no, my indeterminate lines are not expressive.

Bernar Venet

A Conversation with Eddy Devolder

The art critic Eddy Devolder and I worked on this interview for publication in the September 1991 issue of the magazine Artefactum.

It probably was my first opportunity to express myself on the subject of my varied and wide-ranging art activities as well as on the heterogeneous nature of my work.

Eddy Devolder: In 1979, you wrote: "Every real discovery determines a new method and must destroy a previous method." Do you still agree with this statement?

Bernar Venet: Yes, of course. All radical ideas require new ways of communication. Revolutionary discourse cannot use stereotypical language. My entire work has evolved according to the principle that one method always replaces another. Each time it has been demonstrated differently, each time I've proposed a new formal or conceptual strategy that I hadn't thought of before. If you take my work over the past thirty years—whether it's a question of the early canvases covered with tar, the "*Tas de charbon*" (Charcoal Pile), the photo enlargements of mathematical propositions or tape-recorded conferences from my conceptual period, or even my most recent steel sculptures—the diversity of means employed has allowed me to render more obvious the wide berth that underlying strategy provided for my different activities.

ED: In your case, isn't this also a way of analytically treating life's inherent

interruptions?

BV: Unconsciously, perhaps. But this remains to be demonstrated, and I'm not the one to do it. I'm all too well acquainted with the decisive factors that influence my choices and behavior. As an artist, I'm very familiar with the important role intuition plays in all our actions. Our personality, our culture, our environment are so many elements that influence our conduct. Think also of the unexpected effects chance produces. You can't explain everything.

ED: This isn't what you would have said in the '70s. At the time, you showed the desire to have almost total control.

BV: It's true. In 1967, I decided to program my work for the following four years. I even foresaw ceasing production at the end of this period, a full stop to my work as an artist. The experience taught me that ideas evolve, and that the ideas I had in 1976 couldn't possibly be the same as the ones I'd had ten years before. Of course, gut reaction and expressiveness didn't suddenly overpower rationality, but the experience taught me that you have to question yourself periodically, that theories become dogmas when you lose your critical sense, when you no longer doubt yourself.

ED: At the time, did you think that each of your works had a certain place in an established order?

BV: If you're talking about my conceptual period, yes. The order I established for this program permitted me to use disciplines like astrophysics, which is a natural science dealing with the visible world, and then nuclear physics, which is already a much less tangible universe, and, logically to end with, mathematics, a field distinguished by abstract speculation. The order thus proceeded from concrete to abstract. My work at the time was dry, static, cold, and objective, conforming to what I thought was the scientific ideal. It forbade all emotion and excluded my body. Living in this rational universe allowed me to take the linguistic and graphic elements of the mathematical model to its outer limits. My art paid tribute to this mode of thought, to this working context, which had the advantage of being on the

cutting edge of a new field of investigation, the exploration of monosemy.

Thanks to the ensuing six year-halt in production, I took the time necessary to review critically my course so far, and wondered whether I could go any further. This period was like a breath of fresh air, and I was able to start again with renewed energy.

ED: Is this halt in production what you've referred to as a *conversion du regard* (reorientation of mental outlook)?

BV: Yes. I've also called it a time of "definition." In effect, I was convinced there'd be no interest in my repeating variations of the same idea ad infinitum, and I knew there was no place to introduce subjective elements that would have contradicted the spirit of my work, so I opted for a different kind of activity. I went from the active to the verbal stage. I abandoned the aesthetic for the semantic mode of communication.

I noted the damage done by the writings of critics who sought comfort in their received notions about art but failed to recognize the "new". They tried to demonstrate a logical continuity between my work and historical precedents, whereas I was aiming to break with all of that. They were situating my work in the line of Duchamp and ready-made art, or calling it appropriation, as with the New Realists. I thus had to define more precisely the level of originality and interest of my conceptual work. It's at this point that I applied Jacques Bertin's theories on graphs to art. These differentiated three fundamental types of signs in the domain of visual images.

To put it briefly, I'd say that by leaving the fields that already had been dealt with exhaustively, those of polysemy (figurative art) and pansemy (abstraction), I was able to introduce a new type of signification into the field of art, monosemy (mathematical code, diagrams), which tends to have only a single level of meaning.

Going back to my life between 1971 and 1976, the period when I stopped producing in order to reflect on my past activity, that which I called a *conversion du regard*, was a reorientation of mental outlook which allowed me to use my own works as objects of investigation. The advantage of this type of analysis is that it permitted me to clarify the real meaning of my work, to define its latent content.

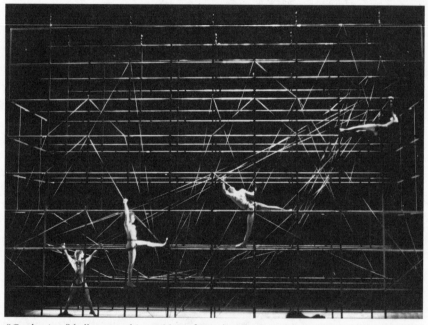

"Graduation," ballet created in 1966, performed at the Opéra de Paris in January 1988

ED: In the '60s and '70s, you defined yourself as an "artist." What do you call yourself today? A sculptor?

BV: I'm a sculptor, no doubt about it, and as for being an artist, I hope so! I remember a conversation I had with Donald Judd a few years ago in which I told him that to me, a person who painted could of course qualify as a painter, while another person who made sculpture was obviously a sculptor. Then I added that it didn't seem logical that these people automatically would deserve to be called artists if their practice didn't purport to bring new definitions to art. He, on the other hand, thought that all painters and sculptors were artists, that there were good ones, but there were bad ones also. Of course it's a question of point of view, but I find it difficult to accept the idea that someone deserves to be called an artist if his or her work lacks ambition, or has proven to be without fundamental interest.

I know that in asking me this question, you were alluding to the multiple nature of my activity. Although it's true that my principal discipline is sculpture, from my first tar paintings in 1963 until today, I've always shown an interest for other fields, like photography for example. A book has just come out tracing the course of these activities over the past thirty years. I'm also interested in sound and music. Two of my laser discs came out in Paris recently, and I'm working now on another composition that will be about three hours and forty-five minutes long. It is called *Mur du son* (Wall of Sound), and, to hear it, will require four CDs. It is a work that capitalizes on the sound recordings I made in 1963, but at the time, I didn't have either the technical or financial means that today are at my disposal.

In 1988, I had the opportunity to create a ballet for the Paris Opera for which I not only did the set and costumes, but also—and especially—the music and choreography. It was a ballet that was performed on a vertical plane, as opposed to a horizontal stage. Three dancers moved among the bars of three steel grills hung perpendicularly from the ceiling, creating diagrams—angles, arcs and indeterminate lines—with their bodies. The choreography which was sober, visually minimalistic, I'd already basically conceived in 1966 when living in Nice. So you see, I've always loved exploring other realms of art when they offer me the opportunity to produce original work.

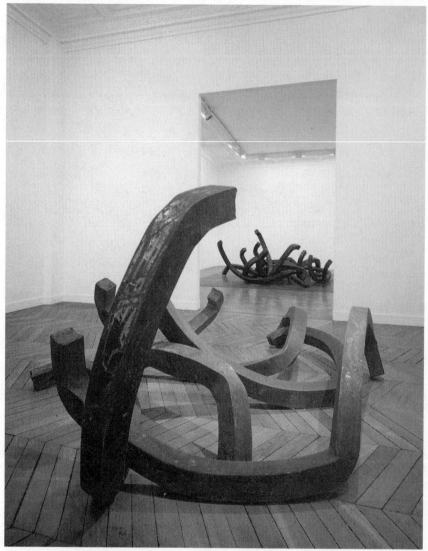

"Random Combination of Indeterminate lines", steel, varible dimensions.
Installation at Galerie Daniel Templon, Paris, 1991

ED: In your case, it's a question of "position."

BV: To put it precisely, it demonstrates that what interests me the most is using different approaches to define an entire context of ideas and work. The heterogeneous nature of my activity will probably bother certain people. For them, artists demonstrate consistency when they find an image or style and keep on repeating it for ten or twenty years. I prefer trying out, simultaneously, all the different possibilities that an entire context of work has to offer, rather then adopting any single practice. I'm not a manual artist, I'm motivated by ideas. This is why in 1963, while I was exhibiting canvases uniformly covered with tar, I also presented sculptures of piles of charcoal (*Tas de charbon*), made black and white photographs of asphalt, and taped the sound of a wheelbarrow rolling across gravel. All of it went together, it was all one, part of the same work, and this is still the way I proceed today. Partition is death. And I'll add that the autonomy of my work is found in the plurality of my approaches.

ED: And from there, it's a question of constructing a world, elaborating a universe that reflects your idea.

BV: That's exactly at what I aim, so that if you hear certain sounds, you can say, "Hey, that makes me think of Bernar Venet." It doesn't matter whether it's a sculpture or a photograph, a gesture or an object that makes people react this way—it's the same sensibility that transpires, the same content that comes across.

ED: From one domain to the other, don't you sometimes have the impression that the most important thing in your work is not so much sculpture, or photography, or music, but the relationship, the palpable abstract construct that unites them all?

BV: It's this relationship that interests me, something that goes beyond the problematics of the object. A group of parallel activities that all converge in the same definition of art. It's thanks to this particularity that I can take formal liberties which at first glance would not seem to have any common bond.

If you take my work with line as an example, I've been able to make compositions that are lyrical and baroque as well as geometric. I also want to point out that my most recent sculptures, "*Lignes indétérminées/aléatories*" (Indeterminate/Random Lines), hark back to the "*Tas de charbon*" (Charcoal Pile) which I executed almost thirty years ago. The common bond is their randomness, the fact that these sculptures have no specific form and that their configuration, which is different each time, is determined, in part, by the law of gravity.

ED: What do you mean by "indeterminate lines"?

BV: I call them that to clarify that they're not mathematically determined. The meaning of the word "indeterminate" can only be understood in the context of my work. Actually, it's a known fact that I've been developing the line as a primary theme in my work since 1976. If you take "*Un vecteur est un segment de droite orienté*" (A Vector Is a Directed Line Segment) as an example, you see the line was already the central subject even in 1966. My work with lines, which I resumed in 1976, took the shape of paintings on canvas followed by reliefs in the form of angles, arcs or diagonals. These works were always accompanied by their mathematical definition. Looking back on those three subjects made me realize that another variation was possible, that of a "free" line in which spontaneous motion would take the place of the geometric rigor that had characterized my other works.

ED: And why do you call them "indeterminate/random"?

BV: I'd describe them by saying that they're a group of steel bars that have been rolled and twisted. A dozen on average. So far, the largest of them are eleven centimeters square and about five meters long. They are freely dropped one on top of the other to form a pile.

What interests me about this new work is its soberness, its simplicity, its immediateness, its clearly demonstrated identity, which, on a formal level, has nothing to do with the principles of Minimalist art. It's a way of turning my back on the authoritarianism implied in Malevich's black square on a white background.

As a rule, the "indeterminate lines" acquire harmony, rhythm, bal-

ance, and an internal logic that is wrought the moment I create them. These new sculptures obey different rules in which harmonious, logical, orderly organization is abandoned in favor of chaos, a more primitive disorder, more poignantly reflective of the brutality of their manufacture and the danger to which I am exposed in the process.

Their random nature recalls the 1963 "*Tas de charbon*" (Charcoal Pile) and their anti-form aspects. The relation between the two propositions is obvious, but with the steel bars, the space is no longer saturated, as it was in the coal piles. Even as they obey the laws of gravity, these bars rise up a bit into space, defining and, at the same time, lending a touch of the baroque to the sculpture. Chance predominates in the shape of these works, which changes every time they're exhibited in a different place. It's impossible ever to create the same form twice, and the very attempt to do so would go to show that you hadn't understood what the work was about. Randomness is the rule of the game. The objective is to liberate sculpture from the constraints of composition and ideal order.

ED: Black predominates in your work. What meaning do you attribute to it?

BV: Soberness and economy are constants in my entire work. My taste has always led me to avoid rich, seductive materials and sophisticated techniques.

Black became important starting in 1961 when I was doing my military service. As I had been privileged with a studio space, I was able to devote most of my free time to painting. I utilized tar with which to cover the entire surface of my canvases in a uniform manner. This work, which I continued in Nice after I got out of the army, lasted for three years.

Why black? Perhaps because it represented an ideal for me, an extreme gesture of protest against the established order. As Adorno says, "is not the ideal of black, from the point of view of content, one of the profoundest predispositions to abstraction?" At the age of twenty, an artist should be a rebel, and black signals rejection of casual communication, and shows the world that you're different. Maybe, as in the work of Ad Reinhardt, it's also a manifestation of a deep-seated Puritanism. In any case it's radical and direct. To me who likes Reinhardt, these paintings appear

serious, calm, sober and clear, all at once.

ED: Your desire to design furniture, how did that come about?

BV: By necessity! When I moved into my loft in SoHo in 1968, I had absolutely nothing to put my belongings in. At first, I got things off the street and from my friends. Later, with time and a little money I'd saved, I began to make some furniture myself, because I had no real taste for either antiques or modern design.

So I made a sofa, and then a coffee table that influenced all the other pieces to come. I tried to give them a coherence and formal logic that satisfied my taste for the severe and the sober. Using steel plate allowed me to assemble units with very precise angles. I rarely abandoned symmetry, and maintained the principle of reversibility throughout. It's a bit like the sculpture Rodchenko made in 1920, "*Construction de distance.*"

This furniture that I made for no one but myself, has the particular advantage that you can actually use it!

ED: Do you make it with your own hands?

BV: No, I give the design to a fabricator. The design has been the same for a long time, and the proportions never vary. I only change the dimensions, which vary to accommodate the space where the furniture will be installed. The actual fabrication doesn't interest me, and in any case, I'm not manually gifted. I already suffer enough from that handicap when I make my sculptures.

ED: In general, your work has an air of austerity.

BV: Yes, that taste for the severe and the sober we were speaking of. This is what explains my deep respect for Ad Reinhardt, my preference for the stripped-down, for an art of content rather than surface.

I should also mention my total disinterest in color, which I associate, like classical music, with the idea of pleasure, sensuality, and immediate gratification. Life can be voluptuous but art must be ascetic, and if we want it to make us happy, then we better settle for that happiness which results

Gravier-Gourdron, 1963, CD recorded at IRCAM, Paris, 1989, and edited by Circé, Paris, 1991

from knowledge.

ED: And yet you produce music.

BV: There are prejudices to overcome as soon as you mention new music, like it's thumbing its nose at tradition, its lack of serious foundations. There's also the notion that it's difficult to understand. These three reproaches I hear about my work as well, especially from people who know nothing about art. They might be a little more indulgent if they knew the anecdote about Xenakis who, at the very beginning of his career, met Messiaen and asked if he would teach him about music, starting with the very basics. Messiaen replied, "Absolutely not! You're Greek, an architect, and a mathematician. Take advantage of all those things and put them into your music!" Similarly, it's my experience as a sculptor, as an artist who's worked with many different materials, that makes my excursion into musical research possible.

My lack of inherited prejudices is certainly one reason why I dare go all the way in the domain of music. Two of my CDs have just come out in Paris, *Gravier-goudron* (Gravel-Tar) and *Acier Roulé E 24-2* (Rolled Steel E 24-2). This second title curiously recalls Edgar Varèse's *Densité 21,5*. The number indicated the density of the platinum of the flute on which the piece was played. In the same way, "E 24-2" indicates the density of the steel. It's pure coincidence. The sounds achieved, though, are very different. The recording took place at the factory where I make my sculptures. It's a work related to concrete music, but it doesn't undergo any subsequent electro-acoustical manipulations to extract the more musical sounds. No, here it's a deafening atmosphere of superimposed noises: the grate of steel bars, the hiss of blowtorches, the screech of ramps, the squeal of materials resisting, etcetera. Everything that invades my acoustic universe twelve hours a day. I'm working on other projects now, especially the composition *Mur du son* (Wall of Sound). It will be the musical equivalent of the black monochromes I painted in 1963. A mass of sound at its densest, so intense that it exceeds the limits of the physically bearable, long enough for the listener to feel totally invaded by this excruciating experience.

What interests me here is sound as a material considered for itself, for its micro-texture, in its internal continuity. The logic of my argument

comes from paying close attention to sound as a material, much in the same way my sculptures are born from the forced rolling of steel bars, from their brutal contortions in space.

On the Occasion of a Retrospective at MAMCO, Nice

A Conversation with Gilbert Perlein

During the summer of 1993, the Musée d'Art moderne et d'Art contemporain in Nice presented a retrospective of my work. The exhibition later went on to the Wilhelm Hack Museum in Ludwigshafen, Germany. This interview was published in the catalogue on that occasion.

I had already met Gilbert Perlein as a young curator when exhibiting at the Musée d'Art moderne de Villenueve d'Asq in northern France. Now, as the head of the Musée d'Art moderne et d'Art contemporain (MAMAC), and certainly owing to the quality of his exhibitions, it only has taken him a few years to help establish Nice as one of the leading cities for art in Europe.

Gilbert Perlein: You have developed both a series of concepts that generate works and a predilection for certain materials (tar, charcoal, rolled steel) that have become the essential instruments of your artistic discourse.

The first tar paintings of 1963, do they mark a departure from traditional aesthetics, a rejection of the classic medium, of a chromatic range, and of returning to the symbolic or imaginary?

Bernar Venet: I started using tar in my work in 1961 at the time of my military service in Tarascon in the south of France. One day, I was taking a walk not far from the barracks when I came upon what looked like an excavation. The sides of this gigantic hole—a sort of crater—resembled cliffs, and a large amount of tar had been spilt down one of them. I must have been quite impressed by the sight because I immediately photographed it, and still have some pictures, taken by a friend, of me standing in front of this impressive spill.

It wasn't long before I managed to get some tar from the local department of civil engineering. I brought it back to a workshop that the army made available for me. What interested me in particular about the tar

was its density. While watching it run slowly down the surface of my cardboard, I discovered original properties in tar which paint lacks. As it does not dry easily, tar retains its molten state for a long time, it stays in motion and becomes soft again depending on the ambient temperature.

My first works from this period were either tar flows or action paintings somewhat in the manner of the Japanese artist of the group Gutai, Kasuo Shiraga. In a 1955 performance entitled "Combat with clay", Shiraga, virtually naked, struggled in a pile of clay until the traces left by his movements became the work as he intended it: the impression of his body in the clay, but equally the residue of the clay on his body. The material plays a key role in this type of work. The artist cannot impose his will on the material without the material claiming its own part in the work's creation.

This respect for the autonomous nature of the material was what motivated me when I produced my first gestural tar paintings. Standing on sheets of paper placed on the floor, I made a series of paintings with my tar-covered feet. I still have a few examples of them.

Soon I gave up this method for another, less action-oriented, less spontaneous one. After pouring the tar directly onto a canvas on the floor, I used a scraper to spread it evenly over the surface. Then I held it up vertically to bring on the flows caused by the unevenness of the tar layer, and turned it around several times on each side until it began to harden.

This method had nothing in common with what painters usually do. I rejected the paintbrush as an intermediary. That took care of the "touch" with all its artifice. The material was not modified or altered. Quite the contrary. I respected the specificity of this viscous liquid that obeys the laws of gravity all by itself.

In those days already, what I was doing was not motivated by idealist thinking. I was not trying to create "the" ultimate painting, in the manner of Rodchenko's 1919 "Black on Black". There was no desire to extinguish the lights on the art of the past, and no nihilism in my thinking process.

Nonetheless, black had its *raison d'être*. It was a radical, extreme gesture. Surely a way of protesting against the established order. A sign of arrogance? At any rate a desire to underscore my individualism. Any young artist—and I was 22 at the time—must be a rebel at heart, and black is a repudiation of one's unwillingness to communicate. A desire to show that

one is different. For two years, until 1963, the somber and the sober hemmed in my universe. Artifice, color and spectacle seemed childish diversions to me. I was, already then, convinced that art is not made for pleasure but for knowledge.

GP: The ideas underlying your 1963 "Charcoal Pile", which you later rearticulated in the form of piles of charcoal, was even more radical still. Do these ideas reflect Robert Morris' subsequent dictum that art is what the artist decides it is?

BV: My "tar" paintings, which interested me particularly for the questions they raised about surface and material, took up most of my time. It could be said that I was a painter above all! However, I was far from satisfied by this activity alone since I did not (and still don't) conceive of artistic commitment as the practice of an isolated technique but rather as a working environment in which several disciplines may meet, overlap and thereby more forcefully express a sensibility, a thought, an ambition.

I took photographs of freshly tarred macadam, moved a film camera, slowly and in a straight line, along a stretch of highway for several minutes, ran a wooden wheelbarrow with a tape recorder across a gravel road and called the soundtrack *Gravier-goudron* (Tarmac). Those are three examples of how, by choosing different media but staying focused on the same material, I was able to broaden the context of my work.

In this overlapping of disciplines, with its principle of equivalency, a single discourse transpired, a single meaning stood revealed.

One more word concerning my "tar" paintings. It is clear (as can be gathered from the title) that, for me, the material was of primordial interest. It is equally apparent that I avoided the principle of composition. One day of that same year, 1963, I was strolling in the neighborhood of the Promenade des Anglais in Nice when I saw, on the edge of a road, a pile of gravel mixed with tar ready to be used for repair work. Right away I realized that there, in front of me, was what amounted to the almost perfect material model for my sculpture. I say "almost", since the material was not, in fact, ideal and later I opted for the use of charcoal which is cleaner and more malleable and therefore better suited to the nature of my work. The aim was to show a pile freely dumped on the floor, devoid of defining shape and obey-

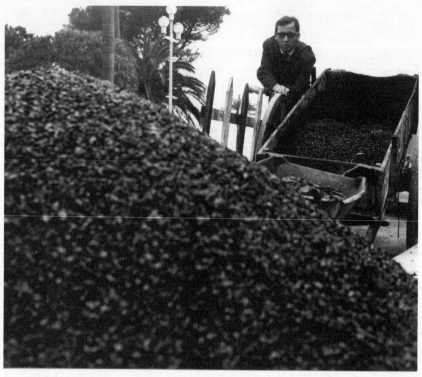

Bernar Venet in stands by a pile of gravel and tar on the *Avenue Albert 1^er*, Nice, 1963

ing the law of gravity. Considerations such as whether there was one or two tons of coal, whether it was placed in the center of the room, in a corner, or against the wall, or whether it was high or flat, were of no importance. In the tar paintings, the material had a fundamental function, i.e., that of being the work. The "Charcoal Piles" demonstrated this even more explicitly. There the material was not the means of creating form, it was the form itself. Charcoal loosely piled up, freed sculpture from the aprioristic notions the artist tended to impose on its composition.

GP: Was the "Charcoal Pile" an act of contestation and provocation?

BV: My aim was not to contest or provoke per se, though there is obviously a certain pleasure in being able to astonish one's most demanding friends. This was especially true in the Fluxus atmosphere vehemently fos-

tered by Ben in the Nice of the early '60s; he was more concerned with provocation, particularly when he staged performances on the Promenade des Anglais in front of an unforewarned public. Nonetheless, I believe that Ben was a true driving force in the ambiance of that time and place. His critical attitude undoubtedly helped many young artists to free themselves from certain overly academic notions about art.

The "Charcoal Pile" was a way of satisfying my appetite for adventure. It voiced independence, disobedience and spontaneity more than contestation. The aim is to determine the field of possibilities by spinning the wheel and allowing it to stop at the nonsensical, the impossible and the forbidden.

What makes "Charcoal Pile" a work of art is the improbability that is enunciated and externalized in it. After all, throwing prudence to the wind is a virtue in art, isn't it?

GP: Are the artist's attitude, gesture and the work's concept more important than the work itself, or are they the conditions for the work to come into existence?

BV: By rejecting the compositional principle and by not choosing material for arbitrary reasons related to taste—or for the symbolic meanings that could be attached to it—I began to let the idea of "distance" between the work and myself, and the idea of "non-permanence" of the work's visual aspect (the "Charcoal Pile", for instance, changes shape each time it is exhibited) intervene in my work. I would like to reiterate the idea of "distance" so as to underscore the fact that my work does not mirror my personality. It does not "echo" my mood of the moment or my nature—be it happy, sad or tormented. It is not a mirror of my personality as could be said of the works of Rothko, Giacometti, or even Mondrian.

The possibility that a work's appearance changes is a recurrent feature of my art. It can be found in the cardboard reliefs, in some of my conceptual works, and in a 1963 project which entailed covering the surface of a canvas at the rate of one rectangle every month. The same is true of the 1966 tubes whose length was determined by the buyer, and of many of my later works such as the wood reliefs or the steel sculptures which do not have their definite positions on the wall or in space.

I emphasized this sensibility by writing about the books I exhibited during my conceptual period: "Here, the work of art undergoes a mutation; no longer the frozen, irreplaceable object to which we attach a fetishistic value, its identity stems from its own renewal."

GP: Since the "Charcoal Pile" is a work that is wedded to the ground, it radically questions the totemic aspect of traditional sculpture.

BV: And that of its base of course! Relinquishing the pedestal was one of the great innovations in 20th-century sculpture; it had been a veritable artifice that "served" figurative sculpture by further enhancing the already larger-then-life portrayal of powerful personages.

The suppression of the base constitutes a giant step for sculpture, reinvesting it with its own identity, and placing it in a setting where the spectator can confront it on a one-to-one scale, on a human scale.

Being that the "Charcoal Pile", the 1966 tubes and my recent sculptures have all been placed directly on the ground, they are perceived as an integrated entity, dependent on the spectator's environment and space. Walls and floor become structural ingredients of the work of art.

GP: In 1963 you also produced your first cardboard reliefs to which you referred as "Industrial Paintings". Is the adjective perhaps the more decisive in this coupling of terms?

BV: Yes, it is. Although the "Industrial Paintings" came after the *"Goudrons"* (Tar Paintings) they exhibit more affinities with the "Black Collages" made of newspapers, torn and uniformly covered with black lacquer. The "Black Collages" call to mind some of Rauschenberg's 1952 black paintings. Recently, I saw those exhibited at the Guggenheim's SoHo branch and I was astonished at the extent to which his works and mine resemble one another.

So, after these "Black Collages" I started using cardboard packages which I folded and then nailed onto stretchers. These reliefs were generally painted a single color, in an oil-based lacquer applied with a spray gun.

My intent, in those works from 1963 through 1965, was to produce cold, non-craft-like art with industrial materials. The colors, typical of the

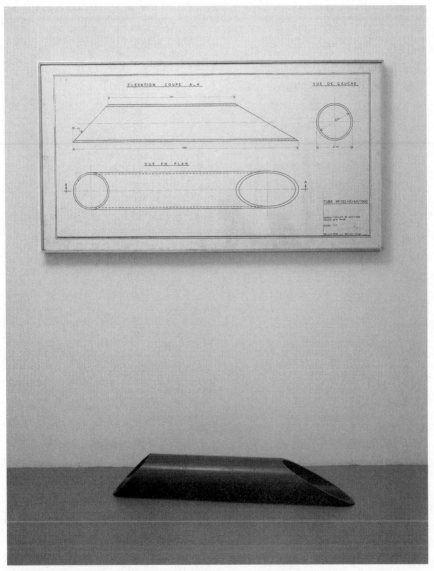

"Tube # 150/45/60/1000", drawing on paper and bakelite sculpture
Musée d'Art modern et d'Art contemporain

kind used to paint automobile bodies, were not definitive. They were meant to be changed after a few years either by myself, an assistant or the owner of the work. A relief that was green in 1964 is now black or blue. Today I would regard a piece that has not been repainted since it was originally made, as unsatisfactory and would not exhibit it. An owner of one of these works who has not heeded my desire to have it repainted lays himself open to my refusal to provide him with a certificate of authenticity.

The *raison d'être* of these reliefs was to demonstrate my detachment from the work's visual characteristics. It was a way of fighting against expression, arbitrary choice, and the personal touch by suggesting that what is perceived is not the mirror of my personality but rather the framing of a statement about art's other aspects. You are right in pointing out that the word "industrial" makes sense in relation to my work, since the "tube" sculptures following the reliefs also derive their material from industry. Incidentally, "industrial material" should not be confused with "ready-made". This was a misconstrued association some people made by linking my "cardboards" to the aesthetic of the New Realists. It is a known fact that the "tube" sculptures, even though I only made a few examples of those in small format, are of particular interest in terms of my subsequent work. I lacked the financial means necessary to produce those works in a larger format, and therefore, in answer to an invitation to exhibit a sculpture at the Musée de Céret in June 1966, I decided to send an instruction drawing for a tube to be made there. The codified system of this industrial rendering immediately caught my interest; it was the fated step that would lead to my mathematical diagrams and the whole of my subsequent conceptual work.

GP: There was a period when you realized works that you called "Random Combinations of Points" and "Random Combinations of Indeterminate Lines."

BV: The intervention of chance and the aleatory impulse have important credentials in the history of twentieth century art. "Duo Collage" (1918) by Jean Arp and Sophie Taeuber-Arp is a highly significant early work addressing this issue. A revolutionary idea in its day, its historical importance is underestimated even now. How it was made defined that work's identity. Kelly, Honegger and François Morellet, among others,

adopted this method as the guiding principles of their work as well. But if I were to compare their use of the aleatory with mine, I would say that theirs manifests itself on a compositional level. Their work generally retains a geometric character.

Aware of the limits of chance intervening in the making of art, I do not aspire to finding the most rigorous possible method to set up my works or installations. Whereas the works of the artists mentioned above are fixed once and for all, mine undergo metamorphoses every time they are exhibited. My installations and the solutions I propose differ as a function of the dimensions of the walls and the available space, and according to the quantity of dots or steel bars. I would like to stress the fact that any attempt to create an exact duplicate of an earlier exhibition would be a serious mistake, and would demonstrate a disregard for the very nature of my work. Such an endeavor, which is nearly impossible to realize, would indicate that the very premise of my works has not been understood. Since randomness is one of the rules of the game, the goal is to free sculpture from the constraints of composition and in doing so defy the utopian principle of an ideal order.

GP: There came a point in your career when you decided to use rolled steel to produce your sculptures: the "Arcs" and the "Indeterminate Lines." Did this change come about by chance? Was it the result of a manufacturing accident?

BV: I produced my first "Arcs" in 1979 at the same time as the "Angles." I was having difficulty finding a satisfactory solution for converting my "Indeterminate Lines" from wood to steel. There were certain problems of a conceptual and technical nature that I needed to overcome, especially when going from the original maquette to the actual fabrication of works that can weigh several tons. It was in 1983 that I developed the basic structure of my "Indeterminate Lines." In 1984 I produced a series of five sculptures set against the wall, which were immediately exhibited at the Galerie Daniel Templon in Paris. The technical solutions—upon which I subsequently improvised—allowed me to increase the scale of my works by contorting increasingly longer and thicker bars of steel.

GP: The steel bar has become the very body of your work.

BV: It would be difficult for me to deny prima facie evidence that, in my work, material takes priority over intention. My sculptures tell the story of their making and of the metal's resistance. It is a confrontation and a struggle between the bar and its tamer. A question of "who" makes the other do "what." A battle between the will of the artist and the rigid nature of the laminated steel bar. The contortions of the metal stem from no artificial devices but are effected by my own movements, the shifts in my body, approaching or drawing away, turning around the piece or penetrating its interior.

My work at the factory is a game of natural constraints between my intentions and the material. Each orients the other and is oriented in turn. I propose directions but am at the same time directed by the steel bar which resists, and refuses to give in to my will to dominate... In this game of concessions I must grant the steel bar its autonomy.

The result? A testimony to forging prowess and to the inherent

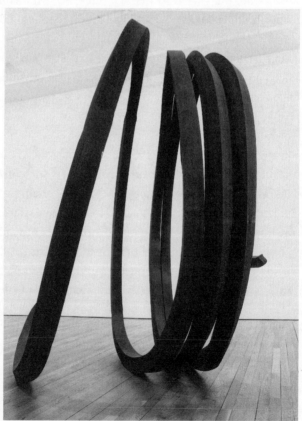

"Undetermined Line", 1990, rolled steel, 106½ x 103½ x 88"

Collection of Joan Borenstein, Los Angeles, CA

potential of the material which I do not transform beyond its natural characteristics. By not changing its nature, I do not manipulate its appearance; that would amount to creating special effects. In my sculptures, I am intent on preserving the energy locked up in their mass, their obeisance to gravity while respecting their singularity, difference and identity.

GP: There is no assembly whatsoever in your sculptures.

BV: With the exception of some maquettes and small-scale sculptures, I rather reject the customary method of welding. "Two Indeterminate Lines" and "Three Indeterminate Lines" are installations of unconnected units and there is no reason for them to be fixed permanently. Since the first experiments by Picasso and Julio Gonzalez, the history of assembled, welded sculpture has not exerted a great influence on my work. It was an outgrowth of the collage tradition and especially of constructivist composition. Works put together in this manner often needed a base owing to the complexity of the arrangement of their parts; in truth, they could not stand on their own very well.

My work brings out a new particularity of sculpture: that of using material not as a means to create forms but as form itself. "Charcoal Pile" in 1963 already proposed this specific approach as a way of giving the work its own unique identity. Assemblage artists metamorphose matter in an imaginary space. The constructivist assembly of different forms and materials into a "third" reality is an approach I reject. I am in favor of works that are literal and explicit, devoid of artifice or ambiguity. My sculpture is the direct outcome of the manufacturing process. As I said earlier, it is the "how" that defines the "what".

My sculptures are self-referential in the sense that they tell the story of their own making. In this way they stand apart from the classical object that disguises its sculptural identity and "speaks of something else". The kind of sculpture that I respect today does not resemble anything, is self-regulating and non-analogous in relation to the external world but in relation to art as well.

GP: Your trajectory as an artist shows the methodical establishment of a purview from which you summon up a certain number of works. The

Americans call this "making a statement". Is there anything that is left to chance on this route?

BV: I tend to believe that an artist cannot venture blindly into the production of objects in the naive hope that it will lead him somewhere. Assuming that he has taste and knowledge, the artist must have an overall scheme as well, a fundamental concept from which his works derive. The meaning will formulate itself as the work evolves with all its imbalances and instability.

My parallel activities in the supposedly separate fields of music, ballet, photography, cinema and, of course, sculpture disturb certain critics who like only well-defined classifications, and swear by the usual, naive categories society holds dear. They see each practice as an entity in itself with boundaries that are not to be crossed. Personally, I am in favor of the interaction of disciplines. I would like to deepen the relations each field entertains with the next. It is a way for me better to define what my work is all about. I consider art a global phenomenon where disciplines have no frontiers. It is the very space in which they meet, overlap and intermingle. I have a need to venture into other territories and to reconsider traditional positions. We must move toward pluralist thinking in art, allowing for different processes to co-exist, each with a stake in the expansion of culture.

What is interesting about the term "statement" is that it is ambitious. It extends far beyond the "little idea" that satisfies those who are less demanding as they discover "their style" and who will spend their lives capitalizing on it to the great delight of "signature" fans. The "statement" is a global vision, an original, radical and open concept of the work as structure. It is the space where thought gives birth to profound reflection capable of begetting an experimental production. This is a way of satisfying the demands of history. However the adventure is a difficult one.

When coming across important new ideas, hardly anyone values them right away. Even those who have discovered them do not fully grasp their real interest. Art is the outcome of a combination of accidents and discoveries. My image might be somewhat crude considering that art does not move forward like a sleep-walker. One of the greatest strengths of art's evolutionary nature is its ability to take advantage of unexpected discoveries— be they accidental of not—in a conscious manner, and to transform them into something that transcends curiosity value.

Some seminal moments in art history suffered temporarily from a certain "atmosphere of unreality". Their authors were misunderstood and could not garner the support of the galleries or the official institutions of modern art. Of course one would wish that such institutions show a bit more imagination. In any event, pioneers must be prepared to forge their paths through the jungle alone.

Art has a complicated, intricate structure. Ideas can come from just about anywhere. Sometimes a good idea is like a contagious disease, spreading suddenly through a group of artists. No one can guarantee it. Ideas do not come with ready-made-recipes. With the benefit of hindsight, we can see things that were not the least bit apparent at the time.

GP: Which sculptors count for you? With whom do you have a true affinity?

BV: I would rather not mention names save those from the past. Naturally I prefer sculptors who took radical steps. I am thinking of Tatlin and his 1912-1915 "Counter Reliefs". I regard Rodchenko's "Construction of Distance" and Gabo's "Kinetic Construction" as momentous works. During that same heroic period, it would be impossible to disregard Kobro's sculptures and her capital contribution to Unism. And then there is Kasimir Medunetsky's "Construction no. 557" which nobody knows but everybody copies.

I tend to prefer simple, direct works, and seminal statements that have unsettled our concept of history.

In contemporary sculpture, I mostly appreciate works that are sober, continue to mark decisive stages and enrich theoretical thinking. Works that do not merely appeal to the intellect but engage the sensorial with equal force.

The ideal sculpture is one whose characteristics I would like to compare to a painting by Mondrian. There, the radicalness of its concept and the thought it engenders are the perfect match for the work's pictorial quality.

GP: Does being a artist mean being demanding?

BV: To be an artist is to commit oneself to seeking. And to risk getting

lost. It is better to be wrong alone than to walk with the crowd. Too many artists today latch on to already invented forms and reproduce them on a larger scale. Occasionally they swap one material for another or mix everything together; they stick to one procedure or to a single manner. In most galleries, modern art is going through an academic period. Since the salon painting of the late nineteenth century, kitsch has never been so accessible to the public at large.

I said earlier that the artist has a need for disobedience, independence and spontaneity. He knows that each step forward is a trial, not a certainty; it is an attempt to seek coherence, to look for something about which he has a strong intuition but which he cannot yet specify in logical terms. Creation seems irrational compared to the order one associates with conventions and classical judgments.

To be an artist is to live in a state of doubt and permanent dissatisfaction. The nineteenth-century American philosopher Charles Sanders Pierce was fond of reminding his readers that all thought since the Greeks is the result of "methodical pessimism", the undisputable precondition of human freedom. The reason my work is in constant motion is that I doubt the value of statements about art, those that are proposed to me as well as those I formulate myself. What could be more deadly to an artist than to hang on to dogmatic certainties? What could be more dangerous than to stop midway, and to lock oneself into a style and to be convinced of having the truth in one's possession?

No philosophy, religion or ideology is ideal. No theory can satisfy all needs, nor stand up for very long. Theories rapidly turn in on themselves, begin to show a doctrinaire character, and benefit an authoritative system only. One principle in art is that all principles must be swept away.
This is what I mean when, speaking of my recent "Random Combinations of Indeterminate Lines", I insist upon the fact that randomness is the rule of the game, and that my aim is to free sculpture from the constraints of composition and ideal order. This is the crux of the matter: "There is no ideal order, there is no ideal solution".

Collection: Bernar Venet

Interview by Corine Pencenat

At the age of eighteen, while living in Nice, I was already exchanging my works with those of my artist friends. Later on, the opportunities multiplied as I began to exhibit alongside the leading exponents of minimalist and conceptual art. Some older artists have been more than generous with me. While they were famous and I was not, they apparently trusted my enthusiasm and my love for their art.

Along with my wife Diane, I have at times gone to extreme lengths to acquire art, even when it exceeded our means. It was Yves Hayat, then editor of the magazine *Galeries*, who published this article on our collection in December 1993.

Corine Pencenat: Very early on, you began collecting informally your friends' artwork. For the most part, these artists were older than you. How did you go about it?

Bernar Venet: We traded among ourselves, of course. It was the only way we could do it. In any case, our work had no commercial value at the time. We were working for "the sake of art," and above all else, we wanted to be appreciated by people whose judgment we respected.

In 1963, I was twenty-two years old, and I'd just gotten out of the army. I met some of the New Realists in Nice and during a few short stays in Paris. Although they didn't actually influence my work, their ideas were so radical that I became convinced that we were witnessing an historical moment. I became friends with most of the artists, and we naturally exchanged our work. In addition to the pleasure of owning my friends' work, the confidence they showed in me as a much younger artist was very gratifying and encouraging.

CP: At the time, the notion of a collection probably didn't make much sense

to you. What did you do with their works?

BV: I hung them in my room in Nice on the rue Pairolière. In the early '60s, these were the artists of the European avant-garde. Instead of looking at their work in art magazines, I had the advantage of actually living with the works themselves.

CP: Did living in such an environment stimulate your work?

BV: It rather stimulated my sense of competition. The artists I knew never inspired me as models, because, personally, the use of objects never interested me. But I think the anti-conformism of their work may have stimulated my taste for risk-taking. Their works didn't show me the way, or give me an example to follow. Instead they were living proof that the history of art hadn't ground to a halt with the abstract paintings of The School of Paris. But then, twentieth-century art wasn't going to stop with the New Realists either.

Very quickly, the aesthetics of my work took a more sober turn, with the materials I used taking precedence—tar, charcoal, and cardboard—being their principal focus. This was before my so-called conceptual period when I began reflecting exclusively, on art's identity and signifying characteristics. I've sometimes said that certain works in my collection represent what I would have liked to do myself. Not in place of what I did, but as a complement to my own work, more like variations or extensions of it by different means.

CP: You were very young when you left your hometown in Provence for New York, where you soon became part of the avant-garde. Your collection is therefore essentially made up of minimalist and conceptual works.

BV: Already in 1963, my tar paintings (*Goudrons*) and my charcoal pile sculpture (*Tas de charbon*) showed a distinct taste for strictness, a preference for an art based on content rather than on surface. It's been said there's no such thing as chance. As soon as I got to New York, in 1966, I met and became friends with almost all the American minimalists. Robert Smithson gave me a drawing after I'd helped him with one of his installations, but, more particularly, I exchanged work with Sol LeWitt and Donald Judd. All

three of us have a passion for collecting. Sol LeWitt exchanged his work with the best artists of his generation, but he was more eclectic about it than I was. The majority of his collection is now at the Wadsworth Athenaeum in Hartford, Connecticut. It's a fine, representative selection of abstract and conceptual art from the '60s and '70s.

I was personally able to acquire several of Sol LeWitt's important works. Some of them are historical, like the first variation in his "Open Cube" series of 1966 that was exhibited at the Dwan Gallery in Los Angeles and New York. It was the first time Sol had ever shown this kind of work, and I was struck by how extremely radical it was. But I'll also never forget the mocking reception he got from the public which called them "chicken coops".

My exchanges with Sol began in 1970 with one of his first Wall Drawings. He had already shown these in galleries, but he had never sold any of them. Mine was the first of his Wall Drawings he'd ever seen installed in a private setting. At the time, I had a huge loft at the corner of Broadway and Houston. It's a graphite drawing, very geometrical, composed of superimposed vertical, horizontal and diagonal lines, about three meters square. Now it's on one of the walls of my loft on Canal Street.

The advantage of the Wall Drawings is that you can have them in several places at once. This is how I can have his pyramid on a blue background in my dining room at Le Muy, and at the same time on one of the walls of my bedroom in New York. I'd given Sol a sculpture. He came to see me with two little watercolors called "B.V.1" and "B.V.2", and let me choose the one I wanted. Not long after, his assistant came and executed the Wall Drawing. Sol is a very amicable guy, very free and generous with his friends.

CP: Donald Judd, as you mentioned, also has a strong taste for collecting. He even created the Chinati Foundation in Marfa, Texas, where he exhibits works he owns or values. How did your relationship with him begin?

BV: I met Donald Judd at his loft in 1967. At the time, he was living right by Max's Kansas City, the famous restaurant where the era's artists got together every night. I remember he owned a huge painting by Frank Stella that was part of the "V" series, done with powder-based metallic paints

("Notched V", 1964-1965). I respect Don. He takes a radical, historical approach, with no concessions. He's very austere, and has very strong and moralistic views about art. He never confuses the passing fancies of the avant-garde with what he considers of historical importance.

I have three of his big wall progressions. He created them especially for me in 1971, 1972 and 1976, but the last one wasn't actually realized until 1986. I was able to acquire them at a time when he was selling practically nothing, and it was still possible to exchange works. I remember what I traded him for each of them—a little painting by Ad Reinhart, a work of Franz Kline's on paper, and one of my conceptual pieces along with a bit of money.

I have other minimalist sculptures. Some of them are in my loft in New York, but most of them are at Le Muy, notably works by Robert Morris, Dan Flavin and Carl André. My preference for pared down aesthetics led me to collect a steel relief by Ellsworth Kelly and a very representative example of the work of Tony Smith. I also own a big Motherwell, very beautiful, very sober, from the "Open" series. It's completely gray, almost minimalist. Because I had the good fortune of meeting Marcel Duchamp and Man Ray quite early, I also own some drawings that are characteristic of their work, which they autographed and personally dedicated to me. These were some of the important moments of my life, and I still remember the place, the day, and the hour each of those meetings took place.

CP: Artistically and intellectually the '60s and '70s were very rich and stimulating, yet at the same time very difficult, materially speaking. Artists had to find the means to express themselves and manage to exist with no institutional support or public recognition. How did you live at the time?

BV: We often got together among ourselves; we were younger, and so we had more free time. There wasn't so much pressure from the market, either. The group exhibitions in which we all took part at the Dwan Gallery, at Leo Castelli's or at Paula Cooper's, always occasioned animated discussions. In 1969, Leo Castelli organized an exhibition at his uptown gallery against the war in Vietnam, called Moratorium. We all posed for a group photo next to an American flag that bore the colors of the Vietnamese flag, and we dedicated our proceeds to an anti-war organization. I remember prints by Jasper

Johns selling for $300, and a superb drawing by Rauchenberg for $1,000. At the time, it seemed like a fortune to me. Things really have changed!

A few years later, galleries and museums began showing interest in artists of my generation, internationally, and began treating Conceptual art, body art and land art as one group. We'd all get together at Leverkusen, Turin, Düsseldorf or the New York Cultural Center, where we could hear the first murmurs of recognition. It was during this time that I added works by Dennis Oppenheim and Vito Acconci to my collection, as well as works by "hard core" conceptual artists like Art & Language and Lawrence Weiner. Before that, when living at the Chelsea Hotel, I remember conversations with Christo, who made a wrapped portrait of me, but also with Rotella and Takis, who were renting studio apartments on the same floor I inhabited. All, or practically all, of the European artists in New York lived for a while at the Chelsea. They knew that the manager accepted art in exchange for a room, and none of us could afford to pay the full rent.

CP: Your collection is essentially American. What contact did you have with French artists? Were these ties reinforced when you decided to go back and spend more time in France?

BV: The fact that I've lived in New York for twenty-six years has necessarily had an influence on the orientation of my collection. Not only for reasons of taste, but more for reasons of opportunity. In addition to certain New Realists (Arman, César, Jean Tinguely), my collection includes French artists like François Morellet and Gottfried Honegger, who have been friends of mine for a long time. We represented France together at the Bienniale of São Paulo in 1975. Olivier Mosset gave me several canvases after having lived in my loft for a year. I own some vintage works of Ben's, "*Banane*", "*Trous*" and "*Écritures*" ("Banana", "Holes" and "Writings"), for which I traded with him in Nice. To these I've added works by Alain Jacquet and Daniel Buren and by younger artists like Serge Kliavin, who was my assistant in New York. As you can see, happenstance plays a big role, along with my appreciation of an artist's work, of course.

CP: When you were acquiring these works, did you think about conservation, building a collection, and ways to exhibit it?

BV: At the time, certainly not. Furthermore, it's still very hard for me to part with a work, to lend it out. I can't conceive of selling any of the ones I own even if, for example, I did exchange several Flavins for one of his more important pieces. Today, I don't think I would even do that.

CP: What role does collecting play in your life today, and how do you think it will evolve?

BV: I developed the idea of collecting mainly in the '70s, after my conceptual period, when I myself had stopped producing. I had much more time to devote to other artists' work and the history of art, and, in addition, I was giving lectures and conferences on the subject. Today, I am very preoccupied by my own work, and have less time for collecting.

The works I've assembled represent for the most part intimate moments I shared with artists of my own generation who had become friends. They reflect my respect for their work, my desire to assemble, for my pleasure and that of my friends, everything I take most seriously. In the future, the essential part of my work and my collection will, perhaps, come together in the form of a foundation. After I'm gone, that is, and if I deserve it.

For *Collections d'artistes* at the Lambert Foundation

Yvon Lambert

Yvon Lambert is one of the most important European dealers in decades. All along his activity, he has managed to buy and to keep for himself some important paintings and sculptures from the artists he represented. It's a great quality and proof of his authentic love for art. I have known many art dealers who have been unable to share this pleasure. To each their own...

I nevertheless have some hesitations concerning the sincerity of dealers of Contemporary art who live happily in apartments full of traditional furniture and paintings...

During the summer of 2001, Yvon Lambert organized an exhibition in Avignon entitled *Collections d'artistes*. He borrowed a few paintings from our collection and this text was written for the catalogue published on that occasion.

I was just fourteen years old when I visited a museum of modern art for the first time. It was the Museum of Grenoble which, owing to the extraordinary intuitions of Paul Andry-Farcy, had been able to put together a collection of contemporary works which were extremely innovative for the time. These paintings surprised me by their astonishing radicalism, and the fact that they were already in a museum awoke in me a curious feeling. Retrospectively, the best explanation I can give is that on that day I discovered that the present could equal the past, that what was thought or expressed today by living and even relatively young artists already was worthy of consideration in the context of history. In other words, I had the feeling that I was experiencing realities in the present that already seemed historic to me. I remain convinced that the shock I felt on that day was decisive for the way I see art, not only as a participant but also as a witness. The history of great art as taught in books commanded my respect, but from that day on, after I discovered the vitality of art in the present for the first time, my passion only was for its day-to-day unfolding—granted that having lived in Nice in the early '60s, and then in New York during a time of great creative effervescence gave me a privileged perspective.

I mention Nice in order to do justice to a special situation which had a capital influence on me. The presence of Klein, Arman, Raysse, Ben and also of younger artists with whom I spent just as much time, created an atmosphere of friendship and solidarity which encouraged exchanges of ideas as well as objects. Our works had no commercial value but we had respect for each other, and sometimes even admiration. We produced more works than we sold, quite obviously, and trading one for another brought us a complicit and reassuring pleasure. It was Ben, I'm sure, with whom I made my first exchanges. He no longer needs introduction but it is certain that in 1959, when I met him, Ben conveyed an aura of authority to young people who came to visit him at his record shop. He knew all the artists of the region. He was also very well informed, like a real archivist, and trading a work with him already meant a certain recognition. I no longer remember if he first offered me a work on paper, "Banana," or if it was a "Trou de Ben." He was quite generous in his exchanges and he would sign anything for you, as long as the date was written in big letters on the side.

As soon as I returned from the army, when at last I was able to move into a little apartment-studio on *rue Pairolière*, my walls were progressively filled with works by other artists. My friends from Nice of course, but also the Parisians, who belonged to the group of the New Realists. From 1963 on, I rapidly gained the support and friendship of artists such as Arman, César, Villéglé and Deschamps, who were quite generous with me. I was totally unknown and having the privilege of making exchanges with artists who were altering the course of history in Europe, was something that gratified and reassured me. I didn't really have any intention of forming a collection, but it built itself with each new encounter, by force of circumstance.

Some items are not very large, but precious for their originality. For example, in the course of a very late night spent at the "Rosebud" bar in Montparnasse, the so-called *Affichistes*: Hains, Villéglé and Rotella signed the artfully torn label of a Seita matchbox for me. Three signatures on what you could qualify as a "miniature", dated 1964. It remains a precious object for me, which by its very nature has nothing to do with the art found in museums. Nonetheless, the sentimental value it holds for me, the memory of that moment spent in such intimacy, gives it a special place in my collection, just as important as more spectacular works that I acquired later. My collection is often made of these intimate objects of special value to me only for mem-

ories they evoke that remain fresh, as is the case with Man Ray and Duchamp, two important encounters in my life. About each one I have amusing anecdotes which would take too long to tell here. But I still own the "Safety Pin" (*Epingle à nourrice*) that Man Ray dedicated to me, and a copy of Transition with the silkscreened comb on its cover which Marcel Duchamp signed for me after a long afternoon of intense conversations about art. That is what constitutes the essence of my collection: personal memories of human beings for whom I have great admiration, living witnesses to history in the making.

I have been fortunate to meet and get to know the great majority of the artists whose work I possess. The exceptions are rare; most of the works were especially made for me, and some have a story attached to them. To mention just a few examples, that's the case with Morellet who did one of his 1991 *Relâche* sculptures based on the letters of my name, or with Arman who did my *Poubelle* and my "Portrait Robot", César compressed my car and Rotella created one of his *Blancks* in my studio on Canal Street. I remember a 1968 exchange with Takis while we were both living in the Chelsea Hotel. Jean Tinguely created a very baroque "candlestick" for my fiftieth birthday and Raymond Hains gave me a work called "Matheymatics" during the exhibition *Douze ans d'art contemporain* at the Grand Palais in 1972. Shortly after my arrival in New York, Christo also did a wrapped portrait of me and in exchange I offered him a "Diagram" painting which I still see every time I visit him. I won't cite all the examples, but it was in that spirit that my collection began to take form.

My exchanges with Sol LeWitt and Donald Judd date from the late '60s and early '70s. On Kawara, to whom I was very close because we often got together to play ping-pong, sent me a series of "I got up at..." postcards, every day of December 1969. Donald Judd and Sol LeWitt took an almost professional interest in collecting. Judd was preparing his foundation in Marfa, Texas, and Sol accumulated works by all his artist friends. Everybody loves Sol and he is very generous. I've known him since 1967 when we made our first exchange. He offered me a Wall Drawing that can be considered historic, since it's the first to have been carried out on the wall of somebody's house or apartment. Hardly was the drawing finished when Sol rushed over to come judge for himself its presence in a private setting. Before that he had only seen them exhibited in galleries or museums. My taste generally runs

toward sculpture or related things, rather than painting. The few paintings in my collection—I should say "ours" now, because some pieces belong to my wife, Diane—still have very minimalist characteristics through their sober forms, and colors which are never very bright. That is the case with our Motherwell, from the "Open series", and our Frank Stella from the "Polish Village" series.

Minimalist or conceptual works (Art & Language, Lawrence Weiner, Vito Acconci, etc.) constitute the largest part of my collection with a few exceptions, notably Arman and César, who have shown such great generosity toward me.

Talking about Arman, it was thanks to him that I developed my taste for African art. Now he is known as one of its greatest specialists and collectors. During the years 1967-1968 I often I stayed in his apartment at the Chelsea Hotel in New York when he was traveling. There I was surrounded by objects which were not as important as the major works he possesses today, but still had a very strong magical charge, lending them a presence to which I was not insensitive. The few pieces I possess today are mostly the result of exchanges. I am far from being a connoisseur, which obliges me to be very prudent and listen to the advice of more knowledgeable friends. I have no taste for useless objects, for decorative gadgets without any cultural connotation. Surrounding myself with works of art, which I do with periodic ups and downs, is meaningless unless those works command my respect and belong to a history still in the making.

Venet Takes a Line

Interview by Henri-François Debailleux

Henri-François Debailleux is a very active art critic for the daily newspaper *Libération*. While *Le Monde* regularly pans my work, I am grateful to *Libération* for its support within its columns of most of my exhibitions in France. Debailleux's faith in my work is obviously the main reason.

During the summer of 1993, *Libération* published a two-page feature that alerted the public to my retrospective exhibition at the Musée d'Art moderne et d'Art contemporain in Nice.

Henri-François Debailleux: What is the link between the conceptual work you were doing in the late '60s and the sculpture you're doing now?

Bernar Venet: It would be easy, thematically, to see different aesthetics operating in these two aspects of my work. And while it's true that they are quite different formally, anyone who's paid the least attention to my work as a whole over the last thirty years can see that I've been following the same logic, that I'm engaged in the same discourse. Take, for example, my first "*Goudrons*" (tar paintings)) or the "*Tas de charbon*" (Charcoal Pile) I did in 1963, which are not all that far removed from the steel sculptures I'm doing today. All of these works present a material for its own specific qualities; they all feature the process of their own fabrication. My work is based on the particular notion of not utilizing the material as a means to create forms; the material is the form. This is why I often say that my works are self-referential.

By installing a pile of charcoal in a museum or gallery, my purpose was to show a material freely dropped to the ground, which thus had no specific form but simply obeyed the laws of gravity. This idea, which seemed

radical at the time, was meant to enlarge the definition of sculpture, to liberate it from the *a priori* compositional dictates of the artist. I'm still doing the same thing today, since my sculptures define themselves by always showing the process of their fabrication. The work is literal and explicit, with no artifice or ambiguity. In other words, the "how" determines the "what".

HFD: How would you define your position?

BV: I've always been motivated by the desire to allow works of art to define their own identity. It's a way to put an end to painting that serves figurative purposes, and even the excessive—exhibitionistic—expression of the individual artist. I take an historical approach to the question. For example, when Kandinsky started painting abstract works in 1910, his painting no longer served to represent the visual world. Later, after Malevich's radical experiments, *Circle et Carré* artists, Van Doesburg especially, went further still. They insisted that a circle is neither figurative nor abstract, but concrete, because a circle does not represent a circle; it is a circle in and of itself. In 1930, Strzeminski, who had a very sharp grasp of theory, criticized these artists for painting circles on canvas. As he saw it, paintings should not have a subject: they should be the subject. His solution? Paint a monochrome.

 The point of this short historical summary is to show that this has been a key preoccupation for artists who think about the intrinsic nature of the work of art. It's a concern that's always been central to my own approach, and I'm always trying to push it a little further. In this respect, the titles of my works are clear. They indicate precisely what is shown. So the diagrams I did during my conceptual period not only depict the graph and its definition, their titles are also repeated on the labels next to the graph.

HFD: The material itself, and especially steel, has been the most important element in your work for a dozen years now. Why is this?

BV: The material is essential because that's what allows me to play on the concept of identity. Moreover, when I'm asked if my black *Goudrons* (tar paintings) are monochromes, I say no. Of course, they only have one color, but this is neither their subject nor their intention. The answer is rather that

they're paintings made of a single material; the color is secondary.

I felt impelled to work in steel after having worked in several other media. In 1976, I was drawing lines on canvas—angles, arcs, straight lines. Next I began making wooden reliefs. This freed me from the conventionality of canvas as a support, and thus allowed me to use the wall directly. Its mathematical definition accompanied every work. In 1979, I created a free line, meaning free from mathematical constraints. I called it "indeterminate", and through a kind of shift in context, I took line, in all its forms, as my essential theme. With that breakthrough, the use of steel gave my work another dimension and a stronger identity.

HFD: The line is thus a constant in your work?

BV: In 1966, the line was already an essential subject for me. One of my works, for example, was entitled *"Un vector est un segment droit orienté"* (A Vector Is a Directed Line Segment). At the time, my work depicted curves or straight lines. Later, my angles turned into broken lines, and my arcs became curved lines. I changed materials, but not subjects. Line and all its possibilities is thus pretty much my area of investigation. Rodchenko, who thought a lot about this subject, wrote that "the line liberates the artist from expression." So, my entire work has consisted of distancing myself as much as possible from artists' excessive, sometimes even pathological tendency to think that all they have to do is express themselves to make art. A line is a stroke, the very spare, stripped-down sketch of a form. A line is what exists before anything superfluous is added.

HFD: Between 1970 and 1976, you completely stopped producing work. Why the silence, this fairly long interruption?

BV: You have to understand the context at the time. I began my first conceptual work in 1966. For the next five years, I lived exclusively in the United States, in a very stimulating environment where I was encouraged by a receptive milieu to develop work whose highly rational and analytical nature took me to extremes that seemed impossible to surpass. I couldn't go any further. But I didn't want to repeat myself or turn my art into objects of decoration for the walls of collectors and, eventually, museums. So I

decided to stop. Definitively.

HFD: So why did you begin again six years later?

BV: Stopping was like a breath of fresh air for me. During that time, I had the chance to take my distance from what I'd done, to analyze it, criticize it, question certain ideas I'd had. I came to understand that the best of theories become dogmas that we have to watch out if we want our ideas to keep on developing. During these six years, I lectured at the Sorbonne and gave conferences all over the map. In fact, all this activity permitted me to stand back and look at things. And then, because it's my nature, because in my guts I can't do otherwise, I started working again. Timidly at first, in secret, until Jan van der Marck invited me to Documenta in Kassel to show my new work. These were canvases in the form of arcs and angles that had their measurements in degrees indicated right on them. I felt it was worth experimenting with these ideas. I wanted to know where this work, still connected to a mathematical context, was going to take me.

HFD: How did you become so attracted to mathematics?

BV: I never had any particular taste for mathematics, and I didn't even find it necessary to understand the precise content of what I was presenting. That wasn't the point. I wasn't a mathematician, and I didn't do math! These subjects interested me because I thought I could use them with justifiable consequences in the context of art. It was a way for me to free myself from the traditions of figurative and abstract painting. At the same time, I abandoned everything that had to do with formal problems in order to explore the possibilities of a graphic and linguistic sign system. I was entering a new area of investigation, and even if I ran the risk of being way out in left field, I thought it was better to be wrong on my own than to go along with everyone else.

HFD: And what about your use of science?

BV: True, this is an area I'm passionate about. In addition, physicists and researchers have done a lot to show me the way through their method, their

desire and their conscience that keeps pushing them to try to find answers to questions, to keep on discovering and enlarging their field of investigation. They know how little we actually know. In art, to the contrary, people think they know more than they really do, and balk at putting it all into question. I often took scientists as models much more than artists. And my inspiration for subjects regularly came from scientific textbooks. When young artists come to see me now, I often tell them to explore sources other than the art magazines. *Scientific American* seems a much richer source of inspiration to me today than Mondrian for abstraction, or Duchamp for the use of objects. Everyone copies everyone else, things get repetitive, and contemporary art today risks being an academic exercise.

HFD: You are also a collector, principally of Minimalist art.

BV: I love art and I love to live with works of art. Not only my own. It's a way of having the history of art all around oneself. For me, it's more a question of knowledge than simple aesthetic pleasure. The works I collect have a connection to my own field of investigation. Generally they're very sober, with nothing of the spectacular about them, and very highly charged conceptually. They're works I also would have liked to create myself. But I don't only collect minimalist and conceptual pieces. I'm very interested in the work of certain French artists like César, Arman and Morellet as well. I equally appreciate Jean Tinguely, even if his work doesn't necessarily correspond to my basic taste for the unostentatious.

HFD: What do you think of this exhibition of thirty years of your work?

BV: I don't like official appraisals, and we are not drawing up the balance sheet. It's just thirty years of my work. If an artist's work doesn't keep evolving, it dies. Everything remains to be done. If tomorrow I happen to have an idea that takes me in a completely new direction, I'd go for it instantly. Even if this direction runs counter to everything I've done up till now.

"STRAIGHT BARS" and "ACCIDENTS"

Bernar Venet

I wrote this short text for the catalog that was published in conjunction with my 1996 exhibition Straight Lines and Accidents at the *Espace fortant de France* in Sète.

My objective was to emphasize the importance of straight lines in the overall context of my work. The "accident pieces" suggest a new approach to sculpture that goes beyond what I did with my "Charcoal Pile" in 1963, and my "Random Combinations of Indeterminate Lines" in 1989.

The unexpected and unpredictable were on the verge of becoming important new considerations in the practice of my art.

The straight bars are the logical sequel to work I began to develop in 1976 and in which line was the lead theme.

Already in 1966, some of my first conceptual works on canvas or on paper had as their subjects mathematical functions represented by straight lines. A notable example, now in the collection of the Musée de Grenoble, is "*La droite D' represente la fonction y = 2x + 1*" (The straight D' represents the function y = 2x + 1).

Another example is "*Calcul de la diagonale du rectangle*" (Calculation of a diagonal of a rectangle). It has the formal simplicity of Rodchenko's famous "Line Drawing" of 1921. However, it sets itself apart from that historic drawing by its monosemic character which leaves no doubt about the painting's real identity. The mathematical symbols in that work render it rigorously univocal.

"Two chords subtending arcs," painted on canvas in 1978, and the 1979 graphite on wood bar "68.5° Diagonal Line", are other examples of my work featuring straight lines.

More recently, in an attempt to see how I could use straight lines in sculpture, I managed to make new works while taking liberties with form on

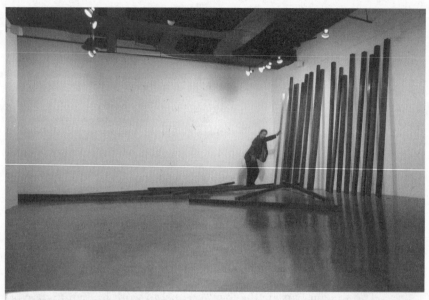

Two views of the performance entitled "Accident", laminated steel, 1996, no specific dimensions. Installation Chac Mool Gallery, West Hollywood, CA
Collection of Eugenio Lopez, Mexico City, Mexico

the cusp of chaos and accident. The bars abandoned on the ground, piled disorderly like a game of jackstraws, echo my 1989 "Random Combinations of Indeterminate Lines", and going back even further, they recall, in its elementary principles, my 1963 "Charcoal Pile." The bars can also be arranged against a wall, obliquely in groupings whose quantity varies according to the space available for their installation. Unequal in length and diameter, they are never welded to one another.

In the manner of my other works, these installations conform to the principle according to which "the material is not used to create forms...it is the form."

I never make preparatory sketches for these sculptures as they are improvised in each instance. My work acquires its meaning at the moment my depositing the bars and lining them up renders their form concrete. The essence of my activity as a sculptor lies in continuous experimentation with the means at my disposal; in the staging of these untransformed, raw steel bars in a perfectly coherent fashion.

UNCERTAINTY AS A WORKING HYPOTHESIS

Some installations bring together about thirty bars. They are leaned against the wall, slightly tilted, at the verge of instability. With the help of a forklift, or more directly with my own hands, I give a good shove to some of the bars which causes the majority of them to fall. Their collapse scuffs the wall and creates a disorderly pile, scattered and often unstable. It is this result which interests me, a product of chance which leaves the sculpture's components visible, for all to see:

a) bars still upright revealing their original positioning;

b) markings on the wall bearing witness to the sliding and eventual collapse of the bars;

c) bars on the floor, both stacked and dispersed in random fashion through the concrete and logical effects of gravity: the result of a staged action, of a past event.

In these works in which the fall of the bars is the primordial compositional agent, the relationship between the action and its result is evident. There is perfect unity between end and means. The sculpture, hence, turns

e.

ving set the preliminary conditions for them, these works
ntrol. Compelled by an outside force, the bars, once set in
ugh a set of random encounters to end up achieving a new
cattering of unforeseen dimensions.

In truth, I do retain real power over the choice and positioning of
the bars, but my detachment is total when it comes to the final result which
is impossible for me to anticipate.

Pushing the bars produces a chain of unpredictable reactions, always
different for being subject to the uncertainty principle.

By dint of interacting forces, an original configuration is obtained
which varies within a range of unlimited and unquantifiable possibilities.
The collapse is gravity's way of undoing, of decomposing, what I, before it,
intuitively had composed. It also is a move in the direction of immobility, a
state of rest, a new balance, unpredictable and chaotic yet logical for obey-
ing the natural laws of force and mass in motion. With these sculptures, I
seek to realize the best possible equalization between a formal, sober, ele-
mentary vocabulary and the structural principles which put this vocabulary
to good effect.

WHY THE TITLE "ACCIDENT"?

There is nothing "dramatic" in this title. "Accident" in the realm of
mathematics is defined as a perturbation, an encounter between an organ-
ized phenomenon and an event. Together they create the unforeseeable. The
same holds true for "catastrophe" which results in disintegration as well. For
the moment I prefer not to use the all too fashionable word catastrophe. This
is a purely arbitrary choice on my part. These two terms, "accident" and
"catastrophe", are not to be seen as negative, they do not imply destruction,
on the contrary. Granted, they cause disintegration, but there is also coming
into being: a tumble of events that combine to form something else.

The collapse we witness as the bars fall, is of an occasional nature
and meant to make us understand that the new organization of the bars con-
structs itself in and by unbalance and instability. This work of mine does not
seek to set itself against other systems of composition. It does not seek to
exclude; on the contrary, it includes, as hypotheses of possible experiences,
the ideas of disorder and, especially, of the unanticipated. It even includes

the latter in what one might call a generative capacity as the disintegration of the old form is the constitutive process of the unforeseeable new form. The notion of "accident" thus becomes identified with the whole of that process of metamorphosis and disintegrative, but ultimately creative, trans-formation.

I am attempting here to push to its extreme limits what already has been outlined in my 1989 "Random Combinations of Indeterminate Lines" and what lies implied in my 1963 "Charcoal Pile." Once more I propose the ephemeral as a parameter for a work meant to be recreated every time it is exhibited. By insisting on its provisional and transitory character, I end up inviting the uncertainty principle to intervene in the process. As I have stated already with regard to preciously made and mentioned works, my goal is to liberate sculpture of the constraints of composition and to critique the utopian notion of an ideal order.

These works composed of straight lines (linked to geometry) pre-sented on the floor in a disorderly fashion (chaotic) are as far as I am con-cerned, the best example of a commitment which consists of developing an open system where one ceases to see things as compartmentalized, cut-off, with hermetic boundaries, and where I propose interrelations instead.

With a great soberness of means, it is my way of reacting forcefully to the academy of the square, the cube or the monochrome, this legacy passed on from Malevitch and Mondrian and which is lazily exhausting itself in its umpteenth variation, in its blind belief in an ideal order.

I like to propose a realm of the non-proportional, the non-struc-tured, the non-pre-established. An area where the parameters to create the unforeseen, the unexpected, are different.

Taking all straight steel bars, allowing them to fall like a game of jackstraws in an unstable pile, is my way of making the determinate and the indeterminate coexist, just as the principles of order and disorder which are at once complementary, concurrent and antagonistic.

My goal is to reunite these two opposite notions in an organizing process which allows for new hypotheses. I am not saying that one must go blindly from an orderly, simple, logical art form to a disorderly, complex and uncertain one. Instead, in my work, I propose to investigate the possibilities that lie not in the alternative or in the exclusion, but rather in the interrela-tion of the ideas of order and disorder.

Logic and Chance

Interview by Catherine Millet

I met Catherine Millet in Paris during her first years as an art critic. She was then twenty and living with Daniel Templon, a young gallery owner with whom I soon after started to exhibit.

It is in *Lettres françaises* that she published her first article on Conceptual art after visiting the exhibition *Conception/Konzeption* in Leverkusen. She wrote extensively on that movement, published the first small book on Conceptual art, and then started to publish *artpress*, which remains a very influential French art magazine.

Catherine Millet always supported my work with lengthy articles in various magazines and wrote the first monograph on my work in 1974.

This particular article came out in *artpress* in 1997, when a large retrospective of my work was organized simultaneously by three different museums in France with each museum showcasing a different phase of my production over the course of one year.

Catherine Millet: Not long ago we were looking at two photos of your work, one of the 1963 *"Tas de charbon"* (Charcoal Pile) and the 1996 "Accident" which consists of steel bars that have been allowed to fall onto the ground. If we put these two pieces side by side, even though they are remote in chronological terms, it becomes obvious that they have sprung from the same basic premise.

Bernar Venet: There are a lot of similarities. You could also detect considerable formal and conceptual parallels with other works, for example the *"Combinaisons aléatoires de lignes indéterminées"* (Random Combinations of Indeterminate Lines) and, typically, a 1961 performance during my service in the army, when I had myself photographed sprawled amidst garbage containers. What first prompts me to make such works is an intuition which may or may not take precise form. Then, because they seem so clearly related to the rest of my work, I include them in the context of what I am doing at that particular time. As for the sculptures you mention, these experiments were not based on logical, deductive reasoning. Rather, I began by acting on a rather "Bachelardian" principle of "why not?".

In 1963, when I came across a pile of gravel mixed up with tar in a street in Nice, I was struck by the visual similarities with the "tar" paintings I was then doing. This encounter encouraged me to think that, based on that model, I could make sculpture as volume and create something original.

ACCIDENTS

The same thing happened with "Accidents". When I inadvertently knocked over a maquette made of straight bars, that accident's formal potential suddenly hit me. After deliberately repeating that inadvertent gesture, over and over again, I decided to appropriate it for my work and named it "Accidents".

The two pieces have many things in common, but of course the differences between them are crucial. To present a pile of charcoal as an artwork is to propose a sculpture that refuses traditional verticality, that obeys natural laws of gravity and, above all, has no specific form. It is not a permanent, durable work, not only because the material is unstable and malleable, but also because, in defiance of the fetishistic value we have bestowed on art, it can return to its original function and be sold as fuel. The idea of the artwork undergoes a mutation: once the material is returned to its original context, all that remains to justify the work's belonging to the realm of art is the concept. The "Charcoal Pile" is always an ephemeral work. It can be shown in several places at the same time and in different forms and sizes. None of the piles is the "authentic" one: the one to keep.

The "Accidents" also have these properties, but not to the same extent because their genesis is different. They are the result of a sudden change of configuration. Within them they carry the potential of an event. There was a previous form: 40 straight bars leaning against a wall and, suddenly, as a result of pressure, they collapsed, creating, in a new, stable state, a new form. This principle of uncertainty is important in that it locates the work outside the organizational systems (composition or installations) I have been using before. I no longer control the physical rules to which the work is subject. The final result is determined by the laws of gravity, weight and the unforeseeable reactions of the bars. Another characteristic of the "Accidents" is that they question the dichotomy of order and disorder. By

bringing into play the geometry of straight bars to create a disorder ending in chaos, this work shows that the determinate and the indeterminate can coexist. It is an act of defiance—and, why not, giving the finger—to that dogmatic, comfortable conformism—I mean academicism of square and cube that amounts to the impoverishment of an axiomatic proposition for which Malevitch brilliantly, but a very long time ago, laid the foundations.

CM: I have noticed that in your titles you make a distinction between "Random Combinations" (*Combinaisons aléatoires*) and "Disorderly Installations" (*Installations désordonnées*).

BV: For the sake of coherence, I prefer to use the term "random" because it is better suited to the complex forms of the indeterminate lines. As for "disorderly", it comes closer to the contrast, to the antagonism I'm trying to render evident by using, for those installations of straight lines, geometric elements that rather lend themselves to being arranged and set in order.

CM: You have often said that with your conceptual works, using the language of mathematics and thus monosemic, you sought to set up but one single level of interpretation. In a recent text you wrote on the question of meaning, you stress the fact that the factor time intervenes in the interpretation of works of art and that we attribute to a work, at the moment of its realization, a meaning that differs from the one we attach to it after a period of time. The question, then, I want to ask you is: can one not attribute today a new meaning to your monosemic works of thirty years ago?

BV: It is possible to see in a work of art only what our knowledge permits us to see. Cultural contexts evolve. Who can claim to have a precise knowledge today of the meaning of a Senufo tribal sculpture made one hundred years ago? It is quite likely that my diagrams and most of my conceptual works were shaped under the influence of semiology in the '60s. I believe nonetheless that thirty years later that approach remains the most appropriate to define with precision what set that work apart from everything then known in the visual arts, figurative no less than abstract.

I have made such a point of that type of analysis, and others like me, that the meaning had better assert itself in the long run. The writings are

there and so are the media to reiterate the information and to insist that the artist's intentions be honored. But no one can foresee, in fact, and I no more than others, what will be said about those works one hundred years from now. The strikingly original analysis of a future art historian perhaps allows him to detect particulars which today we are incapable of imagining. But I doubt it!

ANTAGONISM

CM: In your work, then, there is this constant movement between the dream of control—monosemy, descriptive titles—and the acceptance of chance as a creative agent, of accident, of the behavior of material as a formal determinant.

BV: The work of an artist always begins in an axiomatic fashion, which is to say that it departs from a proposition that is considered "valid", and then engages in a process of deductive reasoning according to its own peculiar logic. It's not for me to say so, but I think that, since 1961, there has been no lack of unity in my work, but that this has been a complex unity, following a course pitted with crises and doubt, with periods that were productively fallow but intellectually fertile.

The most disconcerting thing is the apparent antagonism between the extreme rationalization of the early works, where mathematical rigor left nothing to chance, and the integration of unpredictable and random factors in my new works. But that is a simplistic way of looking at things. To understand this coexistence of order and disorder you have to set aside this logical paradigm in which order excludes disorder and vice-versa. You have to think differently and consider another kind of relation, that of complementariness. By taking into account the principles of disorder, chance and catastrophe, the "Accidents" are just as closely related to mathematical principles as the "*Représentations graphiques*" (Graphic Representations). Except that here we are dealing with recent math, the math of mechanisms that engender complex behavior, like chaos theory or the science of complexity. With the introduction of ephemerality in the "*Tas de charbon*" and the development of this principle in the "*Combinaisons aléatoires de lignes indéterminées*" and the

"Accidents", the whole immobile, unchanging, fetishistic concept of sculpture was called into question. The provisional installations made by many young artists today are proof that this organizational possibility can be of real interest.

CM: Is the number of bars you use in the "Accidents" predetermined? Could someone other than yourself initiate their collapse?

BV: The quantity of bars, like their length and thickness, varies in keeping with the space that is available. This principle is what makes this a work of art. It goes without saying that, providing this basic rule is kept, anyone could make such a work. I have tried this several times with my assistants, and they always achieved the result I was looking for.

CM: I have always thought that it must have taken just as much courage for you to start working again as it did to stop in the first place. Can you tell me what factors were uppermost in your mind when you made these decisions? Theoretical motivations, a desire for self-mastering? Or self-abandon to more obscure and subjective reasons, or, yet again, the reaction to an unanticipated event?

BV: You do things because you have to. Actions that seem radical or risky may just be the result of deep convictions. Some see courage where one is merely following an internal logic. I was not in a mood to please or flatter. But, I was not trying to shock, or play the provocateur either. Some saw my decision to put an end to my artistic activity at the age of 29 as a kind of suicide, others as the sign of excessive self-confidence. For me, of course, it was a completely different matter. It was not a question of taking a calculated risk—I never thought in terms of risk. It seemed clear to me that, having developed an *oeuvre* with an essentially theoretical foundation, in what one might call a "rational" direction, I had no right to bring in subjective elements and indulge in infinite variations. This was the antithesis of Matisse's "pleasure of painting": I was obeying a logic, a discipline that imposed this break on me.

Without that six-year hiatus, I could never have made a fresh start at the end of 1976. For six years I did no work, but I thought, asked ques-

tions, and learned to relativize the value of the rational approach. It was not easy to start working again. I doubted my capacity to produce an oeuvre that would be worthy of interest. During the early months, I refused to show my new pieces and it was only when Jan van der Marck invited me to take part in the Kassel Documenta in 1977 that I decided to exhibit. My return to artistic activity was not without its difficulties and hesitations, the doubts I have emphasized. But it was a matter of personal equilibrium. It wasn't logic that made me do it, but my nature: an imperative need to act. I was again, you might say, "viscerally conditioned".

CM: In 1988 you wrote a ballet based on an original idea from many years earlier. One of the more surprising features of this was the first "all-over" performance of this kind.

BV: When I produced "Graduation" as a commission for the Paris Opera, I was able to adhere fairly closely to the project I thought up in 1966. I had saved all the *maquettes* and all the instructions I needed to keep me from straying too far from the original concept. The choreography was very simple: four dancers in red leotards moving on a perpendicular construction, a metal grid that took up the entire height and width of the stage. Their movements on this structure described geometrical figures which simultaneously were permanently recorded by means of a rope that followed each dancer and traced his or her movements. The music played by the orchestra obeyed a number of simple rules that I defined beforehand. To put it simply, they echoed the ascending and descending movements of the dancers. Each of the dancers had his or her own specific group of instruments (strings, woodwinds, horns). The music was the direct consequence of the movement of the dancers, who were like notes on staves. The deepest notes corresponded to the lowest level of the grid, the highest to the topmost level.

CHOREOGRAPHY

I didn't have to make any major changes, the overall plan was respected. I did however line up three grids, which was not in the original project—three perpendicular planes, to add complexity to the choreography

"Improvisé - Inachevé - Non-formulé", exhibition-performance at the Mücsarnok Museum, Budapest, Hungary, 1999

of the final scene in which, because the grids were transparent, you could see the three layers simultaneously, with arcs on the rear plane, angles on the middle one and indeterminate lines on the front plane. My sober minimalist choreography, in which the dancers moved vertically across grids rising from the proscenium, manifested my rejection of the classic scenic space, its traditional horizontality and its dependence on the laws of gravity.

CM: Sculpture is an art which makes real physical demands on the artist. You have been known to work in public, in a kind of performance. This is a long way from conceptual art.

BV: When I did *"La Ligne à vif"* (Live Line), the performance you are referring to, at the Daniel Templon Gallery in 1990, I was trying to give my work an extra dimension. I was interested in the idea of grappling with material as an artistic act in and of itself, irrespective of the desire to make a "work of art". I was trying to integrate my action, my work with line, as a full-fledged art element. What this activity made visible were the movements of the artist in their intimate relation to the materiality of the steel and its physical laws. I was interested in all the visual characteristics of this work, as well as in its acoustic features resulting from the use of grinding wheels, blow-torches and sledgehammers. This activity, which I refuse to call a "performance", had a precedent in a much earlier action, the one I did in 1961, when I was photographed sprawled amidst garbage containers. I wasn't trying to create an object then either, but to propose a parallel with other floor works of mine and to see how far I could push the limits of how an artist is supposed to behave. I was doing my military service in Tarascon. The Brass had provided me with a loft where I was completely free to get on with my art. So, I had this huge studio where I stored piles of packing cardboard, drums of tar and all kinds of material with which to make my paintings. I knew these were the unsettling days of the war in Algeria, where I was transferred a few months later. No, I wasn't out to make a symbolic gesture with anti-war connotations; it was more a question of making manifest the context in which I worked, of establishing a relationship between the action and my visual work, particularly certain photographs of waste and my first paintings which were made of tar dripped over assemblages of torn cardboard. The idea, in the early '60s, was to reverse values, to criticize the conventional, aes-

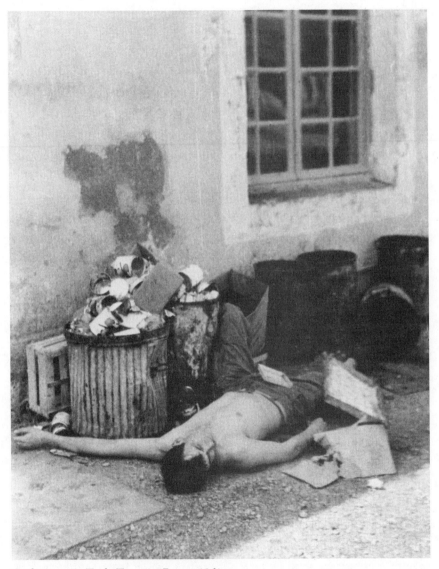

Performance in Trash, Tarascon, France, 1961

theticizing practices of the School of Paris. In retrospect, this action seems clearly related to the pragmatism and literalness of the work that followed it. Again I am referring to the *Tas de Charbon*, to its character as an "experiential fact". There are also formal relations that connect this action to the economy of means, the idea of pilling things up and the severity of the materials used in other later works: tar, cardboard, rusting scrap. I'm thinking of the *"Combinaisons aléatoires de lignes indéterminées"* and the "Accidents". There too you find the same principles of disorder and dispersion, as well as two essential parameters of the new work: gravity and entropy.

CM: Some of these works, particularly the "Accidents", can be described as "action sculpture", by analogy with action painting?

BV: I thought of this idea of "action sculpture" the day I made a model of the first "Accident", but I never made an explicit reference. I prefer to think about new things to say rather than things that recall the past. That job, the game of building historical relations, is better left to art historians. As you know, a true artist should be a potential murderer of symbolic fathers.

CM: Oddly enough, after going further and further into three-dimensionality, your more recent works, the *"Surfaces indéterminées"* (Indeterminate Surfaces), mark a return to the plane.

BV: The first *"Surfaces indéterminées"* was made in very thick plywood covered with graphite. When Donald and Mira Rubell asked to buy it, in 1980, I preferred not to sell, even though theirs is one of the finest collections in New York and Miami. At that time I saw it as a "one-off" experiment. I thought I might come back to it later, but just then I wanted to concentrate on lines. Starting in spring 1989, to see how far I could take my work on indeterminacy, I made a whole series of works to which I gave the name *"Possibilité d'indétermination"* (Possibility of Indeterminacy). These were thin lines of various sizes cut out of steel, which I fixed to the wall in parallel patterns so as to form a chopped-up surface that I had defined beforehand. The most recent reliefs were done in 1995. They are roughly cut with a blowtorch from 35 mm thick sheets of steel. I had to be careful when

I started this work, because it would have been easy to fall into the trap of making free forms in the manner of Jean Arp. I think I avoided it by using the nervous, staccato action of certain *"Lignes indéterminées"*, and by highlighting the effect of surface saturation created by lines that touch each other.

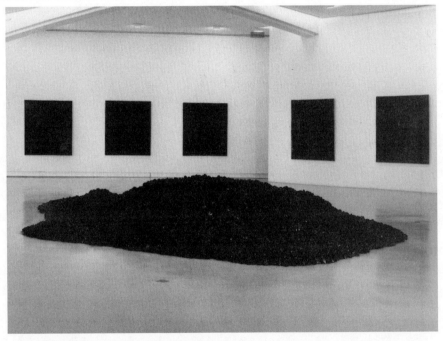

"Coal Pile", 1963, no specific dimensions, installation at the Museé d'Art moderne et d'Art contemporain, Nice, France, 1993

"La vie est une permission de la mort"
(Life is a Leave from Death)

Bernar Venet

Peinture de jeunesse... and an occasion to express my extremely personal perception on the eternal state that is death.

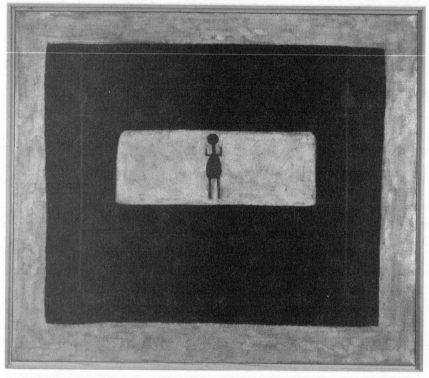

"*La vie est une permission de la mort*", 1959, oil on canvas, 43¼ x 51⅛"
Collection of the artist

I painted this picture in 1959 while I was living in Nice and earning a living as a stage designer at the Opera. The painting is characteristic of a group of works from 1959 and 1960, among which the earliest were strongly influenced by Paul Klee. One of his works in particular, *Extase* (Ecstasy) from 1939, especially impressed me. I found the mysteriousness of its symbols fascinating. The inaccessibility of this language, so different and hermetic to me, born from the imagination of a true creative genius, made me realize how utterly incapable we are of attributing an exact meaning to a work of art.

Other paintings of mine have titles like "*Tombeau*" (Tomb), "*Vie*" (Life), "*Christ en croix*" (Christ on the Cross), and "*Identité*" (Identity). These are precisely the works I chose to exhibit in January 1961 along with some more realistic drawings at the Centre Récréatif in Saint-Auban, just before I left for the army.

"*La vie est une permission de la mort*" is a very sober painting, free at last of Klee's influence, although it still is full of symbolic content. In the central figure, I represent myself fixed in a confined space (life), itself enclosed in another, much larger space, painted black, which represents the

infinite void.

I was about 18 years old when I painted this, an age when we question things and try as best we can to find answers to religious and metaphysical problems, among others. Here, it's the meaning of life, the unavoidable nature of death.

With this painting I was trying to express that life was an accident, a passing whim in "our" non-existence. While we all think life is indisputable and normal, death is unacceptable to us. And yet the reality is different; from the point of view of the physical universe, it's life that's an amazing and improbable event, while death is nothing but the return of our atoms and molecules to their normal physical state of existence.

With "*La Vie est une permission de la mort*", I realized that we have an unavoidable destiny: non-existence. This meant accepting that "our" atoms return to a different activity, one that's closer to what they'd undergone before "us," during a span of time that measured by our own modest scale seems infinite.

Translator's note: the title of this painting implies a metaphor, "une permission" in French being equivalent to a "pass" or a "leave" from military service.

Cézanne did not have to study botany to be able to paint the pine trees of Mont St. Victoire

An interview by Françoise Gaillard

Françoise Gaillard has been a good friend for many years. She teaches Philosophy at New York University and at *Université de Paris-VII*. During the summer of 2001, she spent a week at our home in the south of France while I was working on my first series of mathematical wall paintings.

Françoise is a true intellectual. She raises questions about every subject and tends to analyze all ideas.

This conversation imposed itself almost instantly and became my first attempt to put into words what I was trying to achieve in my studio.

Françoise Gaillard: Your most recent works consist of large flat col-
ored surfaces on which mathematical formulas, complex equations, and
astrophysical diagrams are stenciled in black. For someone who has followed
the development of your work since its beginning, my first question is
unavoidable: you have always favored spareness and austerity and have even,
in different interviews I recall, reminded us, in no uncertain terms, of how
little you relish color. Yet now, you are using striking yellows, blues, greens
and pinks. True, in the early 1960's there were your laminated cardboard
reliefs uniformly covered in automotive paint.

Bernar Venet: Basically, I am not a painter and I don't believe that I'll ever
be one. I don't think like a painter. There has never been an emphasis, in my
work (with the possible exception of that of my earliest adolescence) on
color's nuance or expressiveness any more than its symbolist potential. If I
use color today, it is because I conceive of it as an arbitrarily chosen signifi-
er. In that sense these new "figures" relate somehow to the cardboard reliefs
of the years 1963-1965. They were painted, factory-style, with a spray gun,
because I was dead set against tactility, subtle nuances, clever color mixes

and chromatic relationships. I was so indifferent to their colors that I allowed for the possibility of their being replaced, one day, by other colors.

Today, when preparing for an exhibition, I generally limit myself to one color only. You won't see graphic representations on red, blue and yellow lined up on one wall because I want to avoid such chromatic effects as might interfere with the act of looking and take precedence over the diagram or equation presented. In principle, the whole exhibition is painted in one color, but, if I am given more than one room, then each room may have its own color.

FG: Color, in your work, has no expressive function?

BV: That is correct. It is a mere background which, incidentally, is painted each time by either my assistant or housepainter contracted for the job.

FG: Don't you worry that, in spite of it all, people suspect your making concessions to some form of aestheticism and that they will slight you by saying, "Hey, Bernar Venet plays fast and loose with the notions of austerity and radicalism and he, too, is out to flatter the eye of the public?"

BV: Not really. I admit that my using color could make you believe in my wanting to seduce, but one good look at my new diagrams will show you how weak their seductive powers are, their colored backgrounds notwithstanding. In fact, the colors I use are rather violent and aggressive: lemon yellow, turquoise, vermilion. They are provocative to the point of disturbing the viewer. My most 'difficult' works (those that resist the eye the most) are the ones that give me the greatest satisfaction.

An artist addresses but a small public and does not seek immediate acceptance. In fact, is he obliged to address a public? No matter what public? Specialized or not? I am not so sure. The artist works to discover. He carries out pure research of sorts and finds satisfaction by exploring what never had been conceived before. I know too well that the public, even an informed one, understands and appreciates only what it knows already or, in other words, what is already part of its culture. Hence, the artist's main concern is to shatter the boundaries of that culture. In doing so, he risks rejection. When I was producing black tar pieces at the age of nineteen, I had no

"Related to: The Mayer Victoris Sequence of a Proper Triad", 2001, acrylic on canvas, 78½ x 54 x 75"

intention of pleasing bystanders. As for the mathematical diagrams (of the late '60s), my studio doors remained shut for many years, even today on occasion. The same holds true for my charcoal piles. Everyone gave me the cold shoulder about this kind of work.

Today, I use color but I have not conceded a thing to accommodate the public. My "figures" present the same type of austerity as did my early diagrams. Color does not change them much. Besides, why should austerity and rigor be associated exclusively with black, grey and brown?

I have elected to use color for reasons that have nothing to do with a concern to please. As a rule, gallery walls are white. Colors' basic function is to make my "figures" jump off the wall. By choosing a background color, yellow for example, their visual impact is that much greater than if the wall had been left white. Their signifying effect is ever so much stronger. It makes the viewer understand that he is confronting a work of art and not just a piece of informative writing.

So, in short, I don't believe that my work has the power to seduce. Besides, you only had to see the reaction of people faced with the works in my last two exhibitions, at Rio de Janeiro's *Museu de Arte Moderna* and at Cajarc's *Centre d'art contemporain Georges Pompidou*. They were, for the most part, completely lost, skeptical or perplexed.

FG: You mean that the public which knows you for your sculptures, becomes disoriented when faced with those new "figures?"

BV: You know, there are several publics. There are those, quite familiar with contemporary art, enthused by being in the presence of something different that may well enrich them. But then, there is a whole other category of people who have no inkling of why, in a place customarily reserved for the display of works of art, works like these should be passed off on them. Those who give it some thought are known to have reached the conclusion that these works must be the preliminary studies or technical calculations for the sculptures exhibited, in some instances, on the outside of the galleries.

FG: In talking about your new works, you often refer to them as "those things". Could you explain, with more precision, what they are?

BV: Indeed, if I use the expression "those things," it is because I am dealing with relatively new aesthetic premises for which I have yet to invent a proper name. Let's say, to not loose time, that they are "formulas", "equations", and often "figures" drawn directly from books on mathematics or astrophysics. Some are a bit more formal than others but all of them demonstrate the highest degree of abstract thought.

FG: Why do you choose to work with equations, graphs, scientific formulas, in short with what you refer to as "figures" that, I stress, do not have the slightest connection with the figurative whatsoever?

BV: I choose mathematical symbols for very precise reasons, reasons that related directly to purely artistic issues, particularly those issues relevant to problems of a work of art's identity and specificity. It is a known fact that, in the '60s, I developed a body of work, referred to as "conceptual," that employed mathematical language and symbols. Today, I am returning to that chapter of my past in some way, but with different ambitions. Should you ask me why I made that choice, then I would answer you that I am dealing with a radically new language, with a system of signs propounding hitherto unexplored or deliberately sidelined formal and conceptual structures. The novelty and the unknown I am forced to face suggest that I am finding my bearings in an area potentially much richer than those with which I am all too familiar, i.e. the figurative and the abstract. All those variations artists are now making on Marcel Duchamp's "Bicycle Wheel" strike me as much too easy. Moreover, instead of sticking to one isolated object, whole department stores now find their way into the museum. True, one gains in terms of spectacle and that may appeal to those curators fearful of loosing touch with the latest developments and a public hungry for distraction. They are familiar with the points of reference and do not balk at making an intellectual effort.

 Now why, within this language, do I choose one "figure" over another one? Let's say I am drawn by what sets itself apart the most from that to which I am accustomed. I do not use, for instance, "figures" bearing the slightest resemblance to my past geometric pictures. What interests me is their radical newness, their original character, their difference from what preceded them, and, of course, the conceptual inferences bound to be drawn from them.

FG: You insist on what differentiates your work from that of other artists, notably the conceptual artists of your generation. And yet, someone ill-informed could easily imagine your having gone further down the road pioneered by Kosuth. Instead of substituting the actual thing by its definition borrowed from the dictionary, you decided to present us with its scientifically framed analogue. I know that I may be wrong in drawing this parallel but how do you conceive of your work as being original?

BV: I am struck by your bringing up the example of Kosuth and this may be the right moment to straighten out a longstanding and extremely annoying historic confusion. Thirty years later, a mess has been made of the facts. How can we overlook Lucy Lippard's authoritative *Six Years: The Dematerialization of the Art Object (1966-1971)* in which she treats historical fact with the precision of an objective and well-informed witness. Let's not beat around the bush. Not only did Kosuth not realize that series of triadic representations of which "One and Three Chairs" is the best known example before 1969 but he was well acquainted for my having shown him in 1967, photographic documentation, with the origins of my conceptual work, that is with the "Tube" exhibited at the Museum of Céret in the summer of 1966, a piece of bakelite pipe accompanied by its framed technical drawing and details.

There is no doubt that Kosuth is a good artist who merits the recognition his work has received. But we should stop treating American artists, blindly and systematically, as models for their European counterparts, certainly when the opposite is demonstrably the case. Moreover, Joseph has often tried to advance the idea that what I did had nothing to do with art. One should further know that Filiberto Menna, in an early study of my work, pointed out that my theoretical position, as a result of the denotative particularities of the mathematical language, diminished the relevance of that of Kosuth as he remained dependent on connotation and polysemy. That must have bothered him to the point that he retorted, as if in self-defense, "Mathematics is mathematics and art is art. These two areas have nothing in common."

To explain the naivety of those who think they know what art is, where it begins, where it ends and where its limits lie, I often cite the following example illustrating the problems that have confronted me since

1996: Let us imagine that for religious, ideological or other reasons, figurative art had been taboo since the beginning of time and that all art people knew was abstract. Under those conditions, one fine day, an artist with more guts than his colleagues invites a friend to visit his studio and shows him what he has just finished painting: a very realistic portrait of his wife. The friend, surprised, but unaccustomed to seeing that kind of subject committed to canvas, gives the artist a friendly slap on his back saying, "Listen, what you are showing me there has its merits and it is even original, but, my dear fellow, it is not art... it is your wife." That anecdote shows us to what degree we are conditioned by our cultural references, by what we have learned but also by our abiding beliefs. We know all too well what art is and we find it difficult if not outright unacceptable for an exceedingly extraneous element to insinuate itself. It is a well known fact that the pioneers of twentieth century abstraction were victimized by such reactions for a long time. And before them Picasso and Braque when they began painting in the Cubist manner. Other examples could easily be added throughout that century of visual experimentation.

I have had many opportunities to tell that story in an attempt to convince art lovers to accept my diagrams as legitimate and integral to the field of art. Numerous were those who slapped me on the back with indulgent disbelief. Numerous are the ones who have yet to be convinced. But is it really necessary to convince them?

FG: But, those scientific diagrams, you paint them on the wall. You cannot claim to be merely interested in the abstract quality of a mathematical language. I also notice your sensibility for the beauty of its writing, or, if you prefer, its graphic quality. True?

BV: Absolutely. You might compare it with the era of Constructivism or that of Concrete Art when the introduction of geometric forms led to a radical renewal of established esthetics.

The world of mathematics interests me because I discover in it an original language, that of the symbols and the formal structures marking those series of equations. We are dealing with a visual proposition very different from all those put to the test before, and I am currently attempting, by having recourse to a language so rich in potential, to develop a body of

work that will claim its own identity.

Our reaction to the beauty of those symbols and to that of their visual presentation in specific mathematical terms, is a highly subjective one. They appeal to a taste for a non-expressive, detached type of beauty. Granted that one has to get accustomed to these new works, as their formal interest is not immediately clear. True enough, whether we liked or hated mathematics in school has a lot to do with how we look at mathematical equations now and, either way, we'll have trouble appreciating them for their aesthetic value when we rediscover then on the walls of an art gallery.

It is worth noting that, generally speaking, the introduction of a new language has the advantage of altering the way we look at art. We are no longer talking of a subtle variation of existing formal and conceptual principles of operation but of their total replacement. True enough, there are artists capable and content to make works that visually resemble those of other artists even as they remain faithful to their own mode and idiom. Works, one might add, that manage to hold on to their original concept.

For a long time I have had this odd wish to organize an exhibition reassembling paintings by different artists whose outward features would show a superficial likeness but whose content could not be more different one from the other. Such an exhibition could include "White Square on White Background" (1919) by Malevich, an all white composition of 1930 by the Polish artist Stazewski, one of Bob Rauschenberg's white paintings of 1951, a "Monochrome Blanc" (1957) by Yves Klein, an "Achrome" (1960) by Piero Manzoni and a Robert Ryman of the early '60s. Other important works like Barnett Newman's "The Voice" (1950) and Ellsworth Kelly's "White Angle" (1966) might add further scope to the comparison.

I think it would be interesting to present these works which, to an untrained eye, resemble one another despite differences in format, all in one gallery. It would be necessary to accompany an exhibition like this with a catalog or wall panels analyzing each work in detail. This reflective enterprise would have the distinction of defining the originality of the various approaches, different for each artist, and it would reveal the level of critical subtlety required to articulate, however tentatively, meaning when we speak of art.

In all of this we should pay homage to Malevich and acknowledge that the date of execution of his painting is of capital importance. The

courage it must have taken to challenge his colleagues with such a radically innovative picture cannot be underestimated and makes "White Square on White Background" a milestone in the history of art.

A radically innovative formal statement always goes hand in hand with an argument people have not heard before. Different frameworks of thought occasionally allow for the development of works whose visual appearance holds no surprises. Those works, in most instances, are but a stage, an aside or a wink, yet certain artists, unfortunately, settle for them. How many artists today produce monochrome paintings? In the hundreds, I bet. They think of themselves as radicals, somehow, but most of them have hitched their wagon to a new academicism. Each one of them will tell you that his or her work has nothing in common with that of other artists, that the idea is not the same and that their technique is different. The argument runs as follows: my colors are more or less thickly applied, they are more or less glossy, mine have sand in them, are wax-based, use chocolate or pollen or whatever. That does not diminish the fact that an artist, who paints canvases uniformly covered with a single color or a single material, owes a huge debt to those who opened the way for him. Producing variations is within the scope of any art student, unrestrained admirer or even those ignorant of the masters who hold them hostage. But let's remember that the pioneers themselves never would have been caught showing excessive respect for received ideas.

FG: Mathematicians, astrophysicists are not impervious to the aesthetic dimension of their work. They love to talk about the beauty of an argument and by that they mean the economy and elegance of its demonstration. Are you not outdoing the mathematicians and their concept of beauty by adding your own concept of the beautiful graphic representation in which the argument can be wrapped up? Do you not feel that you are returning to those scientists, in a palpable form this time, the very abstract and invisible beauty of their creation?

BV: You are answering your own question and I do not know what I can add to it. It is true that there is a mathematical beauty. It springs from the simplicity, immediacy and purity of a formula reduced to four symbols. One can find it articulated to perfection in Albert Einstein's $e=mc^2$, a formula that

encapsulates one of our universe's fundamental laws.

In my work I am rather fascinated by the rich content and economy of means of the equations I choose. True, I often think that each of my paintings is an equation of sorts and that it reaches masterpiece status when the perfect synthesis is achieved, between the idea and its plastic solution, with no imperfection remaining in the close relationship between concept and pictorial rendering. But in reality, and I repeat myself, what truly interests me is to open up, as much as possible, the field of art to new propositions that are visually original.

FG: Even though your latest works fall within the perimeters of the curves, graphs and equations of the 1960's, they come across as less austere. Urgency and radicalism are still high on the agenda, but their maker seems more relaxed. Is this, perhaps, a factor of his maturity?

BV: You are right, of course. That started to manifest itself in 1976 when I began to seek some distance from the purely theoretical work of the conceptual period. At first, I cautiously introduced certain material effects in my pictures that were still rendered in black and white. Then I accepted the fact that my reliefs adopted a greater freedom and that their compositions did not need to be so rigid. In fact, I sought to liberate myself, to open myself up to other possibilities without abandoning the context in which my work operated, which came down, to be precise, to a reflection on the nature of the line in art. I took those liberties in large part to call into question my thought processes during the conceptual era. In this manner I arrived, in recent years, at the point where I could introduce the elements of chance, complexity, indeterminacy and above all, unpredictability as in "Accidents," the spontaneous collapsing, domino-style, of iron bars leaned against a gallery wall. More and more, I had to overcome the self-imposed constraints with which I started out. Constraints, by the way, I do not regret because they bought me the time I needed to advance my research and today I owe them my ability to push forward on the same road without too much of a risk of repeating myself.

In my view, a true artist is not the one who, having discovered a style, spends a lifetime making good use of it as one would of a lode in a gold mine. Rather, he is someone grounded in a strong conceptual matrix who

seeks to explore its riches by often complex and uncertain roads. It is the overall concept that confers on a work its true identity, comparable, in the field of mathematics, to the all-encompassing demonstration referred to as a "major equation."

FG: Passing from sculpture, which implies a corporeal relationship to the material employed, to these abstract formulas, is no easy feat. One might even call it one hell of an adventure.

BV: It is in this field of opposing forces that I find the energy to persevere. I savor the intellectual discomfort derived from calling into question the very things with which I was beginning to feel comfortable. This should be kept in perspective though for I never abandoned the context in which my work developed. If there is a break, it occurs on the level of form only and in terms of the general concept one hardly would have noticed it. The adventure you referred to is a sort of liberation from what used to be the foundation and point of departure of my past work. It is also a constantly going back and forth between earlier and later work. For instance, I have worked simultaneously these last years on different subjects in order to develop them in a new way. Making sculptures like the "Indeterminate Lines" was no reason for me to abandon the "Arcs", "Angles" and "Straight Lines." Those subjects reoccur on a regular basis as long as I perceive a way in which to further their evolution. It also deepens our experience of them and lends greater evidence to what I seek to demonstrate about their true nature and overall potential.

FG: Even though you have returned to equations, diagrams and figures of that nature, can it be said that, at this moment, you have reached an intellectual comfort level with the visual aspects of your work?

BV: In the process of drawing my subjects from books intended for specialists in those fields and then introducing them to the field of art, I effect no real change on the visual level, but in terms of meaning, everything changes. That aspect is still difficult for me to put into words or to differentiate, in a precise way, from the works I made in the '60s. Though it is too soon to draw conclusions, particularly since the new work still is in its devel-

opmental stage, one can take a stab at analyzing the difference between those earlier works and the ones I am doing now.

Could one not claim for instance that after my so-called conceptual period (1966-1970) and in the wake of six years of self-imposed inactivity, it was the visual elements embodied in my diagrams of the time that truly constituted a new beginning? I am thinking, in particular, of the straight and curved lines, but also of the dots as in "Magnetic storms and associated phenomena" (1967). One should add the arrows which, later on, spawned a group of wall reliefs entitled "Random and Divergent Trajectories."

I was headed, at that time, in a more physical direction and it showed in more aggressive materials and bolder dimensions. Thus, following the 1976-1978 paintings, my wall reliefs in painted wood initiated a formal vocabulary that was given full reign in my three-dimensional sculptures, specifically in their monumental application as in the 1986 "Sharp Angle of 19.5°" in Austin, Texas, and, in its wake, the "Arcs" of Berlin, Nice and Geneva, as well as the "Indeterminate Lines" at La Défense in Paris and in San Francisco. I am currently working on my first gigantic "Straight Line" in steel, intended to be placed against the Arc de Triomphe in Paris. As far as my recent mural paintings are concerned, I have abandoned those linear subjects in order to concentrate on the more abstract equations but also on language which, after all, was a component and visual counterpart to the "lines", "curves" and "angles". The work I am now doing is in the process of taking a turn that sets it apart, quite spectacularly in fact, from those conceptual works. I'm using color, without constraints, and I'm enlarging the graphs, equations and figures to suit the dimensions of the wall. Finally the choice of figures and the way I isolate certain equations differentiates them even further.

FG: In a recent article on your new work, Donald Kuspit emphasizes its innovative character, at once new and adventuresome, even within the context of contemporary conceptual art. I agree that looking at those colorful figures, one does not get the impression at all that they echo the late '60s. To the contrary, they strike the viewer as being ahead of their time. That is what renders them more interesting, in my eyes at least, than what is being done in video today.

BV: You are a bit harsh now. True, video has become, along with pho-

tography, a fashionable medium in which innovative content is often lacking. But there are exceptions and I myself am a fan of video which is about to take off in earnest with "virtual reality." There is no doubt the danger of overdoing the special effects and veering away from real-life experience. But we must trust the best artists in that medium to hit the right note. Often, when given a chance to express my opinions from this or that lecture podium, I ask my audience what distinguishes an artist from the person engaged in an art discipline? I am well aware that there are people out there who practice painting in a fully professional way, with a real commitment to their craft and an agenda of exhibitions. The world calls them painters. There are other who practice sculpture with the same seriousness and devotion to their métier. The world calls them sculptors. But neither category necessarily qualifies as artists. Why? Because it is impossible to detect in their work that transcendent insurgency of calling art history's received wisdom into question. They quite simply paint pictures or make sculptures and that activity satisfies them. They broadcast and popularize the discoveries made by the true creators. Often, they make them more accessible through embroideries and variations for which the original artists lacked time or motivation.

Nothing comes from nowhere and certain influences can be very constructive. But often it is through reaction, in a rush of confrontation, that ideas emerge. For example, in 1961, on the threshold of my career, I was, of course, aware of what Yves Klein was doing. My own work with tar deliberately challenged Klein's which, at the time, I considered too idealistic. The differences between our worlds should be clear to anyone who has taken a good look at the photograph of Klein leaping into space and then looks at a picture, taken a few months later, of the young Bernar Venet, sprawled in front of army garbage cans ("Performance in Garbage", 1961). In contrast to Klein, I opted for gravity and solid matter. Accepting the laws of nature, my gesture was pedestrian, pragmatic and non-illusionistic.

The fact remains that I owe Klein for having opened my eyes to a broader field of artistic endeavor and for having challenged me into identifying my own means of expression. He enabled me to develop my ideas in the realm of the pictorial but also to stretch those ideas so they encompassed the neighboring disciplines of sculpture, photography, performance and music. The great contribution of Klein, whose influence on my work between 1961 and 1963 is evident to me now, is having introduced the

notion of "artistic context", best explained as going beyond the single and the unique to make a statement that is universal and all-encompassing. Yves Klein was an artist even before being a painter and as such he interested me.

FG: There is really no method for grasping the new, is there? One cannot even imagine it, right?

BV: Should one wait for ideas to come uninvited? Can one prompt their arrival? Do they just chance in our direction or do we discover them while working? There is no rule or method and but little hope for those who do not set their sights high enough.
 Our objective should be to call everything into question and to understand that one does not stand a chance to create something of interest if what one has made resembles what one already knows. On this subject I can tell you an amusing anecdote going back to my youth in Nice. The subject is yet another celebrity artist from that city now living in the remote countryside. We are talking about the early '60s when I was full of doubts and questions. So he asked me how my work was coming. I answered that things were difficult, that I was not too sure where I was headed. He shot back immediately, "Well, you know, new ideas do not come by themselves... with all that has been created already, one has to squeeze the hell out of the lemon to get a single drop!" To which I retorted: "No, I don't agree, you got the wrong method. Try changing the lemon!"

FG: And was it by choosing the language of mathematics that you "changed the lemon"?

BV: At least that is what I tried. My lemon, at the time, was perhaps still a little too green. In any event, the public, for its part, was not ripe either. It is fair to emphasize though, that when I began to develop a body of work derived from mathematical texts and diagrams, I embarked, without any doubt, upon a course never associated with art before.
 Intuitively attracted by this new language's unexplored potential, I put forward a hypothesis. It dawned on me that here something was possible that no longer functioned in those areas already explored by figurative and abstract art. On the level of content, that change of direction forced me

to think in a new manner and to figure out how, on these different foundations, works of art still could be built. I was going to have to avoid numerous traps, including that of making concessions to past aesthetics. It took me five years to grapple with that.

FG: One cannot say "look there, a crescent moon!" Monosemy gives the imagination little leeway.

BV: At least she tries. Actually, and in general terms, each work of art conveys ambiguity: the same work can be described several ways, each one different from the other. Each enunciation or treatise is open to several interpretations. We are dealing with the essentially equivocal nature of the work of art. Abstract art won a great victory when it abrogated issues such as identity and subordination. Finally, a painting was no longer a copy of nature, a rendering of the human body or, as in ancient times, a representation of the divine being. It became non-referential, non-analogous. We owe this new-found freedom to the great pioneers of Abstract Art, active between 1910 and 1920. It was a little later, though, around 1930, that this visual emancipation reached its first theoretical peak in the paintings and theoretical writings of the Polish artist Strzeminski. He is the author of monochrome canvases and texts that are as fresh and challenging today as they ever were. A former student of Malevich, he managed, in a masterly fashion, to go beyond the confines of Constructivism by presenting the world with paintings whose unique subject was a single color applied in a uniform manner.

In the United States, Frank Stella's "What you see is what you see" has often been quoted as the Minimalists' creed. Donald Judd, even before them, attempted to attain that level of pure autonomy with his "Specific Objects." The solution I have proposed with my mathematical diagrams finally put a stop to the interpretative game: forget about imputing symbolic meaning to the colors (mostly black and white) and forms (geometric) in my vocabulary! By introducing monosemy (subjects with one possible meaning only), I was able to raise the stakes of abstraction and solve the problem of identity: the work of art and its subject become one.

Allow me to bring up Filiberto Menna once more. In his book, *La Linea Analitica dell'Arte Moderna* (1975), the author argued that, in order to avoid all semantic ambiguity, all stratification of meaning, I had abandoned

polysemy in favor of monosemy in my work. How did I do that? By using exact and highly formalized codes which made it possible for my work to rise from the level of connotation to the no longer subjective level of denotation.

FG: And you have thereby contributed to broadening the field of art?

BV: I have done what I could. It is not up to me to answer that. It is better to remain modest, dissatisfied, prudent, for it is up to future generations to judge us. Thirty-five years later there is still so much reticence and incomprehension about my work, I feel. That work was and remains very difficult... It is not enough to have the bright idea: "Mathematics has never been the subject of an art proposition, so I am going to do it." That type of thinking has no place in a creative process that wants to be taken seriously.

One often hears it said that everything has been done, that the history of art has reached its limits, that there is nothing left to discover. Courbet already thought that way and never tired of repeating it. My answer would be: if, indeed everything that has been made can no longer be made, then everything not yet made remains to be made. History changes only at the level of grand concepts. Stop to think for a moment what was recognized as being art in the 19th century and compare that with what we recognize as art today. If Cézanne, the most advanced and visionary mind among the painters of his era, were to visit one of our contemporary art museums, he would not be able to make heads or tails of it. One therefore has to expect changes of definition, such mutations of meaning that the vocabulary in which we talk about art today risks being outdated, inadequate and nonsensical tomorrow. So much remains to be conceptualized and a lot of artists are going to knock themselves out to do it. Pity those who, bogged down by intellectual laziness, content themselves with the comment, "all is well today, nothing new to report."

FG: I detect, in your case, a more outspoken interest in the intellectual than in the sensory. That may be paradoxical for an artist but at the same time we know that it is by overcoming paradoxes that major works are produced. It strikes me that the world interests you not as a palpable reality but as a challenge to the intellect. And I believe that what you always have liked in mathematics is that it shows you a way in which to intellectualize the

world. It is no coincidence that in the late '60s you chose to exhibit meteor-ological charts. Geographical maps, by comparison, are analogous in charac-ter as the eye recognizes the familiar contours of coastal areas, for example. I ask myself if the real challenge for you has not always been to find the means with which to translate into a three-dimensional language the intellectual connection you entertain with the world?

BV: You hit the nail on the head. No one has ever put it to me that way. I feel it intuitively. My preference goes to a form of abstraction that reduces everything to an analytical proposition. I remember the day, in 1967, when for the first time I clipped the meteorological chart from a copy of *Le Monde*. After all, I thought, that was just another way of presenting a landscape. But a landscape reduced to objectively verifiable data. At that moment it became evident to me that my work's most interesting feature was its deliberate sub-stitution of sensorial and empirical knowledge by purely analytical knowl-edge. I have also presented, following a similar line of thought, financial graphs from *The Wall Street Journal*. This kind of subject was a far cry from what we were used to at the time. The Stock Market as a source of inspira-tion, a subject never broached before, interested me because it was so far removed from what is customarily defined as art's proper province. By every-one's reckoning: cold, objective and non-poetic.

FG: Mallarmé wanted the world to end up in a book. You would like to see it reduced to mathematical formulas with a potential for art. That sets you apart from all currents in the history of abstraction.

BV: "Setting me apart" is just one way of putting it. In point of fact, I now put myself totally outside the abstract mainstream. Those new works are as far removed from abstraction as they are from figuration. My work functions in another category, a proposition the pertinence of which I still have to demonstrate in an arena that until now excluded it. What fascinates me in the works I am doing, is the degree of abstraction of their symbols and of the equations I put upon the wall. This type of abstraction has nothing to do with what is commonly understood when people speak of abstract paint-ing and sculpture.

If I reduce the world to mathematical formulas as you claim, then

why not to the single formula of which Stephen Hawkins and a few other physicists or genius are dreaming? A thrilling objective as such and an enormous step forward, from a scientific point of view. But is it conceivable? And how much time will it take before that formula proves incomplete or even incorrect?

We know all too well the limits of all those grand theories which subsequently have been shown to retain their validity in a certain context while losing it in a much wider one. It is important to understand the limits of everything the mind conceives. As early as 1930, the mathematician Kurt Gödel sowed seeds of doubt within the scientific community by rigorously demonstrating that from one logical link to another, reason inevitably turns into mockery for sooner or later, it will end up enunciating two theorems that are perfectly contradictory to one another. Such as confirming, for example, that the same object is at once altogether white and altogether black. If science accepts that its knowledge is relative, the first lesson we artists have to draw from it is that we better recognize the relativity and the limits of our ideas, their restricted and temporary character. We should know that even those ideas most opposed to our own fall into the realm of possibility. The history of contemporary art had better be seen as home to multiple evolutionary lines, a framework of sorts that goes off in all different directions. I am reminded of Mondrian, as hard to please as any person who ever lived. He was not prone to smile at his theoretical inflexibility when he wrote a letter to his confrere Theo van Doesburg who had just introduced the diagonal in his work: "After your arbitrary modifications of Neo-Plasticism, all further collaboration with you is impossible for me." The rigor of our aesthetic choices should not lead to a lack of openness and tolerance *vis-à-vis* other people's work. That would have us believe that in art there is one ideal solution and that we are its guardians.

FG: Most artists, no matter the style they have adopted, try to link up again with the sensory world. Even the most abstract ones draw from that world the excuse of a form, the choice of a color, a material they like. You have always denied yourself (to borrow a phrase from Jean-Paul Sartre) that suspicious complicity with things. Your relation to the world is based on the mode of pure thought. That formed the origin of the arcs, the diagrams, the charcoal pile... For we should remind ourselves that the charcoal pile was not

the ingenious display of humble matter we came to associate with the practitioners of Arte Povera a decade hence. In stark contrast, your work explored the effects of gravity on materials, the idea of a lack of form and the concept of indeterminacy.

BV: We know that there is nothing of which we have a total understanding. Setting oneself the objective of getting to know everything about a given subject or phenomenon is utopian and unrealizable. My fascination for those equations and figures whose specific meaning eludes me can be attributed in part to the fact that they are already so charged with meaning in their proper context. They show us the result of the most complex abstract arguments of which the human spirit is capable today.

Is it necessary for me to call attention to the fact that I am not practicing some form of primitive scientism? I have no intention of glorifying science by substituting its discoveries for the biblical themes or religious scenes that for a long time nourished the inspiration of the artists. As with Matisse, an agnostic who designed the interiors of chapels, one can take the position that the choice of subjects is merely an excuse to paint. Even though those painters of religious scenes may have had the wrong idea about the origins and history of the human race (and mathematical figures would have been ever so much more accurate), we should avoid falling into that type of ideological trap.

As far as I am concerned, really, I think that those subjects are worth looking at and merit a place in the field of art, if one takes into consideration, on the one hand, their potential for a new interpretation, and on the other, the visual originality of their formal structure.

FG: What you are saying there reminds me of someone I liked a lot, Roland Barthes, whose singleminded passion it was to intellectualize the world. Artists have often been expected to entertain a sensory relation to the world. You are living proof that that relation can be of a purely cerebral nature as well. But haven't there been artists with an interest in mathematics before you?

BV: Yes, the use of mathematics in art has quite a history. If you want to hear my version of it, I'll give you a quick rundown. After Rodchenko, whose

sculpture, "Construction of Distance," dates from 1920, it certainly was Vantongerloo who conceived of the idea, as early as 1930, to give his sculptures titles like "y=ax^2+bx+18." Van Doesburg's painting, *"Composition arithmétique"* of 1930, also rates as a major work. His influence, no less than Vantongerloo's, on the *Art Concret* artists in Switzerland such as Max Bill and Richard-Paul Lohse, was considerable. Less known is the fact that Paul Klee can be credited with some very relevant writings about mathematical progression in the composition of works of art. After Morellet and Honegger, in the '50s, it was Dan Flavin in the United States who, with his "Nominal Three" (1963), reintroduced the principle of mathematical progression of to a milieu of Minimalist artists prominently including Donald Judd and Sol Lewitt. Mathematics enabled them to trade their formerly intuitive compositional principles for systematic ones. To come up with a new work it sufficed simply to vary a volume's dimensions or to change the coordinates of a line. For me, applying mathematics to form has never held much interest. I figured that a different level could be reached if I were to develop mathematics' purely linguistic aspect. And this is what I have done.

FG: All the same, your 1963 experiment entitled "Recover A Painting's Surface," played with the notion of seriality.

BV: That is true indeed, to the extent that I had set myself the task, on a monthly basis, to paint a rectangular canvas of identical dimensions in a very systematic way until the whole surface was covered. I was using a simple mathematical principle according to which one unit at a time is added to another unit $(1 + 1 + 1 + 1...)$. Flavin and Judd would also apply this system but they varied their additions to read, for instance, $1 + 2 + 3 + 4...$, or utilized the Fibonacci principle of $1 + 1 + 2 + 3 + 5 + 8 + 13$, etc.

FG: And besides, seriality offered an opportunity to get rid of the problem of composition, something art history was loathe to relinquish.

BV: The history of composition is intimately linked to that of painting. After the Middle Ages and the influence throughout the Mediterranean basin, of Byzantine painting history followed a course marked by very distinct changes, the first surge of which could be felt at the advent of the Renaissance.

Leonardo da Vinci's "The Last Supper" derives its power from one of the most convincing compositional schemes in which symmetry is a constituent and essential element of the painting. Subsequently, Rubens' magnificent "Depositions" marked a period in which the asymmetry of their diagonal compositions heightened the subject's dramatic character. Monet's "Nymphéas," even before Jackson Pollock's "all over" canvases, sought to unify the painting's surface. An objective that was attained, albeit paroxysmally, by monochrome painting. There you have the major stages in the history of Western art. I forgot to include the introduction of chance in the works of Jean Arp and Sophie Taeuber-Arp, beginning in 1917. Together they produced their so-called "duo-collages", made from cut-out painted paper squares, dropped on the floor, reassembled as fallen and glued down in that ludic arangement.

From the early 1960's, Arman's accumulation of objects and Warhol's repetition of images inaugurated a new, quantitative approach to composition. In the wake of Minimalist art which centered on the idea that mathematical and serial progression, the so-called "Anti-Form" counterreaction by the likes of Morris and Serra with their cut felt and thrown lead demonstrations, arrived as a liberation. But even as they relinquished control over form to chance, these artists seized control of the spaces in which they worked as never before. The works that I call "Accidents" (vertical steel bars poised for imminent collapse) attempt to go beyond those static floorbound dispersals of the late '60s. How? By introducing the unforeseeable, the unexpected. The collapse, almost one by one, of my steel bars causes order and chaos to coexist, temporarily, in a space I no longer control. The concept put forward here inspired the title I chose for a January 1999 exhibition of my work at the *Recoleta* in Buenos Aires: "Uncertainty as a Working Hypothesis."

Two months later, at the *Mücsarnok* Museum in Budapest, I was given the opportunity to exhibit my works helter-skelter as they has been off-loaded or lifted from their crates. None of them were installed against the walls or in the spaces intended for them. Instead, my "Straight Lines" and "Indeterminate Surfaces" were sitting on pallets and dollies, often upside down, in the midst of an array of lift trucks, hoists and cherry pickers. All museum spaces were cluttered with my works in the kind of disarray that precedes an exhibition's installation. For the duration of this event (an

"Indeterminate Area", 1988, torch-cut steel, 89 x 100 x .8"
Collection of Frieder Burda, Baden-Baden, Germany

"installation piece" if ever there was one), the works remained in place. The equipment, however, was used as needed and returned by the end of a workday but not necessarily to its original spot. Nothing was fixed, nothing was definitive. I offered the museum the unaccomplished as my accomplishment. By playing fast and loose with the rules of the installation game, I sought to challenge the status (or determine whether there was a loss of status) of the work of art under these conditions. In my recent works the issue of composition looses all meaning. It is "off the agenda". Each work has its own structure, and each structure is independent of the others. There is no compositional choice any longer.

FG: All your work aims at wresting art from the problematics of composition as though you feared that a long time preoccupation with composition had inhibited your reflection on form.

BV: That is true. I still recall that day in 1980, working in my studio, cutting out with a saw "Arcs" in a wood-relief, when suddenly a big hunk of plywood fell down on the floor. Its bashed look was so unexpected and its crisp form in such tatters, that I decided to make a relief of it which I called "Indeterminate Surface." That work seemed to fit the pattern of earlier works such as "Random Deployment of Dots" and "Charcoal Pile". I did not wish to pursue that type of work at the time because I was not fully satisfied by the formal result which, for my taste, came too close to some of the curved shapes of Jean Arp. Today, that relationship hits the eye much less but, as it happened, I took my time and deferred to later the further development of those types of work in the expectation of finding more original solutions for their form.

That solution came to me fifteen years later, when, yet one more time, I tried to imagine other variations on the theme of the line. With a felt-tip pen I was drawing zigzags that came ever closer to the confining edge until I obtained a total saturation effect. That experience gave me a glimpse of how I might be able to use these "saturations". By force of insisting, they became surfaces with sinewy and always different edges.

By enlarging them and by torch-cutting their shapes out of steel-plates 35 mm thick and 5 by 2.5 meters in size, I have obtained reasonably satisfactory results. I call the group of works produced in this manner

"Indeterminate Areas".

That solution which flowed directly from a work that had "line" as its theme, satisfied the logic I seek in my working methods. After "Random Deployment of Dots", after "Charcoal Pile", a volume without specific form, and in the wake of the "Indeterminate Lines", I came full circle: Volume as an infinity of surfaces, surface as an infinity of lines and line as an infinity of points. My 1984 exhibition at the *Musée d'Art moderne de Villeneuve d'Asq* took this theme as its point of departure. It included "Charcoal Pile" (volume), "Tar Paintings" (surface), the "Indeterminate Line" (line) and "Random Deployment of Dots" (dots).

FG: Today you expose yourself as much as you expose your work since with those graphs and equations you have moved to the cutting edge again. Are you not afraid of the reaction of the public?

BV: I would deceive you if I answered that I do not have the desire to win people over to my ideas. Yet, if you stop to think how frightfully difficult it must be for the public to be faced with these works cold, then it should be obvious that I do not count, at least not immediately, on its approval and support. With work like this, one knows in advance that few people will show enthusiasm in a hurry. The average art critic will not know what to say about it and the average collector will now know what to do with it. Experience has taught me that when people are confronted with a "difficult" work of art, they tend to reject it. The public rarely accepts that what artists make and do should be open, like a space, to multiple forms of experimentation. It is astonished and loses interest from the moment it realizes that a work of art it is shown has not been executed in adherence to the conventions it knows and respects. Such a work comes across as boring and is quickly written off. People are not accustomed to confront what resists their understanding. They can conceive only of what they know already, art of the past they have seen reproduced (hence respect) but which would have them baffled just the same.

An artist does not fear the reactions of the public. The one who goes out of his way to please the public had better find another profession. In that sense, the artist joins hands with the scientist for whom, when it comes to pure research, there is neither desire, nor value, nor good, nor bad, nor end. They are, in their respective pursuits, free of moral and utilitarian exigencies.

Bernar Venet

Interview by Philippe Piguet

Philippe Piguet often writes on my work. He is a serious and respected art critic with whom one feels quickly at ease.

This interview was conducted on the occasion of the exhibition of my new paintings at the *Galerie Jérôme de Noirmont* in Paris in February of 2001. An excerpt of this piece was first published in the French magazine *L'Oeil.*

Philippe Piguet: While you've continued to produce sculpture over the years, recently you have increased your output with what you call "murals," which are based on mathematical principles. How did this come about?

Bernar Venet: In a very natural way. In 1998, Christian Bernard, the director of MAMCO in Geneva, suggested publishing my collected poems under the title *Apoétiques* (1967-1998). Some were based on the mathematical language I frequently use in my work. Some time after the publication of this book, I thought it would be interesting to reproduce one of these poems on a large scale on my bedroom wall. I clearly visualized a mathematical equation against a uniformly colored background, and didn't wait long before carrying out the work. I was enthusiastic about the radical nature of the result and was encouraged to pursue this idea which already had, in my opinion, the force of a potentially rich statement. Throughout the course of 2000, and thanks to a series of exhibitions in France and elsewhere, I was able to produce approximately thirty murals. Most recently I have continued this work with various figures, graphs and equations using canvas as a support.

PP: This type of work is diametrically opposed to your sculpture and recalls your earliest works. Is this not, in some way, a step backwards?

BV: Only a superficial reading of my work could give this impression of a move backwards. My sculpture has always had close links to mathematics. This is true of the geometry of the "Arcs", the "Angles" and the "Lignes Obliques", on which, as you know, I have their mathematical identity engraved. Take for example "224.5° Arc x 5", which is inscribed on a sculpture made up of five arcs, each one of 224.5°. My more complex works, such as "Combinaisons Aléatoires de Lignes Indéterminées" or "Accidents", on the other hand, can be identified with more recent mathematical investigations, such as chaos or catastrophe theory or the science of complexity.

 I have no intention of abandoning sculpture and if I return today to certain aspects of my work of the '60s, I do so because I detect, in those earlier works, the possibility of a new and original development. I see no reason to deny myself that return. What interests me, what really motivates my activity, is that freedom of moving back and forth, that possibility of putting conventional thinking on its head. Admittedly, there is a good deal of uncertainty hovering over this new work in terms of where it really fits. It does not conform to any current models nor to what one observes today in the art world at large.

PP: In your opinion, what is such a resurgence linked to?

BV: First of all, it is linked to what I have always maintained, which is that there is no ideal model, no unique method through which a body of work evolves and that even the most unlikely intuitions can give rise to new hypotheses. I have often gone back to certain aspects of my past work in order to develop them in light of my more recent experiments. One only has to look at my "Straight Line", introduced in my work in 1966, to note its various metamorphoses into the 1996 "Accidents", for instance, or even into the more recent Arc de Triomphe project. I have always criticized the idea of style or the instantly recognizable formal propositions to which certain artists adhere out of concern for consistency. This kind of consistency does not interest me.

PP: Style is not only the man, it is also the stamp he bears. There's an idea of style associated with Venet's work.

BV: If you like—but is this not rather a matter of how I conduct myself? It's more associated with concept and less with form. In my work there are multiple forms but the concept remains unique—unique, yet open. Ann Hindry developed this idea in a recent text she devoted to my work entitled *L'equation majeure*. She refers to what characterizes my work as a 'general equation', a kind of 'conceptual matrix', from which derive 'sub-equations' consisting of so many parallel works that are variations and extensions of the main theme, representing an attempt on my part at conceptual or even formal enrichment that in no way detracts from the unity of the work.

PP: Of what basic intention is the figure of this major equation the vector?

BV: The introduction of "non-representation" in the history of art was a crucial step—certainly the most radical in the field of the visual arts. At last, the work of art was no longer subordinated to nature, and owing to that kind of emancipation, it established its autonomy. This problem linked to the identity of the artwork has always interested me, and its roots already may be found in my 1963 "Tar paintings" and "Charcoal Pile". In each case, material is presented in its specificity, without artifice or multiple connotations.

The introduction of mathematics in my work is an attempt to push this problem of the identity of the work of art to its extreme limit by introducing univocal signs and by proposing monosemy as a working hypothesis. All my activity during my so-called conceptual period was directed to this end. Since then, my obsessions with neutrality and the rational have clearly become less marked, and by revising or relativizing some of my ideas, I have been able to continue on my way.

PP: There is a considerable gap between formalism and abstraction. On which side of this divide do your recent "mathematical paintings" stand?

BV: I reject formalism just as much as the idea of abstraction, as it is commonly understood in the visual arts. While abstract art refers to what is non-figurative, these new works function within another category. By presenting what are usually defined as "mathematical objects" (numbers, figures, spaces, functions, relations, structures, etc.), the work of art can attain a maximum level of abstraction, which was previously beyond its reach. The non-referential is pushed to its' extreme limits. We no longer have, as in abstract art, a symbolism of, say, form or color either. I offer a maximal self-referential system, which only a mathematical equation can offer.

PP: Is the formal motif used in these murals borrowed as is, by way of straightforward appropriation, or do you allow yourself to alter it as the work may require?

BV: I borrow these formulas, these "figures", from science textbooks. It sometimes happens that I add an equation to a figure I have selected, because it complements it, but also because it revitalizes the formal aspect of certain subjects selected and renders them more complex and less open to be immediately interpreted as a "beautiful image". My subjects are chosen for their novelty, for their visual originality. And often because of their difference, their distance from everything I have learned about art. The use of mathematics, in my practice, is meant to introduce another reality. This is a language that has its own formal peculiarities, its own organization, its own aesthetic rules. What interests me here is the richness of a proposition freed from the stylistic restraints of the kind of art that is identified with the great historical movements of the 20th century.

PP: Is there not a kind of slippage of meaning in this way of doing things that makes the work conceptual in intention but abstract in the way it is perceived?

BV: People respond to works of art according to cultural references, conventions, and habits. The public looks for what it is accustomed to in paintings and sculptures. And for it, "nothing should resemble a work of art more than another work of art." As you know, it was an enormous shock when in the early 20th century Kandinsky and his fellow artists proposed works from

which all representation was excluded. My new equations arouse similar reactions among people who fail to find the symbols and structural principles to which they are accustomed. What they have before them is neither a representational painting nor an abstract painting. We should very clearly distinguish, following the semiologist Jacques Bertin, the graphic and mathematical representations that he terms monosemic from polysemic figurative images, and pansemic abstract images.

Over and beyond these theoretical aspects, by introducing "formulas" and "equations" into the artistic domain, I offer a structural—rather than compositional—system that is both original and new in that it previously was confined to the scientific field exclusively.

PP: The near-cabalistic mystery of these diagrams gives them an enigmatic beauty, confirmed by the colored grounds. Why is it that now you are willing to produce a "beautiful image" while thirty years ago you violently refused to do so?

BV: I do not rule out the idea that the paintings I produce can be seen as attractive. This is certainly a matter of taste, of a tendency to derive pleasure from a cold, non-expressive aesthetic. As I have already told you, it's an aesthetic specific to them. But let's be careful: What appears beautiful to some people does not appeal to others. Often enough, incomprehension results in rejection. Some people think it's necessary to decipher these equations in order to appreciate them. This raises a question that seems interesting to me: what is meant by "understanding" works of art? The combined characteristics that we are in a position to perceive while looking at a work of art, even the most conventional, are infinitely less than the total number of characteristics belonging to that same painting. Certain people find beautiful only what they understand and can clearly identify. With my new paintings, viewers are challenged by a high level of unreadability, and are either ignorant of, or insensitive to the context that has generated this type of work. The average spectator turns away and can not even imagine that one can speak of aesthetics.

During my conceptual period, any relation to formal or aesthetic problems was taboo. My works remained austere, and as neutral as possible in order to focus attention on their contents. I did nothing to improve their

presentation; I had to avoid the risk of seduction. As I've grown older, I've learned that delight is not prohibited and that pleasure is not outlawed. So color has been introduced into these new works—why not?

I don't make a special point of color and I am still a long way from Matisse's "pleasure of painting". However, here color has a precise function, a signaling function. My color choice (lemon yellow, turquoise blue, emerald green, etc.) reinforces the surprise effect of these paintings. The mathematics/color opposition is affirmed and the painting gains in impact. These colors have no poetic connotation. You should know, as a matter of fact, that the color of the murals can and will be changed according to the place where I exhibit them. I have no *a priori*, and one shouldn't look for any relation between the "figure" and the colored ground. The choice of color has no particular significance.

PP: Within the unity of a particular exhibition, is there not, however, a concern for the whole composition, from one wall to another?

BV: The rule I currently abide by is to use only one color for each room. Several colors would become distracting. They would interfere with the apprehension of what is essential, namely the "figures". I need to avoid the overly spectacular effect of walls following each other in a succession of different colors. Color should act as a focusing device with the sole function of assigning value to what is essential, i.e., the work's content.

PP: When producing these murals, are you personally involved in the work or do you delegate it?

BV: Yes, at a practical level, the layer of acrylic paint which functions as the ground is applied by someone else, either an assistant or a house painter. On the other hand, I myself project and trace the diagram because a number of decisions have to be taken in terms of its precise location, its dimensions and therefore the space it will occupy on the wall. This stage of course takes place after I have worked out on paper the exact positioning of the original figure which I have taken, as I've already told you, from specialized books. The projection on the wall is necessary to accurately re-copy the figure selected. There are very few and only minor changes to the original, and

naturally I alone am in the position to make these changes.

PP: It seems that something of a relation to architecture is operating in this work. The painting/architecture relationship is a key question in 20th century art. In particular, it was raised by Léger and by Matisse. What's your thinking on this?

BV: The murals once more question the validity of painting and indeed, evoke architectonic criteria. Last year in Brasilia I painted a 57 meter long wall. Five large figures on an emerald green ground separated by intervals of yellow. A real architectural space was created, but originally this had not been my explicitly formulated intention. Except in rare and very complex situations, the painting/architecture relation is not, in my opinion, a difficult problem to master.

PP: In fact, where does this interest in mathematics come from? Do you see mathematics as the way of describing the world that comes closest to the truth?

BV: When people encounter my work, they tend to think that I am a mathematician and that I fully understand the contents of my paintings. In fact I am nothing of the sort and I make no secret of it. I use these mathematical signs and figures for reasons specific to art. My work has nothing to do with some kind of idealistic ambition. There is no more absolute truth in mathematics than there is in any other field of knowledge, be it art, other scientific disciplines or philosophy. All one does is interpret things or phenomena, and always from a specialized, compartmentalized viewpoint. Cézanne's apple is no more or less an apple than Jean-Baptiste Chardin's. Both are as far from reality as what a philosopher, a gardener or a chemist might say about it. Each one has a distinct approach, a different interpretation, and a partial response.

For the uninitiated, mathematics represent the paradigm of certainty, the model of rational perfection and absolute truth. But mathematicians themselves soon became aware of the weakness of this way of thinking. As long as mathematics have existed, we have been aware of an element of inexactitude and uncertainty. Some of the most basic mathematical rules still are

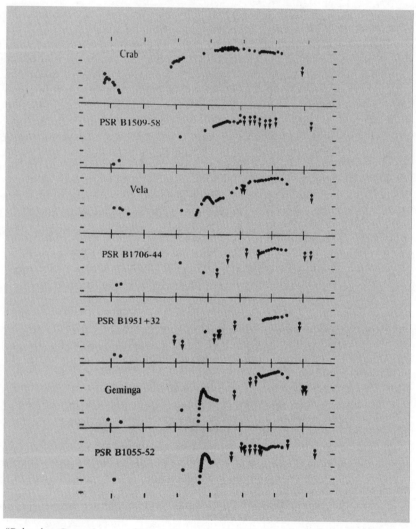

"Related to: Power Spectra of Pulsar Detected at X-ray Energies", 2001, acrylic on canvas, 79 x 67"

mysterious even today. To the specialists, the infinitesimal and the incommensurable are just two all too well known examples.

PP: What specific models do mathematics provide you with?

BV: I don't use mathematics as a substitute for artistic models. They do not take me any closer to reality and, besides, that is not what I am aiming at. I use them because in addition to the particularities attributed to them, which I have described above, they are a way of enriching the domain of art with a different approach to the world and a different mindset. We have to admit that this approach was held in abeyance until now, probably because it was too far from the figurative and abstract models that we are used to, and that have dominated art right up to the present time.

PP: How do you answer those who say, "It's not art, it's mathematics"?

BV: The answer is very simple and obvious for anyone who is prepared to open his eyes. Did people say that the religious scenes El Greco painted were not art but theology? Did they say to the Le Nain brothers, who painted peasant life, that it wasn't art but sociology? Did they say to Michelangelo, who painted nudes on the ceiling of the Sistine Chapel, that it wasn't art but anatomy? Did they say to Courbet, who painted landscapes made up of trees and rocks, that it wasn't art but natural science? And did they say to Malevich, who painted squares and triangles, or to Rodchenko, who painted circles and straight lines, that it wasn't art but geometry?

Why should theology, sociology, anatomy, botany, mineralogy, geometry, and so many other sciences that I have overlooked be the only ones to have the privilege of being used by artists? I am not surprised that the public finds my works difficult when it first sees them. It doesn't understand, and is taken aback by the complexity of the unfamiliar symbols and formulae, and so it immediately rejects the purportedly artistic character of my work. It seems obvious to the public that what it has before its eyes is not art. But that obviousness is precisely what we need to reflect on. Immediate obviousness is not a fundamental truth but, rather, an obstacle to be surmounted. This first observation, this immediate judgment keeps us at a distance from the real nature of works of art. In reality, what I am proposing is

only one possibility among others. Art keeps its vitality only in this permanent process of differentiation. It is the center of multiple lines of evolution, of diverging directions, and it is by virtue of this heterogeneity that it survives.

PP: You seem to be an out and out optimist about the evolutionary possibilities of art.

BV: One would have to be very naive to doubt them. Apart from the fact (and this, from a demographic viewpoint, is a mathematical fact) that there are probably as many artists living now as there have been in all of history, the history of art, as a discipline, is barely emerging from its infancy. In spite of the quantity of masterpieces produced in centuries past, I have the feeling that the 20th century will be seen as the time when we broke free from a simplified mode of thought based on principles that we believed stable and eternal. This subject is much too vast to go into here, but what we can emphasize is that artists nowadays seem to be more involved in an open-ended way of thinking. A way of thinking that is trying to gather together and organize aspects of a body of knowledge that is more complex than in the past. They feel a need to inject external elements into their work in order to enrich and develop it. At last they are breaking free of the conventional models that served the heroes of the previous century, whether Matisse, Malevich or even Duchamp, and moving into other fields of knowledge and drawing sustenance from a multiplicity of new sources and perspectives. The creative process is steeped in unpredictable, random encounters. It obeys certain principles which unite disparate elements into a new unity. At last we are seeing a new consciousness that will no longer make do with ready-made formulae and that accepts the end of certainty. Personally, I take pleasure in difference, in things that are foreign to me. I am still attracted by what surprises me, by those episodes that, retrospectively, we associate with great periods of change. No, the hour of definitive answers, of the exhaustion of concepts, in a word, the impending funeral of art, is not yet upon us.

A Conversation with Enrico Pedrini

Reflections on my Self-Portrait

It was probably in 1974, while I was exhibiting at the Gallery Daniel Templon in Milan, that I met Enrico Pedrini. At that point in time, he was a collector captivated by the most radical ideas, and above all, by Conceptual art.

He later became an art critic and curated exhibitions in many countries. We have been friends ever since we met and, although his writing style tends toward the abstract, we managed, in the following conversation, to communicate quite effectively.

This interview was published in the catalog for my exhibition "Self-Portrait" at the Musée d'Art moderne et d'Art contemporain in Nice during the spring of 2003.

Enrico Pedrini: Various upcoming exhibitions in Nice give us the opportunity to discover a number of works that weren't in your 1993 retrospective at the Museum of Modern and Contemporary Art. These include sculptures on the *Quai des Etats-Unis*, very recent paintings at the Galerie des Ponchettes, and finally a "Self-Portrait" at MAMAC. A self-portrait is surprising. To me, it seems quite foreign to the areas you usually work in. What was the origin of this idea?

Bernar Venet: As you have followed my work closely since the late '60s, you know that, at that time, it was completely oriented toward rationality and science. This was when I started thinking it would be interesting to do a self-portrait. It was not my intention to present my own subjective vision of myself. Self-portraiture has always been a tradition full of imaginative variations, from Dürer to Rembrandt, and from Francis Bacon to Chuck Close. While I did try my hand at it when I was very young, by 1968 I did not feel I could use any of these artists as my models. In fact, this is precisely the moment when my ideas for a self-portrait started to take shape most clearly.

I had letters of recommendation from the director of E.A.T.

(Experiments in Art and Technology), Billy Klüver, whom I saw often at this time. I also had a letter from a gallery owner, John Gibson, and from Bates Lowry, director of The Museum of Modern Art. They were all addressed to the director of public relations at the Medical Center of New York University, requesting him to help me make a self portrait based on the results of a full physical, electrocardiograms, X-rays, blood tests, respiratory examinations, and the like. I did have some meetings about it at the time, but it took much longer to realize the project than I had hoped.

Along the same lines, my obsession with "objectivity" led me to do another self-portrait "Head Details—Working Drawing", executed in the detached style of an industrial drawing. It was a line drawing of my face (front view, side view and top view) on graph paper that indicated all the dimensions and characteristics of the object: "Head of Bernar Venet." Jan van der Marck recently wrote an article about this drawing for the catalogue of a 2001 exhibition of "Instruction Drawings from the Gilbert and Lila Silverman Collection" at the Bergen Kunstmuseum in Norway.

In November 2001, my friend Rodolphe Gombergh, who's both an artist and a radiologist at the CIMN (*Centre d'Imagerie Medicale Numérisée*) in Paris, created a work for me that he himself calls a "virtual 3-D clone." It's a very precise reconstitution, as close to reality as today's advanced medical technology can offer. It is made by using computer tomography, a spiral CT scan that furnishes millions of images, hence documenting my anatomy. The visual results are quite surprising. It's a veritable voyage inside my body made possible by a revolutionary technology that creates images with ultrasound and electromagnetic waves. This technique, which permits us to explore a body that's been rendered transparent through an infinite number of ready images, will definitively transform the perception of human physiology.

The history of portraiture is very rich in approaches. This one, miles removed from the subjective way in which artists' likenesses are usually captured, consists of an "Objective Self-Portrait" that results from extensive scientific analysis, i.e. a tomographic examination of the body to measure bone density.

EP: Your work in the area of performance is not all that well known. Could you say a few words about it here? How does it relate to your other activities?

BV: A principle of equivalency runs through all my different activities. Performance is another approach, an additional means of expression that permits me to demonstrate my true aims. Rather than limiting myself to obsessively producing "esthetic objects", I want to work on content, to enrich the discourse of art through all these synonymous activities, so the viewer can better seize the true meaning of my work.

The evening dedicated to my performance art at Beaubourg in May 2002 offered me the chance to demonstrate what I've just explained. The program lasted an hour and a half, and consisted of a presentation of my films, poetry, musical compositions and performances. The program was designed to make the public discover the relationships among all these different disciplines. In 1961, when I was making "paintings" of used cardboard, cheap wood and tar, I also staged a performance where I was photographed lying amidst garbage containers facing a pool of tar. In both media, my message maintained its coherence, its unity because their context and discourse were the same.

EP: Has performance been an important aspect of your work throughout your career?

BV: After 1966, during the time that's been called my "conceptual period", I had the chance to do other performances. I did not actually participate in them myself because I used scientists, real professionals whose work was originally very far removed from an art context.

The best known of these performances took place in May 1968 at the Judson Memorial Church Theater. This is the legendary place in New York where all the avant-garde of the '60s congregated and showed its work. It was here that artists like Carolee Schneemann, Robert Morris, Jim Dine and Robert Rauschenberg gave their first "performances".

Jon Hendricks, who was then its director, offered me the opportunity to use the Judson Church to present my ballet, "Graduation", which I'd conceived two years previously in Nice. But I didn't have sufficient money, so I decided to show work that was more closely tied to my actual concerns of that moment. This is how I came to engage three nuclear physicists from Columbia University to give simultaneous lectures at a blackboard. Another performance showed the physicist Martin Krieger developing "Neutron

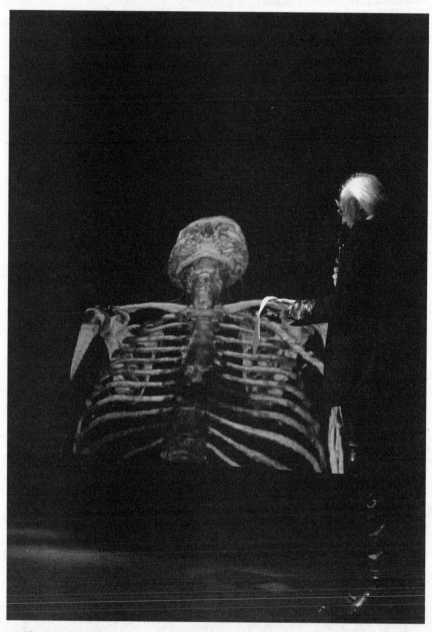

"Self Protrait", performance with Dr. Rodolphe Gombergh, Centre Georges Pompidou, Paris, May 15, 2002

Emission from Muon Capture in Ca 40" accompanied by a slide show illustrating his points on a screen.

The third performance was on "Voice Mechanisms" by Dr. Stanley Taub. A camera filmed the movements of the larynx, which were projected live on a large screen, while I recorded the proceedings with my video camera. I thought the simultaneous filming and projection of the video image was a very interesting and visually new idea.

Other performance opportunities came up, most notably at The Theater and the Loeb Student Center, both in New York, and in Germany where I had an exhibition at the Kunsthaus in Hamburg in 1970. Decades later, a 1989 performance entitled *"Ligne à Vif"* at the Galerie Templon in Paris gave me the opportunity to present the many activities that enter into making my sculptures as one large performance. Grinding, cutting with blowtorches, soldering. The idea was to use all these actions to create a performance, but with a shift in context. The factory and everything that makes up its environment (machines, steel bars, sawhorses, deafening noise, workers) were presented as an art activity. I conceived this performance as a way to go beyond a mere installation by adding action, smells and noise. I was able to use what had happened there one other time, at the opening of my exhibition at the *Mücsarnok* Museum in Budapest in 1999.

EP: We find ourselves confronted here with something different, with the problem of presenting artistic criteria the value of which is no longer dependent upon a direct, conceptual relationship to aesthetics.

BV: In this type of situation, the visual presentation of objects is no longer at issue. In fact, it is an entire activity, I would even say an entire discipline in action, which is proposed as art. This was already a preoccupation of mine in the late '60s when I invited the public to visit the New York Stock Exchange, or when I engaged scientists in my Judson Church Theater performances. I availed myself of all obtainable means to introduce new disciplines that were heretofore foreign to art. Television, newspapers, the mail, and telephone were substituted for conventional pictorial activity.

I introduced science, meteorology, and the Stock Market as subjects for investigation. Other artists today choose fashion, media, politics, or sociology in order to find new issues rich in possibilities. The notion of style,

which has prevailed in the past as a guarantee for the originality of the artist, has given way to a broader concept. This new concept, which I call "working context", allows for a richer and more complex type of creation. The artist then has an expanded field of activity. He can act simultaneously in different disciplines: sculpture, photography, or painting. He can also express himself through performance or music. Evidently, it is this "working context" which is important here. The artist does not address himself exclusively to the public's eye, but instead proposes a body of work for consideration with its multiple approaches, in its globality, and in a more conceptual way.

EP: You decided to end the performance at Beaubourg with your musical composition, "*Mur du Son*" (Wall of Sound). Can you describe the nature of this work?

BV: "*Mur du Son*" is closely related to "*Gravier-Goudron*" (Gravel-Tar, 1961), in which I recorded the sound of a wheelbarrow pouring tar. It's a very regular, monotone composition, two hours long, made by recording the engines of the Concorde. The particular originality of this work, which is now on CD, is that it cannot be heard in its totality, which is to say it's impossible to listen to it for longer than 48 seconds. These first 48 seconds capture the noise of the engines revving up. The sound begins very low, and gradually amplifies until it becomes unbearable. After 48 seconds, the intensity remains the same until the end of the second CD. The decibel level is so high that it's impossible for the human ear to stand the noise. You either have to stop the CD—or leave. This is what I advised the audience at Beaubourg to do, after explaining that I'd chosen to close the evening by playing this piece.

EP: Doesn't this work show the influence of John Cage?

BV: Maybe, in the sense that "*Mur du Son*" is the direct opposite of Cage's "Silence". It's no longer zero degree music, but its opposite—that which contains all existing sounds, from the deepest to the most piercing, making it the richest sound matter obtainable.

This work is certainly related to what is called concrete music, whose pioneers—Pierre Schaeffer in France and John Cage in the States—

today are widely recognized. Their work often consisted of using sounds recorded in their immediate environment which they took apart, classified, remixed, and rendered in a higher or lower register. They used the computer like a palette, excluding, as I also do, everything the general public associates with music, such as harmony, timbre, rhythm, notes, chords and measures. Their work marked an important turning point in the history of music, and they still exert tremendous influence.

EP: How were you able to realize these compositions, concretely speaking?

BV: A team of technical experts first did the actual recording, and then Michel Archimbaud at IRCAM in Paris gave me access to the electronic equipment available to musicians there, which I used to produce the final results. Most of these compositions were published by Circé-Paris.

EP: Do you see other possibilities of developing your work on sound? Are you working on any other projects in this area?

BV: This year I hope I can find the time to compose some works around the theme of "saturation". I think this idea is full of potential. For the time being, I've only created one piece which superimposes several classical scores, but I think I can produce some other very convincing results. These will directly depend on the choices I make from the beginning, on the composers I select and the way I superimpose their works.

EP: Staying within the framework of the events that are taking place in Nice, you are going to install some huge sculptures on the *Quai des Etats-Unis*?

BV: People in Nice who initially disliked my large "*Arc de 115.5°*" when it was installed in the Jardin Albert 1er have now become familiar with the work. Recently I've been given the opportunity to show other sculptures there on the same theme. This will allow viewers to understand and better appreciate the relationships among the different variations.

The installation on the *Quai des Etats-Unis* will consist of five large sculptures in cor-ten steel, with a diameter of 14 feet and a cross section of

7 inches. Each sculpture is made up of five arcs of the same degree each. These arcs are randomly arranged within each individual sculpture, and the installation of the entire group also follows the principle of chance. The positioning of the sculptures is always ephemeral, and changes each time they're installed, according to the space made available to me.

EP: Twelve paintings on canvas will be shown at the *Galerie des Ponchettes*. To me they seem closely related to the conceptual works you were painting in Nice in 1965. What motivated you to go back to your sources?

BV: These paintings are certainly related to those I did in the '60s. My objectives are different now, although all these paintings share themes I took from books on mathematics. My new paintings are free of the constraints I imposed on myself at one time, i.e., an austerity focused exclusively on the-oretical thought. Today, I have much more freedom in my choice of sub-jects. I select them for their originality, for their remoteness, on the visual level, from anything, as far as I know, that other artists have ever painted.

Formally, these are very rich subjects. Some people will attempt to justify or make sense of them by comparing them to geometric art. But geometry is not my concern. I didn't choose these subjects because I have a taste for geometry. They aren't the one more variation to help push the already excessive redundancy of geometric abstraction, minimal art, or neo-geo to the brink of extinction. I'm aiming at a level of abstraction in this work, different from anything we've known before. It leaves formalist abstraction behind and enters the field of conceptual abstraction—an abstraction that's "non-Greenbergian"!

Six "Saturation" paintings will also be exhibited. They are very recent, and so far this type of work has only been shown at Grant Selwyn Fine Art in New York. These paintings superimpose numerous equations, to the point that it becomes impossible to decipher them.

EP: Let's stay with the subject of your recent paintings. You have to admit that the public is confused by them and has difficulty finding anything artis-tic about them.

BV: That's because these works don't fit into any of the usual categories.

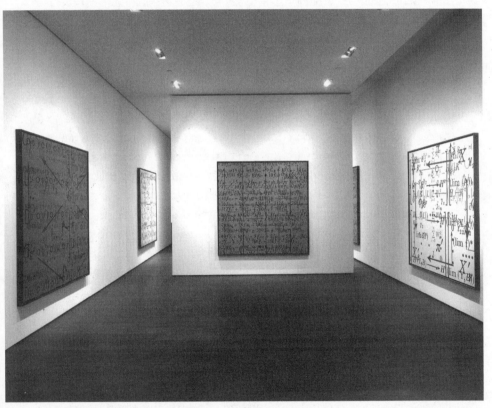

"Saturation" paintings, 2002, acrylic on canvas, 72 x 72"
Installation at Grant Selwyn Fine Art, New York, 2002

People think of the history of art as a whole, as a fairly homogenous entity. They don't take the time to think about the influences, the different, often contradictory motivations that justified the creation of these major works that we view today in museums, churches, or certain private collections. Take the Venus of Willendorf (24,000-22,000 BCE), Byzantine art, and the paintings of Leonardo de Vinci, for example, the work of Delacroix and Cézanne, or that of Munch and Yves Klein, and so forth. Where's the common denominator? What I mean to say is that there is no one concept, no single thought that dominates or underlies the entire history of art. There is no universal truth, no single moral, no fundamental value. To assert that there is, would be doctrinaire, tantamount to yielding to an *academisme* of thought.

Every picture corresponds to a given conceptual context. The history of art is composed of contexts just like scientific thought is made up of categories. In science, something that is true in one context is false or incomplete in another. In art, the idea of true or false makes no sense whatsoever, and yet the general public thinks it recognizes what is art and what isn't. People think this way because they have a few art books at home, handy guides comfortably within their physical and mental reach. This is like leafing through the dictionary to double check the meaning of words one already knows by heart. What a catastrophe if one day, the meaning of those words were to change!

EP: You mentioned new works that deal with "saturation". Can you explain this?

BV: The theme of "saturation" reoccurs throughout my work, developed in different forms. For example, in my paintings or photographs I superimpose images, one over another; if it's a question of poetry, numerous texts are read at the same time; or when I'm working with sound, I employ several musical scores, that are heard simultaneously. Dominique Paini's invitation to present my work at the Pompidou Center last May gave me the opportunity to show a film which consisted of 27 other films, all superimposed. A maximum saturation that amounted to zero degree readability.

Although the idea of saturation was not then consciously present in my mind, the performance I staged with three physicists at the Judson

Church Theater in 1968 can be considered as the first manifestation of this concept.

What interests me about saturation is that it represents another level of abstraction. Saturation is explained in a part of information theory called "noise theory." Too much simultaneous information prohibits us from grasping the meaning of what's being conveyed. It's an interesting subject for reflection that suggests a wide range of new art ideas. Exploring it in several different disciplines as I do, I now am beginning to discover just how rich it really is.

EP: You do run a risk, that of being criticized for spreading yourself too thin?

BV: I've probably been criticized for many things, but luckily for me, I don't feel obliged to make everybody happy. Everyone has the right to do what he wants. For the time being, I'm doing what seems right to me. I do not hesitate to venture into areas of uncertainty, because the risks I take in practicing parallel disciplines can result in happy surprises and be richly rewarding. I'm not necessarily searching for coherence; I find it in remaining true to myself. Some people are always looking back over their shoulder, looking for coherence as if to make sure that their shadow is following them.
Without the support of other fields of knowledge, art would have a hard time evolving, and it may well be true that hybridization is often a precondition of originality. It's by digging down into other disciplines, in freeing ourselves from rigid frameworks, in accepting the principle of interaction between painting and science, or music and information theory, that we open up the conceptual framework of artistic reflection to the possibility of discovering new meaning.

EP: This need for renewal you express, which seems to correspond to the necessity of continual self-questioning—isn't this also a form of self-criticism?

BV: To reflect on what I've produced or thought about is, in effect, to subject myself to self-criticism. For me, it's a sort of indispensable mental hygiene that allows me to push forward, to surpass the limits of what I already know. I don't see how it's possible to be active otherwise.

What does it mean to you to be an artist?

A Conversation with Laura Tansini

Laura Tansini is a very enthusiastic and passionate art critic living in Rome. She is an integral part of the art scene in Italy. I only recently made her acquaintance when she came to visit me in Paris with the intention of doing an interview for the American magazine *Sculpture*.

Laura Tansini: After "Coal Pile" (1963), which you consider your first sculpture, you abandoned sculpture until 1979.

Bernar Venet: Not really because three years after "coal pile", I created and exhibited my "Tubes" sculptures in Nice. These works are less known by the public because they were not exhibited as much, and yet they fit quite logically into the evolution of my work. They even play an essential role because they are at the origin of my industrial drawings (tube plans) which marked the passage towards a work in which the object was abandoned in favor of the diagrams of my conceptual period.

In the spirit of the cardboard relief paintings, which preceded them, I sought to develop a work with an industrial character, as impersonal as possible and devoid of imagination, a work that underscores the rupture with the understanding of the artwork as an expression of its author. My propensity for neutrality led me to present sculptures without getting involved in the production stage. The buyer could thus choose the length of the "tube" the ends of which were cut according to his wishes, in slants, or more simply still, perpendicular to its length.

These "Tube" sculptures made with cardboard rolls were painted in an industrial Kodak yellow. Others were made out of cylindrical gray polyvinyl chloride pipes commonly used for industrial purposes. The smallest of these were considered as models which I later reproduced on a larger, definitive scale in steel.

These sculptures were empty, that is to say that their surfaces were visible both from the inside and the outside (Donald Judd was also interested in transparency and, in 1966, he too created open parallelepipeds). The placement of my sculptures was directly dependent on the laws of gravity because the slanted cuts determined their position. One can say that the Lodz Museum (Poland) "Tube", whose ends are cut at 90° has neither top nor bottom, neither front nor back.

These considerations are not only theoretical. They add nothing to the aesthetic of the work but they are interesting insofar as they create new experiences by each time compelling one to learn how to look in a new way. This was my main interest at the time.

LT: At the end of the '60s you stopped making art for six years.

BV: Yes, and to be more precise, I stopped my activity at the end of the year 1970.

LT: What does it mean for you to be an artist?

BV: To be an artist is to ask questions about the very nature of art, it is to engage in a creative activity that allows one to ask these questions. Unfortunately, total confusion reigns in the public mind which associates any painting or sculpture whatsoever with an art product. These objects are devoid of real cultural value, without any formal originality or substantial innovative content, they are only painting or sculpture and don't, in my view, merit the status of a work of art. Their authors, these chameleon actors, are faithful to a program and base themselves on the foundations of the past, on a repertory of known forms, and it is through a resemblance with this art of the past that they believe to be making art. They act according to the principle of duplication, of repetition, of multiplication whereas true artistic activity should be conceived as an uninterrupted construction of innovative

events. You have understood that I have little respect for looking back, for rediscovering primitive or primal sources of expression. I understand the logic of this for those who can no longer advance to a higher degree of abstraction. They need to breathe and seek the reassurance of foundations that are concrete, certain, accepted and above all, understood by all.

Increasing levels of abstraction and complexity frighten those for whom art is a means to attain the comfortable expression of calm, luxury, and delight.

LT: Were you confused about your "role" as an artist?

BV: No, my position and my convictions were very clear. If one understands the ideas from which my work evolved, if one accepts its rational, methodical, depersonalized, almost scientific character, one can then comprehend the logic that led me to cease all activity. One must also remember that from 1967 onwards, I established a work program, a list of disciplines susceptible to be explored within the context of my artistic activity in order to broaden its sphere. This program was to end in 1970. That is what I did.

LT: And was that the end of your strictly conceptual phase?

BV: Yes, of this period during which my work was developed around the principle of monosemy. That is the use of texts and mathematical diagrams that have only one level of signification. This principle can be found in my sculptures on which their measurements in degrees are systematically inscribed.

I saw this end without emotion and in a definitive manner! There was no way around it, there was a logic to it and I had to respect it. I thought that I had pushed my process to its extreme limits and this called for an end. One either speaks of art, or one lets oneself slip into a production that suffers in quality. At thirty, one has convictions. An artist explores, he does not exploit.

LT: During the time you stopped making art you continued your activity as an art theoretician, writing and giving lectures. You could not escape art.

BV: Art theoretician is saying a lot. No, I don't master abstract thought sufficiently to deserve such a title. It is true that I taught at the Sorbonne on the subject of Theory in 20th century art, and that I wrote and gave several lectures. It is true that I wasn't abandoning the artistic field, but teaching and thinking about this discipline did not make an artist of me. To the notorious statement "This is art if I say so," I countered, "I am not an artist if I say so" (smile).

LT: In 1976 in New York you started using mathematical data again in your paintings, a very unusual subject for an artist. You were not interested in the comprehension of equations, you simply used them as subject matter to give new forms to your paintings. Did that happen by chance or because you were searching for a new language?

BV: When I resumed my activity in the fall of 1976, the mathematical subjects that I used were different from those I used in the '60s. Notably the "Straight lines", the "Angles", and the "Arcs", became the basis for my investigation into the theme of line. First translated onto canvas then in relief form, these subjects, to which the "Indeterminate Lines" were added later, took on a central place in the context of my sculptures. Motivated by the desire to constantly enrich what I had previously created, over the years, a shift occurred which allowed me to move from the "dematerialized" art of the '60s to today's rather large scale sculptural activity.

LT: Do you agree that scientists, mathematicians, and artists are similar in that they are all researchers?

BV: I read many books written by some of the most prominent scientists and researchers. I think that their intuitive process is very similar to that of artists. It happens that the most implausible hypotheses are at the origin of ideas that are among the richest in potential.

One must then prove the validity of these first intuitions. Intuitions which may perhaps bear fruit or which deviate to become something else that is even more unpredictable. Some think that scientific thought is more oriented towards reason, demonstration and objectivity. I admit that I sometimes feel quite close to these methods that have the advantage of short-cir-

cuiting the wait for inspiration.

LT: We have been talking about the conceptual basis and content of art. Does aesthetics have any role in your work?

BV: The two go hand in hand because it is in the aesthetic field that my activity and ideas co-exist and stimulate each other.

LT: I would like to know what you consider to be aesthetics.

BV: All that which, in my eyes, has a profound intrinsic beauty. All that which provides me with a satisfaction, an intellectual pleasure and which often transcends the field of the visual. It is a vast territory which of course covers all of art history from the first artistic expressions of humanity all the way to today.

Even when it is enriched by knowledge, the aesthetic feeling remains profoundly subjective and culturally determined. Nobody will ever provide a definitive definition.

My aesthetic feelings are satisfied far more successfully by Piero Manzoni's *"Merda d'artisti"* than by Marie Laurencin's *"Bouquets de fleurs"*. But the aesthetics I am most interested in is the one that remains to be discovered, the one whose meaning still needs to be formulated. All these objects or phenomena that I am not yet sensitive to, that surround me without my even taking notice of it. Objects or events that remain foreign to me, to which I am deaf or blind, like these people who pass by an Ad Reinhard without feeling its charge. The aesthetic sense is that which allows me to move to another level of perception. It is a more subtle perception when I am familiar with the theoretical or contextual knowledge. In this case, the black painting on which one can barely distinguish a cross, becomes the site where the subtlety and originality of Ad Reinhard's vision is concretely exteriorized.

LT: Your sculptures have their own strong beauty, based on balance, the strength of the material, and changes in spatial perception. Your pieces raise questions and have their own aesthetic quality. When you create a new sculpture do you start with a drawing or a small model?

BV: I never make preparatory drawings, and if you are alluding to the "Indeterminate Lines", each one was the result of an improvised, intuitive, empirical work. I am uncertain of the result during the entire elaboration process. Steel imposes its limits. I must yield to this and accept its nature.

LT: Would you say the work creates itself?

BV: No, these sculptures don't create themselves… one must witness their production to understand how difficult it is to cold twist these solid steel bars with a four and a half inch diameter. One then understands the dangers to which I expose myself and the physical effort it takes. At each instant it is necessary to improvise solutions so that I can attain the desired goals.

Despite the mastery I have acquired over the material, there is always an element of surprise that awaits me each time that I finish a "line." It is in the most recent "Indeterminate Lines" that I have best handled these unexpected results. I now create installations with "Indeterminate Lines" of variable configurations. I can achieve five, six, or seven lines tangled up in each other. The same lines are then used for different configurations according to the space available.

LT: When you create monumental works, you have to make a maquette first: form, weight, and balance have to be calculated and decided in advance. Do you do everything by yourself or do you work with engineers?

BV: Depending on the importance of the project and the installation difficulties that I expect to encounter, I sometimes create several different models. I then choose the one that best corresponds to the chosen site and to the limits within which I must work. The role of the engineers is limited to "wind testing" problems. This is true for my big vertical arcs and straight lines, which are subject to vibration phenomena (galloping). They also study the requirement of foundations and some of the technical details that I know little about.

LT: Do you make changes between the maquette and the final work?

BV: Only the details that were not well resolved by the workers during the

production stage in the case of monumental sculptures. My greatest difficulty consists in properly calculating the relation of the square section of the line to the work's dimensions. There is an element of uncertainty that I have a hard time getting used to when I tackle large scale formats and more particularly new subjects which I do not yet master.

LT: The titles of your works often suggest contrasting meanings, for example, "Order-Disorder".

BV: That's true, my·sculpture is based on concepts that appear to be divergent, but which in the context of my activity organize themselves in a complementary manner: order and disorder, the determinate and indeterminate...

　　We know that matter, nature and life organize themselves at all times according to complementary principles (organization, disorganization) and my work is no exception to this universal model. We know how important a role the negative and conflict play when it comes to surpassing a previously achieved goal or standard.

　　My works called "Accident-1995" obey the "disintegration" principle; the result of the falling bars is "unpredictable." This presents another type of assemblage which no longer depends on the control and organization of the artist and I have to accept the completely "unexpected." Some may be tempted to speak of a "contradiction" between works where randomness intervenes and the very simple determinate lines such as "Diagonals" or the "Arcs", the Nice "Arc of 115°" for example. I need these oppositions to move forward, it is this complementarity that is vital for my sculpture. I understand that my work may appear incoherent at times. That is because the observer bases his reading on frameworks from the past, on explanatory schemes to which I no longer subscribe.

LT: In your sculptures you use different forms. Are they all originated by the line?

BV: Generally yes. The better part of my sculpture originated by taking the "line" as a point of departure. They come in four variations: the straight line (the "Diagonals"), the curved line (the "Arcs"), the broken line (the "Angles")

and the line freed from mathematical constraints (the Indeterminate lines).

In 1979, I created an "Indeterminate Surface" in wood. A relief that was covered in graphite. It is later, in 1995, that I had more success in solving the problem of "surface" by creating an entire series of steel "Indeterminate Surfaces" that were cut with a blowtorch on a very large scale. The "Point" is a subject on which I have also focused, something which allowed me to create an installation in 1984 at the *Musée de Villeneuve d'Ascq* where I showed the relation "volume", "surface", "line" and "point" maintain between each other. It is there that I exhibited the "Coal Pile" and on the walls a painting "Tar", an "Indeterminate Line" and a "Random combination of points."

LT: Do you like to create outdoor works?

BV: I create some, so that means that I like this kind of activity. But I take as much pleasure, if not more, in installing my sculptures in interior, closed and more neutral spaces than one finds in nature, which is often too present. The relation to the landscape can affect the identity of the sculpture. The observation is affected by the beauty or richness of the surrounding nature. In the same way, on a neglected or cluttered site, the sculpture will be diminished and lose its impact. Sometimes the situation is different. Right now I am working on the installation of a large "Straight Line" that leans against a château in France. In this example, it is only the integration of the steel bar into this environment that legitimates its status as a work of art, it is its ordering within it that gives it an artistic value.

LT: When you create a monumental piece are you inspired by the site?

BV: The site defines the dimensions of the work that I will install there, but it very rarely inspires me with new ideas. It is the range of my different possibilities that determines my choice, that such a type of sculpture will find its logic and full expression on that site.

LT: In other words, you get ideas from your mental archives and not from the site.

BV: That's right, even though sometimes a substantial transformation can intervene. This was the case for "Sharp 19,5°" angle in Austin, Texas, as well as the project "Major Arc" on the A6 highway in France.

LT: When you develop a new sculpture, what is your main interest: material, form, balance or spatial perception?

BV: What I am interested in is to discover how, from certain starting principles that are mine, from these concepts we mentioned before like "order/disorder", the chaotic and the unpredictable, my sculpture can evolve and be enriched. The best moments are not those of official inaugurations, but rather those when, either through chance or systematic study, I discover other conceptual or formal options to advance my work.

LT: Do your paintings and sculptures ever overlap, influencing each other so that while you are painting you have ideas for a new sculpture or vice-versa?

BV: Although these works arose from the same "conceptual matrix" that is the same family of concepts, there is no relation on the formal level and therefore no reciprocal influence. There are some rare exceptions, but they are very subtle.

LT: Where do you live and work best, in Europe, or in the United States?

BV: I can work anywhere...it's like having two studios. Distance is not a limiting factor for me.

LT: Besides your many current projects-concrete music, exhibitions such as the one in spring 2004 on Park Avenue-you are also working on a very special project, Global Diagonals.

BV: The "Global Diagonals," subtitled "Global Art - Global Communication - Global Humanity-," is a very ambitious project I have been working on for several years. If I remember correctly, the idea came to me in 1989, when the French Minister of culture asked me and four or five

other artists to think about a gesture to commemorate the bicentennial of Declaration of the Rights of Man. Generally my work does not identify itself with particular events that are exterior to it, however, for this occasion I immediately thought of proposing a large scale straight line that would virtually link two continents.

The two ends of this 10 yard long line were to be visible (about a 110 yards long), one in France and the other in a country chosen for its respect of "Human Rights." My idea was not accepted, but with time, I was able to develop another aspect of the project which concerns the interior spaces that are attached to it.

Since then a catalogue was put together in which a link between New York and Shanghai is proposed. It illustrates and describes, in greater detail than I can go into here, the underground part of the project where people can go and communicate directly, and in real time, with their counterparts on the other side of the earth. We have planned to use giant screens to give the illusion that you are in the other country. "Virtual Reality" has also been considered as a possibility (one can imagine virtual trips to China, to Sydney or Pretoria) to make communication between people of different cultures and races possible.

This project goes far beyond the creation of a sculpture. It goes beyond it through its symbolism and its humanist goal. The Eiffel Tower makes it possible to see distant Parisian suburbs; "Global Diagonal" would put the world virtually at our reach.

LT: What is your definition of art?

BV: There are artists, who in taking themselves for Louis XIV, would answer "L'art, c'est moi." I am not so self centered and think that art is multiple because it is there where expression grants the greatest freedom.

My personal definition would be too restrictive and limited because I can only speak of it up to now. What is art? When one speaks of it we all fall prey to too many personal appreciations, sensations which are difficult to communicate; there is too much vagueness in the interpretation.

Only traditional aesthetic theories attempted to define art. They attempted to formulate criteria that were sufficiently open to be definitive.

Today we know that this is impossible, that the concept of art is an open concept. We have to be prepared for new creations, new entities which will contribute to extending this category called aesthetics.

The paradox is that in order to make art one must each time move beyond the domain of art. For those who believe that they can define what art is and what its goals are, I would like to remind them that, as philosophy teaches us, "the world is intrinsically devoid of meaning, foundation and finality," so how could it be any different for art?

Transparency and Opacity
The Work of Bernar Venet from 1961 to 1976

Christian Besson

By the end of the '80s, I met Christian Besson at the *Villa Arson*, a legendary art school in Nice which influenced many young artists. He is now a renowned professor of Art History.

This text is particularly effective at challenging everything written on the work I produced between 1961 and 1975. It contains extracts from the thesis he defended in 2001, in which he proposed the application of semiotics to the study of contemporary art. He quite convincingly developed what linguists call the opposition between "transparency" and "opacity", and, within the realm of a single work of art, he differentiated between elements that either speak about the work itself or about something else entirely.

*It is very difficult for me to discern what is clear
without reflecting on what is positively obscure.*

—*Paul Valéry, Monsieur Teste*

At the beginning of 1971, after completing the program he had
established for himself in July 1967, Bernar Venet "definitively ceased" pro-
ducing works of art. He had swept through the field of conceptual art and
had his moment of glory immortalized in Lucy R. Lippard's *Six Years: the
Dematerialization of the Art Object from 1966 to 1972.*[1] No formation left
in his tracks had ever so resolutely brandished the colors of scientific lan-
guage.

This saga nevertheless had its origins outside Conceptual art in
series of works Venet created in Nice during the early and mid 1960s, where
members of the New Realist and the Fluxus movements helped initiate him
to contemporary art. Very early on, the first monograph consecrated to his
work, a biographical study by Catherine Millet published in France and Italy
(1974), states Venet's conceptual work only began after his initial period in
Nice. The first two museum catalogs of his work, however, from the *Haus
Lange Museum* in Krefeld (1970) and the New York Cultural Center (1971),
present a different story. Especially striking is the fact that this latter, *The
Five Years of Bernar Venet*, described as a *catalogue raisonné*, bears no mention
of Nice, presenting his work without a context as if it were distilled from

thin air. The history of the first ten or fifteen years of Venet's art has thus always been based on the rarified tracing of a conceptual program seemingly drawn from the clouds, and a far more complex and personal story grounded in an image of the artist that ever-changing biographical accounts are still constructing today.

1. Transparency
Definition after the fact

The theory for this conceptual period came after the work itself, between 1971 and 1976, years which Venet himself has described as consecrated to reflection:

> [During my] activity from 1971 to 1976, the period where I "stopped" producing in order to reflect on my former activity, what I called *la conversion du regard* was a reorientation in vision which allowed me to use my own works as objects of investigation.

Venet still calls this time of "reorientation" when he was not producing new works his period of "Definition." He thus inverts the sequence of Conceptual art (where, in principle, definition precedes the stage of action or verification) without, nevertheless, contradicting the internal coherence of a proposition that constantly reveals its own "logic." Such *a posteriori* theorization or, more exactly, the process by which it was retrospectively constructed, deserves to be followed step by step.

Reflecting in 1977 on the works he had created at the end of the '60s, Venet is aware of the singular role he played in the development of Conceptual art. Contrary to Joseph Kosuth and Art & Language, he did not develop a system of linguistic investigation in line with the Anglo-Saxon philosophy of language, where the practice of analytic logic is based on questions and examples. Nor did Venet resemble the artists Seth Siegelaub promoted, for he never attempted to create situations of open or polysemic communication, as did Lawrence Weiner or Robert Barry, for example. Nor, like Douglas Huebler, did his work concern the program and traces of actions that had taken place elsewhere. And although Venet may resemble On Kawara, in that both pursued a systematic program, Venet's work was never organized around his daily life.

With a view to clarifying my position in relation to other conceptual artists who have worked with language, I have already written elsewhere that no parallel is to be found between the preoccupations of other artists and those that interested me at the time I was producing conceptual work.

Venet refers to information theory, which he describes as teaching that, "at the end of their discoveries, [creators], in principle, encourage adherence to the messages they propose: the 'force of conviction' in the messages they transmit will determine the degree of public adherence." Venet opposes two systems of communication which, if we refer to Jakobson's typology, seem to include the opposition of the referential function to a composite mingling of the poetic function (centered on the message) and the cognitive function (oriented toward the addressee): [2]

One, based in "rational constraint," is used by scientists and theoreticians: this corresponds to the *semantic mode of communication*, where communication can be decomposed into words and isolated elements of a standardized nature. This is the domain of *argumentation*.

The second system is exploited by writers and artists in general, who persuade through the use of *seduction* and the *aesthetic mode of communication*. A pleasing style and the repeated exhibition of works causes a process of adaptation that brings about a kind of fascination in art-lovers, who find themselves in the midst of metaphysical illusion without being able to explain it. (B.V. 78)

As we will later discuss in detail, the faith in rational symbolic systems that allowed Venet to reject metaphysics also led him to retain, for his purposes only, the referential function of language. In other words, Venet was unlike other conceptual artists in that he did not believe in direct knowledge; moreover, he did not even subscribe to core theoretical ideas that were then being developed on discourse and everyday language, be these in linguistics as an heir to formalism (the least likely to confound *langue* and *parole*) or the Anglo-Saxon philosophy of language (following Wittgenstein). (Benveniste advances the notion of discourse at the end of the '40s, and his famous articles on the nature of pronouns and subjectivity in language date from 1956 and 1958, respectively; Jakobson's article on gears is from 1957;

Austin's lectures on performatives also took place in the '50s; *How to Do Things with Words* was published in 1962; and Searles' *Speech Acts* appeared in 1969.)

The only conceptual artist to focus attention on scientific language, Venet is understandably disinterested in everyday language and discursive phenomena, but he also quite deliberately leaves out an entire dimension of language. The meaning, not the use of language interests him, and he continues to adhere to semiology as Barthes conceived it, or even a semiology of communication like that of Eco, which is entirely focused on codes. Information theory, with its ideal of transmission without waste (*sans reste*), is extremely important as well, for it furnished him the model of a binary code with no third term, gradation, or modulation.[3]

Venet maintains the interest of his work is completely unrelated to the entire order of phenomena which contemporary French and English linguistic theory has repeatedly set forth: discourse, enunciation, the act of language, pragmatics, etc. (There are, however, occasional slips: he revokes artistic language because of its rhetorical function to persuade, yet in attributing the powers of argument to scientific language, he places it under the jurisdiction of the same rhetoric, which in classical times was precisely the art of persuasion.) In 1970, in a preface to an issue on enunciation for the review *Languages*, Tzvetan Todorov wrote that a similar reticence was found throughout contemporary linguistics to *énonciation* and the literariness of poetic language: "Reflection on language in Western thought obstinately refuses to consider language as action [...] Censure [of such things] instead gives us an image of language as transparent, transitive, expressive and instrumental."[4] It is precisely this transparent, transitive, instrumental language that fascinates Venet, who conceives of it as an alternative to expression (without worrying about the fact that the concept of expression most often presupposes transparence and transitiveness as well).

Jacques Bertin's theory of graphic semiology furnished Venet with the theory that, even today, determines the meaning he gives to the conceptual work he began in 1966. This, however, happened *a posteriori*, for the theory itself was only published in 1967, after Venet had begun his work.[5] In 1970, a synthesis of Bertin's work appeared in the review *Communication*.[6] Venet's first mention of Bertin's theory does not occur until an interview in 1974, where he refers to the author's distinction between monosemic, poly-

semic, and pansemic signs, which he uses to extrapolate an entire theory of art and its evolution:

[My] activity since 1966 has consisted of presenting monosemic works. The recourse to linguistic signs turned out to be insufficient, for their meaning takes place through differentiation and depends on the relationships among these signs within the linguistic chain. A term presents stratified meanings that depend on its context, and this multiplicity gives birth to poetic images. By contrast, the vocabulary and symbols of mathematics tend to avoid polysemy completely in having a single meaning that the univocity of the terms employed rigorously define. [...] Paintings belong to the domain of visual messages and the signs they employ can belong to one of these three groups (as developed in the work of Jacques Bertin, in France):

1. Polysemic [...]

2. Pansemic [...]

3. Monosemic—here we find graphic images (diagrams) and mathematic symbols, which have the distinction of possessing a single level of meaning.

Up to the present day, the history of painting has evolved within the limits of these first two groups. The second did not take place until our own century with the advent of Kandinsky and Mondrian; it remained to develop the third, which means leaving the realm of the expressive image to explore that of the rational image.

In 1975, Venet published *Lecture de représentation graphique de la fonction* $y=-x^2/4$ (A Reading of the Graphic Representation of the Function $y=-x^2/4$), coauthored with Thierry Kuntzel. The article contains a schema situating the work from 1966 in a "rational" line, where it is the only monosemic work. This schema, which was later often reproduced, links tiny reproductions of works of art together in two parallel chains, which are represented with thick black strokes to produce a striking graphic effect: the reproduction of Venet's own work appears as the end result. Venet recognizes predecessors who have worked with "rational images" as he does, such as Vantongerloo and Donald Judd (and his notes from 1975 start with Malevich's "Black Square", going on to cite Rodtchenko, Van Doesburg, the Concrete art movement in Switzerland, and Morellet), but he presents him-

self as having gone a step further in producing the first monosemic work. Bertin identified both "the graphic" and "the verbal" (i.e., the scientific treatise) as monosemic; in 1967, Venet went from reproducing graphs to copying entire pages of scientific treatises. We therefore see that in Bertin, Venet found both the explanation of his own field of exploration and a pattern of development similar to his own.

Venet had formerly drawn on other sources for his theoretical underpinnings. In 1971, he used a long citation from Bertrand Russell to introduce an article on the unity of logic and mathematics that he published in the review *VH101*. Venet here explained his position on logical calculation:

> Every calculation supposes that we substitute precise and very rigorous symbols and the rules that determine their meaning for the terms of everyday language that designate the objects of our calculations. It is thus necessary from the very beginning to create a new language free from subjectivity or, as it is called, a metalanguage.

Thus it is that the logician's move to translate everyday language into terms for logical calculation serves Venet as the model for substituting monosemic art for the art that had thus far prevailed in western culture. Once this substitution is made, language in all transparency permits direct access to all-important scientific content. Venet concludes from this that if theory changes, its manifestation in art must also evolve, according to the adjustments and revisions of science, just as a book discussing the theory of probability undergoes revision with every new edition.

This point of view is diametrically opposed to that of other artists (Supports/Surfaces, for example), who at the time were arguing for the materiality of the signifier. For Venet, scientific content exists outside of the signifier that transmits it. In this respect, he adheres to the same belief in the transparency of signs that animates a good part of early conceptual art; that is, the belief that art can be dematerialized, and that everything else is nothing but the illusion of the eye denounced by Duchamp. Hence a list of "media employed", the term "medium" signaling the idea of a neutral sign which is only a simple mediation: a report on canvas, blow-up, tape recorder, book, letter, record, newspaper subscription, scientific treatise or conference invitations. "The medium employed plays an important role in the function of communication," says Venet. Consequently, he opposes his use of the

blow-up, which in his sense "does not transform the sense of expression" and "whose only role is to make the message comprehensible," to its use by other artists as a means of expression. In his program for 1967, Venet presented the same thoughts about the transparency of the sign as nothing but a pure medium, for which he delegated the choice of subjects to experts in various disciplines:

> In insisting on my desire to disassociate myself from the works that would follow, my purpose was to show that their material and plastic characteristics were independent of their concept. The concept alone was important, and it should be the only information taken into consideration when defining the validity of my work.
>
> The media employed are not considered for themselves; they are part of a whole, and function to bring a particular theme to the fore.

If Roman Jakobson had had to classify scientific language in his famous article of 1960 that defines the functions of language, he doubtlessly would have situated it along with numerous other messages whose "so-called 'denotative', 'cognitive', referential function is the dominant task." (Jakobson also uses "orientation to context".)[7] Drawing on this typology in 1967, Roland Barthes set up a comparison between poetic and scientific language. (His remarks concern the liberal arts but are not contradicted by hard science).[8] If poetic language is a message whose purpose lies within itself, and is sufficient within itself, then that of the sciences is defined less by content or method than by its social status as a message worthy of transmission: for science, language is nothing but a transparent instrument transmitting content which preexists outside of itself. While opacity is the attribute of poetic language, scientific language is characterized by transparency.

We thus can oppose the transparency and transitiveness of scientific language to the reflexivity proper to poetic language. Such an opposition is characteristic of a typically modern typology whose accent derives from a double *caesura*: one, the beginnings of the age of modern science; the other, the advent of German Romanticism, which places reflexivity at the heart of poetic language. This undoes the unity characteristic of the age of (figurative) representation, where such disassociation was inconceivable: for the classical artist, each sign, every act of representation, supposed the presence/absence of the sign, that is to say, simultaneously the thought that we are thinking and, virtually, conscious of the fact that we are thinking it.

Francois Recanti has illustrated the classic status of the sign with the following diagram, where x is that part of the sign that represents (*le représentant*), and y is what is represented (*le représenté*):[9]

In their search to establish the foundations of scientific logic, Russell and Whitehead had recourse to two complementary tools to aid them in their constant struggle against psychological interpretation and their effort to do away with the many paradoxes of everyday language. One of these is the theory of types, which allows us to recognize heterogeneity, respect functional hierarchies, and stop confusing a "collection" with the "objects of this collection". To put it briefly, this forbids any proposition of a reflexive nature. The other, the theory of descriptions, permits us to eliminate all logically impure elements by translating the *énoncés* of a reflexive language into functional propositions whose variables can only be logically proper nouns or purely referential expressions. These two tools, taken as means of rectifying everyday language, allow us to reduce the classical diagram to a purely transitive form:

This clears the way for a division of roles, and the institution of a typological distinction between scientific and poetic language. When Jakobson describes the poetic function, he has no difficulty in using the other dismembered part of the disjointed classic diagram for his own purposes; that is to say, the reflexive half that remained associated with repre-

sentation in the diagram:

X

 Rene Wellek and Austin Warren's essay defining the nature of liter-
ature (and art in general), furnished a full description of the opposition
between the scientific and the poetic. Wellek and Warren noted that:

> Ideal scientific language is purely 'denotative': it aims at establishing
> a word-by-word correspondence between the signifier and the sig-
> nified. The signifier is totally arbitrary and can thus be replaced by
> equivalent signifiers. Moreover, the signifier is transparent: this
> means that, without attracting attention to itself, it unambiguously
> orients us toward the signified.
>
> Scientific language hence tends toward a system of signifiers of the
> type found in mathematics or symbolic logic. Its ideal is a univer-
> sal language, like the *Characteristica Universalis* that Leibniz had
> begun to imagine at the end of the seventeenth century.

By contrast, literary language "abounds in ambiguities," and is charged with
associations that render it "connotative"; it is "not uniquely referential", but
has an "expressive side" which is "not content to utter and explain [but]
intends to influence the reader."[10] This is to say that it has a "pragmatic"
aspect, and that the accent is finally on the signifier itself.

 Another way to define the scientific language in relation to poetic
language is to situate them both in relation to the (limited) rhetoric of fig-
ures. Zero degree rhetoric cannot be absolutely defined, but as Jean Cohen
points out, we can at least approach it through scientific language, which
reduces divergence to a minimum and thus has the advantage over written
prose.[11] Henceforth, zero degree rhetoric, rather than reflexivity or trans-
parency, defines scientific language. At one and the same time, to define
style as a departure from the zero degree rhetoric inherent to scientific lan-
guage is to establish scientific language as the norm.

As it is well known, the expression "zero degree", popularized by Roland Barthes, was first applied to literature.[12] To explain what he meant by "zero degree writing", or by "blank writing" or "innocent writing". Barthes relates them to neutral terms found in linguistics. He uses the example of the indicative, an "amodal term" compared to the subjunctive or imperative modes. Writing of this type is "freed from all servitude to any marked order of language." On one side, it tends toward its own disappearance, the "final *agraphia* of Rimbaud or certain surrealists." According to Barthes, who ends his book with these reflections, "[writers'] search for a non-style, or an oral style, for a zero degree or spoken degree of writing, finally anticipates an absolutely homogeneous society [...] a kind of anticipation [which] would represent a perfect new Adamic world, where language would no longer be alienated."

As far as our purposes are concerned, it is important to note the existence of a kind of poetics that willingly contravenes the poetic domain by refusing distance or separation in the search for a transparent style of writing. This transparency is furthermore imagined as closer to ordinary speech than to science, and in any case pertains to a language that would state things directly, in a sheerly denotative way. When Barthes dreams of such a language in the '50s, finding examples in the work of Alain Robbe-Grillet and Jean Cayrol, he is thinking of something that would signal the real world, of signs that would only be made of signifiers and referents. "Hence a language which is purely substantive (i.e., a language of nouns, not adjectives) and, by the same token, a poetry with no recourse to judgment, impressions, or images: words would construct things, not what the poet has to say about their qualities [...] The word signifies the object with no relaying, no extras, no surroundings to conceal it: the word is the object."[13] "Language is no longer separate from reality," Bernard Comment has remarked. "In one fell swoop, the narrative (*le récit*) can collapse, and with it an entire logic of representation."[14]

Curiously, we see that the dream of a purely denotative language-object, purified of all values and value judgments, is also found in Frege's well known writing on *Begriffsschrift* (his work on ideography, which itself reaches back to Leibnitz's project on universal characteristics), as well as Frege's distinction between the expression of meaning and the denotation of reference.[15] The work of Carnap also comes to mind and, more generally,

the neo-positivist line of thought. In this latter, and in the quest by members of the Vienna Circle for a *Wissenschaftliche Weltauffassung* (a scientific conception of the world) the goal of realizing "absolute syntax" was connected to achieving social unity, as Antonia Soulez has shown.[16] It is important to note that Carnap, in defining the meaning of *tabula rasa* as a formal, or protocolic language on which the institution of science is based, turned to the doctrine of physicalism in his search for a model, which uses the language of common sense to designate the things of the world.

From this point on, it is possible to schematize the position of different artistic or literary attitudes in relation to scientific language. The first thing to note is the characteristics of a division which, although diversely formulated, all seem to go together:

Theorists	Scientific Language	Poetic Language
Russell/Whitehead	non reflexivity	reflexivity
Jakobson	denotation, referentiality	reflexivity
Wellek and Warren	denotation, referentiality, word-by-word correspondence,	ambiguity, connotation
	transparency	expressiveness pragmatic dimension
	arbitrariness of the signifier	accent on the signifier
Cohen	zero degree rhetoric	gap (*écart*)
Barthes	transparency	opacity, reflexivity
Bertin	monosemy	polysemy

There is much to be learned in the comparison between Carnap and Barthes. The first is unable to oppose scientific language to metaphysics except through annexing everyday language:

Carnap	*Wissenshftliche Weltauffassung* scientific conception of the world		metaphysics
	scientific language	everyday language	
	physicalism		

Barthes follows a similar tendency when, in the desire to oppose zero degree writing to ideology, he shifts the zero degree closer to a purely denotative everyday language:

Barthes	anticipation of a homogeneous society non alienated language	ideological language

In both cases, everyday language is relegated to a section of the table only as waste to be reabsorbed. But it is impossible not to see that it resists such assimilation by virtue of its "supplemental" character, and hence disturbs the arrangement of neat Manichean oppositions. In both cases, the syntactic absolute is revealed as a philosophical, even metaphysical, undertaking.

The conceptual phase of Bernar Venet's work should be extended to include the years from 1971 to 1976 for, during this period, the artist pursued on a theoretical level the same purpose that had organized his conceptual work from 1966 to 1971. This was centered in the search for a purely denotative, logically pure language and the sort of absolute syntax which men at the heart of scientific inquiry had dreamt of long before him, as exemplified by Frege, Russell, and the Vienna Circle's somewhat maladroit reading of Wittgenstein's *Tractatus*. In fact, the dream of a monosemic universe, where words would finally correspond to things and all ambiguity is reabsorbed, the dream of eliminating all rhetorical gaps or distance through the use of transparent signs, is a dream based in the ideology of Unity. For Carnap, this was the unification of the sciences, but also the convergence of scientific and everyday language in a single "scientific conception of the world." For Barthes, it was the conjunction of literary and everyday language, with the same ideal of attaining the neutrality he called "the zero degree". For Venet, it consisted in placing artistic and scientific language both under the aegis of a victorious *monosemy*.

FETISHISM AND CODES

The best article that has ever been published on the first ten years of Bernar Venet's work remains the essay by Thierry Kuntzel that appeared in a book Venet himself had published in 1975.[17] With no paratextual apparatus to signal a difference in register, this essay on the work of the artist is

here presented at the same level as (but following) two other scientific texts in English: one, "Mathematics", concerns tangential numbers, Euler numbers and Bernoulli numbers; the other, "Astrophysics", examines the composition of one of the galaxies. The paratextual indication, "Analytic text", above the title of Kuntzel's text, which by analogy makes it appear to be a scientific article, does not in truth refer to any known science. But beyond its recuperation by the artistic paratext, Kuntzel's study very objectively discusses Venet's rigorous research on monosemy, and further explores the cultural and social reasons why this work may have emerged when it did, as well its unconscious side.

Kuntzel breaks this period into three phases: the first, which extends from Venet's coal piles to his painted plastic tubing, and includes his lacquered cardboard reliefs, "incessantly repeats the same problematic, i.e., the search for a 'zero degree' of painting most readily identified by the 'absence of style." (There reference here is to Barthes, of course.) The second, which begins with the dimensions indicated on industrial drawings and ends with mathematical diagrams, aims at "eliminating the residue of ambiguity" and "eliminating connotative processes." In the third phase, which concerns the conceptual work proper, the designation of the monosemic code is improved to the extent that it is "displaced throughout different materials." "Venet's course thorough different scientific disciplines can be said to correspond to that of symbolic logic, where individual terms are replaced by "object variables," conceptual terms by "predicative variables," and so forth. The logic of Venet's work most basically countered the valorization of the object (a diagram, a book, etc.), and sought to undo the fetishism of the art world. Taking his distance from this course, Kuntzel compares what he calls "the logic of the neutral" to Freud's theory of the death instinct (the tendency to cancel out or lower stimulation to a minimum).[18] Turning Venet's own anti-fetishist argument back against him, Kuntzel calls on Baudrillard to show that fetishism is not characterized by the passion for an object, but the "passion for a code."[19] He thus definitively situates Venet's work within the very fetishism Venet maintained he had escaped.

2. Textual Heterogeneity

It is not difficult to see that the scientific language in the books from

which Venet extracts passages for his conceptual work has more than the purely referential function he claims for it. Since message content is also a characteristic of the text itself, according to Jakobson's categories we here are certainly dealing with a shift toward the poetic.

CONNOTATION

In effect, it would be quite surprising if it were scientific theory that the general public saw and read in Venet's texts. The interest and thoughts of such a public are not primarily oriented towards science; average visitors to galleries and museums are not in search of scientific content when they look at a conceptual work. From their point of view, the object before them has every chance of seeming opaque, abstruse and obscure. Furthermore, it is highly unlikely that the majority of viewers would read such texts completely: on the contrary, most of the time reading is limited to noting that the text belongs to a certain genre, the scientific treatise, and goes no further.

Although the suggestion may well seem incongruous given that we are speaking of scientific discourse, it is possible that, in reducing scientific language to nothing but its appearance, to its exterior aspect as a scientific text, actually amounts to stocking it alongside other types of discourse in the "ideological warehouse" of a period, society or group, where it becomes part of the whole supply of intertexts from which artists can draw. (The general public, it must be remembered, is unable to follow even the argument of scientific texts.)

This the reduction of scientific language to its surface appearance and, more than to its monosemy, to its style (lists, formulae, tables, etc.) most definitely places it with other ideologies that art manipulates (and from which art itself is not excluded). While Warhol draws on conventional images of movie stars and other public icons, and Lichtenstein uses the ideolect of comic books, Venet looks elsewhere—not to scientific language, but to scientific language as an idea seen through art, a language on the same level as the representations that art makes of the world and all the languages in it, a language reduced to visual stereotypes even when the artist has nevertheless strictly respected the content of the scientific text. Incorporated into art, the scientific text is less a vehicle for scientific information than a kind of self-stereotype (if I may use such an inelegant term).

On the scientific level, it is no longer the scientist—or even the artist—who determines meaning, but the public, for whom it is part and parcel of "pre-received and pre-constructed ideas, which themselves are rooted in collective life (that of the group, society, or culture)."[20] Such a viewer essentially picks out certain signs such as numbers and graphs; he reads the page before him with reference to a descriptive schema with which he is already familiar and which belongs to his own sociocultural code. For this kind of viewer, "sense can only be based on stereotyping, as this is the obligatory starting point of all meaning."[21]

Thus each scientific term that the artist advances or displays denotes science in general, and not only a specific scientific content. Ideality or abstraction overrides every utterance, turning it into a scientific message "in general". The connotative, which is a second, quite separate semantic system, thus grafts onto the denotative system, but this is all the less apparent in that this second system, the connotative, is always seemingly predicated on the same object as the first, i.e., science. The only transformation that takes place from one system to the other is hence the passage of a specific instance of science to its type—or, to use Peirces' terms, the passage from "token" to "type". For Umberto Eco, the tulip connotes the class "flower" of which it is a part; in the same way, for Venet, a scientific text reproduced as a blow-up hyponymically connotes the class of all scientific texts, a class to which it, too, belongs.[22] Connotative meanings thus can stealthily morph into denotative meanings, not only because they are strictly isomorphs of the first, supported by the same signifiers (a mathematical graph, for example), but because their individual content does not apparently differ from extended content (a specific scientific utterance verses all scientific utterances). In reality, however, the character of stereotypes also modifies the sense of what is being comprehended (a single scientific utterance verses the scientific), and hyponymic connotations conveyed through stereotyping doubtlessly introduce semantic heterogeneity.

FIELDS

To examine Venet's move on its own grounds, i.e., in terms of a typography that distinguishes scientific from poetic language, it is necessary to return to Frege's ideas on quotation marks, Russell's theory of types, or the

distinction between referring and mentioning in Strawson and Searle.[23] When Venet states, "I do not present my work as art, but I present mathematics and other scientific disciplines for [what] they are, i.e., pure knowledge as such," he introduces the idea of a purely logical language without heterogeneous levels, and which is characterized by the absence of reflexivity that Russell defines as a criterion. But is this actually the case? Are there not some implicit quotation marks here? Searle, following Strawson, warns that we may be confusing "use" and "mention". The word referring to the Greek philosopher is not used in the same fashion in /the philosopher Socrates/ and "Socrates" the eight-letter word. Contrary to direct use in the first case, the second is an instance of mention, which comes about with the use of quotation marks.

Given a sufficient degree of education, it is possible to enlarge or verify our scientific knowledge by listening to a tape-recorded lecture by Guy de Balbine, Note on Random Permutation. In this case, we use the recorded lecture in a specific way, listening to a text concerning experimental data and scientific laws. If, however, we listen to this tape (or look at it) as an art collector who has acquired it as a 1967 work by Venet, this use falls into the category of mentioning—the mention the artist makes in setting the tape before us. Numerous markers act as quotation marks in an artistic setting: the presentation of the tape recorder on a pedestal, its casing in the wall, and the display room in which it is exhibited. Among these is the least visible marker of all, the immaterial framework of the limits of art itself—what Pierre Bourdieu has called the "field" of art, whose limits perpetually reconstitute themselves, as Daniel Buren has shown (*Limites critiques*, 1971).

Venet himself is aware of mentioning and its function. In 1969 and 1970, in the framework of his set program to examine a succession of various disciplines, he presented the enlarged pages of a book. Enlargements of only the title page and summary were exhibited, and the book itself was posed to the side on a pedestal. In his explanation of this work, he describes the images in his first blow-ups in terms that resemble a stereotype ("a fixed piece of information"), then explains how "mentioning" functions in his most recent blow-ups:

> My use of blow-ups in the presentation of books has a very different function than in "Weather Reports", "Grammatical Analyses", or pieces from 1968 such as "Neutrino Viscosity in Cosmological

Model". In these latter pieces, the blow-up is the direct support of the theme, and directly sets, or fixes, the information. First, it is necessary to point out that the blow-ups in the book presentations reproduce the title page and summary page of the book they accompany. They are not indispensable to the functioning of the piece, but are used to attract attention to the book; hence this essential feature actually signals that, in contrast to symbolic representation, a sign has only an arbitrary and extrinsic rapport with the signified.

While mentioning plays a clearly perceptible role in the works Venet here describes, he nevertheless does not consider it pertinent to all of his conceptual works. This is because the artist, eager to distinguish his work from ready-made art, must silence the fact that mentioning is a function common to both. Hence, he repeatedly insists that his presentation of scientific texts is "direct", and attempts to erase all trace of quotation marks. Those who do perceive the mentions in Venet's presentation of scientific texts (through the use of markers or quotation marks) can easily situate these works in the category of ready-made art, with the understanding that this artistic genre pertains to the transfer of a text just as well as to an object.

TYPOLOGY

If we remain within the domain of textual analysis, we thus can ask this question in yet another way: what type of texts are scientific works that Venet extracts and enlarges? Are these texts entirely scientific, or do they contain traces of the poetic? If so, how do these two types secretly cohabit in Venet's texts, the presence of one seemingly masking the other? To ask the question thus, in terms of textual topography, amounts to catching the artist with his own words. Very early on, while claiming not to present mathematics as art, but purely as mathematics, Venet defended his work against assimilation with ready-made art:

I was not presenting mathematics as art, but as mathematics alone,
for its own importance, its own function. (It was not an attempt to
make mathematics into a new object, a new instance of ready-made
art.) Their presentation had a didactic goal.

In so strongly distinguishing the artistic genre in which he is working from that of other conceptual artists, in distinguishing scientific language from

that of art in general, Venet makes use of an implicit typology. His allusion to the "didactic," moreover, clearly reveals his preoccupation with typology. Hence, the problem that interests him is partly of another order than that of ready-made art, and on this point he is right to protest. It is not a question of examining only the relations between different fields, but also of identifying, of classifying different types of languages and playing with their juxtapositions—taking into later consideration, of course, the field in which this distinction is inscribed.

When Venet was asked whether his use of tar was the type of appropriation used by New Realists, he situated the act in the tradition of the visual arts, comparing his tar paintings to the monochromes of Yves Klein, American painting in the '50s, and minimalist painting. His first work with diagrams dates from 1966 when he displayed an industrial drawing of a tube along with the tube itself at an exhibition in Céret. From the very beginning, Venet defended this move on the visual level: it was not an example of ready-made art, but in the line of traditional painting, a genre which, it is true, had been regenerated since Duchamp. When Venet says "I reject all personal emotion," he is speaking of what takes place on the canvas, and his graphs can be taken as a new motif. Venet seems to have authorized a local journalist to explain this very point in his account of a visit to the "painter" in the early summer of 1967.

The "painter" explained to us how his symbolism, influenced by Paul Klee, had led him to minimalist art. During a rather short period, he "painted" with tar, monochrome, entirely black canvases of various sizes which nevertheless incited the interest of art lovers!

He then began working with cardboard reliefs, done with industrial paint. This new "style", which was just as hermetic as the one that preceded it, was accepted in the specialized milieu of "painting" […] After "painting on cardboard", he concentrated on the use of "industrial paints", which he now applied to tubes, and to tubes cut up in a factory, at that!

From the industrial domain, Bernar Venet moved on to science. And thus he "is the only painter" in the world now exploiting a new style: he takes his subjects from reviews specialized in astrophysics and cosmology, "paints" the graphs, and accompanies them with a tape explaining his "paintings".[24]

Despite his imprecision and even his errors, the reporter's insistent references to "painting" are not entirely off base. Even in 1974, Venet speaks of his meteorological charts as landscapes, and his blow-ups as visual spaces. Throughout the entire conceptual period and even later, as we have just seen, the genre of his work remains uncertain: against all evidence, he continues to deny his adherence to "dematerialized" art, and somewhat confused references to painting undermine his claim to scientific language. Beginning with the '80s, the word "line", which frequently reoccurs in his texts and interviews, at times seems to indicate a leaning toward the genre of drawing. In conjunction with a central concern with sculpture, this reference to the line, quite certainly, is a tie or common thread meant to unite the works that came after 1976 to those Venet had previously produced.

Venet himself seems to have had an uncertain understanding of the textual typology he employed during his conceptual period. Evoking Jakobson's outline of functions, he identifies an expressive and a poetic function, contrary to Jakobson himself; although he makes an allusion to the "didactic" function, he does not develop it. In his defense, however, it must be said that Venet does develop a later textual typology, after the '60s. Yet serious typological scrutiny reveals that another textual type overdetermines the scientific text and its recognizable attributes (transparency, monosemy, etc.). The use of quotation marks discussed above are nothing less than a means of embedding scientific language in a structure where it is not the dominant authority. "The dominant," says Jakobson, "can be defined as the focal element of a work of art: it governs, determines, and transforms the other elements. It is that which guarantees the cohesion of the structure."[25]

Jean-Michel Adam, who borrowed the concept of typological dominants from Jakobson and Philippe Hamon, clarifies the term by discussing it as a sequential structure.[26] Certainly, Venet's proposition, belonging as it does to the visual arts, is not linear enough to permit a strictly sequential analysis, but the embedded structure, the use of parentheses (or *parenthesage* as Adam puts it) nevertheless exists. On the level of the utterance or *énonciation*, art is the over-all illocutionary purpose, and scientific argumentation is caught in the artistic argumentation which encompasses it; the "I-here-now" which anchors the utterance does not belong to the subject of the scientific discourse, but to the artist who is showing his work in a space devoted to exhibitions (or, more exactly, to the person who is viewing and reading

it). On the semantic level, art guarantees the over-all coherence of the work; science is only present to furnish art with a subject in the permanent renewal of content and form. "The 'work of art' undergoes mutation. It is no longer valued as an irreplaceable, fetishistic object; rather, its identity is based in its own renewal," says Venet. Art furnishes over-all syntactic coherence as well, for in spite of what Venet says, it is "with art" that he randomly chooses the graphs whose homothetic coordinates, next to the blow-ups, furnish a framework for this latter; that he displays a tape recorder on a pedestal and a text on the wall; that he positions three simultaneously speaking lecturers in front of three contiguous canvases.[27]

It nevertheless remains no less true that a process here at work attempts to disclaim the artistic text by annulling its effect. This process of typological manipulation, amounts to a displacement of focus: it consists of extinguishing the latent power (*prégnance*) of the dominant structure, and using the authorial paratext to call attention to the scientific text—i.e., to a completely other structure that has been embedded in the first. On the typological level, the rupture is not apparent except in the passage from scientific syntax to artistic syntax or vice versa. (If we accept the artist's invitation to follow the logic of scientific language from the start, we have the illusion of a single focus and total coherence.) All in all, it's a rather simple case of embedding, whose true originality lies in the fact that its textual dominant has been all but emptied of its proper content. In other words, Venet reduces the textual dominant to a mere shell (the encompassing parentheses) into which he inserts scientific language (encompassed within the parentheses). The content of this scientific language, to the contrary, is saturated and fulfills the role of a heterogeneous sequence.

Transposed from Adam, the schema looks like this: /#'/ symbolizes institutional paratextual marks; /#"/, the authorial paratext; /Ø/, the vacuity of proper content; bold print, the potential power of the text:

(Ø #' (Ø **artistic language** (#" (scientific language))))

In such a structure, the *prégnance* of the dominant text and the over-all axiological dominant are disjointed, contrary to what occurs in the construction of most texts, which have a coherent focus and subordinate secondary textual types to a single dominant. (For example, in the adventure novel,

narrative dominates description, explanation, dialogue, etc. because narrative simultaneously gives the text its overall meaning and takes up most of the space.) Such a disjunction creates the grounds for a typological conflict in which the artist himself sides with and confers power to the subdominant, while refusing the dominant (to the point of almost denying its existence).

The means of this denial are essentially paratextual, the institutional paratext here coming as it were to the aid of the auctorial paratext. This latter is all the more convincing and effective because the institutional paratext, which in this case should clearly signal an artistic text belonging to the domain of art, feigns a neutral context instead (a white cube, the absence of frames, etc.). In actuality, Venet's work cannot construct the neutral logic Kuntzel described unless the institution of art itself has previously neutralized the visible traces of its existence by creating an illusion, an inscription on a blank page as transparent and decontextualized as the means of scientific communication itself.

An important part of the art that took place around 1968 invented a new way of envisioning context. Rather than referring to an exterior authority, to the contrary, it absorbed it into the artistic project—in other words, it constructed it like a principle text. Yet Venet is the leading example among artists of the time who felt the need of a neutral context in which to conduct semiotic experiments with strictly controlled parameters. It is as if the blank page on which they sought to inscribe the signs of this experiment would, in a sense, serve as protection from the confusion of contextual disturbance.[28]

Even while vaunting the analytical nature of these propositions and the rigor of mathematical, monosemic language, Venet always leaves the door open to artistic meaning:

> [The] mathematical vocabulary and its symbols tend to foreclose all polysemy and convey a single rigorous meaning that is defined by the univocity of its terms. The important thing is not so much mathematical demonstration, but what it signifies and provokes in the artistic context.

Otherwise stated, Venet certainly recognizes that his move involves a textual shift, but he does not go so far as to say artistic language takes precedence over the scientific. He is perfectly aware of what we could call the "credo of conceptual art": art is valuable to the degree that it calls the definition of art

into question.[29] He also reports a conversation where Donald Judd claims that any painter or sculptor is more or less a good artist. To this value judgment, Venet opposes an existential judgment: some are and some aren't: "I added that it wasn't logical that these people automatically deserved to be called artists if their practice offered no new definitions of art."

Although he is highly conscious of the crucial role the act of definition plays in the world of art, Venet maintains the fiction of total neutrality, where a heterogeneous language could be introduced into the language of art, and take it over entirely. He cannot allow the suspicion that the scientific language thus introduced changes its nature; he cannot openly admit the idea that artistic context could thus overdetermine the analytic nature, the monosemy, the transparency, and the pure transitiveness of the means; that it could consequently be irremediably absorbed in the poetic, and hence take on reflexivity and opacity—for to do this would be to admit a contradiction in terms. It remains to be seen if an implicit assertion of belonging to artistic language is nevertheless understood; if it is not "stated without being stated" (to borrow Oswald Ducrot's formula).[30]

Starting with the examination of how typology operates, such an analysis would reveal a somewhat misleading displaced focus, and overturn the stated purpose of attaining logical purity, whose progress Kuntzel reports. Beyond Venet's effort to eliminate the heterogeneity of art (its fetishism, traces of style, the individuality of drawings made by hand—all the marks of the artistic which he voluntarily did away with); beyond the "logic of the neutral" which he declared he had attained and explained at the end of his work; beyond his denigration of artistic utterance, it is not very difficult to reestablish either the actual authority of such utterances (as Venet is working within the field of art) or even semantic coherence from the artistic point of view, as long as it is true, as we have seen, that Venet continues to define himself as an artist. Everything takes place as if the contract between him and his public required the latter to accept the artist's self-effacement in favor of scientific language; but the contract itself includes a hidden clause maintaining that Venet remains all the same an artist.

TITLES

In many places, Bernar Venet's work comprises metalinguistic forms whose meaning is always anchored in the same logic: in 1966 and 1967, he integrates captions into his graphs in the attempt to establish that each has a univocal meaning. Later, after 1976, the canvases of Angles and Arcs include their dimensions and even the mathematical definition of the figures, inscribed in capital letters on the wall as in: "*POSITION DE DEUX ARCS MAJEURS DE 254.5° CHACUN*" (POSITION OF TWO MAJOR ARCS OF 254.5° EACH) 1978. The same holds true for the undetermined lines at the beginning of the 1980s, such as "POSITION OF THREE UNDETERMINED LINES", 1983. Venet is not the first artist to incorporate the title in this way, but in his case the act, from his conceptual period onward, seems to have been born of the inner necessity to develop an art of transparency to counter or control the misinterpretation of his work. As a foundation for reading a work of art, this move is analogous to that of other artists whose titles take the form of indices which list, for example, the materials they've employed, or their methods of fabrication (Toroni, Ruckriem, etc.), or who furnish viewers with leaflets explaining their work (Buren).[31]

Such captions not only denote mathematical content (an arc or angle, i.e., a geometric figure whose value is designated by degrees) or, in other words, a "type": they refer to the materially present work, i.e., an occurrence or "token". This latter denotation constitutes a self-reference (as the title of a painting beginning with "Portrait of …" often does). Self-reference "introduces a circular relationship between two different levels of logic: that of 'metalanguage' and that of that of the 'language object,' and thus violates the theory of logical types that Whitehead and Russell developed [...]."[32] Seen from a linguistic point of view, whenever Venet integrates captions or titles with graphs or other figures, his typology becomes heterogeneous. From 1976 on, the heterogeneity of the geometrical figure accompanied by its caption recalls the less obvious (yet just as present) heterogeneity of his conceptual work which, as we have seen, creates hierarchical parenthetical structures through embedding scientific texts into artistic contexts.

While Venet's entire work can be seen as a logical and homogeneous

whole whose "identity, unity and homogeneity" Venet himself insists upon, I have not been alone in detecting its "heterogeneity" as well. That said, the concept itself is purely descriptive, a concept used in semiotics to designate semantic and enunciative phenomena, and carries no judgment as to aesthetic value. This heterogeneity is detectable on at least three levels: the semantic, where meaning is disconnected from connotation; the poetic, which is distinguished by typological embedding; and the figurative, which integrates paratextual elements into the visual image itself. This is not to mention the pragmatic level, where we find scientific and artistic fields mixed together and confused. Heterogeneity thus amounts to an isotope in Venet's work: an essential of its underlying structure. It is, however, difficult to discern, for it is largely masked by surface logic, and seldom appears for what it is because of the very terms Venet has employed to assert the meaning of his work—scientific language, logical syntax, denotation, and the absence of ambiguity.

3. Discursive Opacities
Ideology

The stated difference between scientific and artistic language, and the corresponding difference between Venet's work and the rest of conceptual art did not appear fully formulated out of the blue. In an interview for *le Méridional*, which took place in late summer 1967 at the time he was formulating his conceptual program, Venet asserts the difference of science-based work and also demonstrates a surprising penchant for obscurity. He here presents science as a new subject for art (rather than a language), and the motif of a dominantly "industrial" age; at the same time, however, he also refers to art as the domain of the incomprehensible:

My purpose is to discover new subjects by turning to science and abandoning any classical idea of the visual arts, and perhaps the art of it is in the fact that I don't understand what I'm doing. I want to create something very sound that no one will understand, and I want this to be why the work I do remains art. My works have no interest for a scientist who understands their meaning. [...]

My development will be seen in the fact that a painting from 1970 will be more precise than one that treated the same subject in 1967,

because of all the new discoveries made between those dates. My work will evolve with science: the criteria for an artist's development that are based on the plastic transformations of his work have nothing in common with the forces directing my development. [...]
I reject all personal emotion translated onto canvas; we live in an age where industry has taken over. In my desire to translate this aspect of modernity, I think everything can be reduced to graphs, which have no place for spirit and emotion. Development can only come about through logic: this is why I have taken my art in the direction of logic, which relies a great deal on discipline.

In such an article, we certainly must take into consideration how the artist's words may have been interpreted by a local journalist little informed in matters of contemporary art.[34] It is nevertheless doubtful that a journalist would have entirely invented the axiology reported here. The statements sound as if they came from an artist who has organized his stance around a value system which, far from limited to infra-artistic argumentation (the specificity of scientific language as opposed to artistic language), contains ideological elements outside the domain of art.

These ideological elements include, on the level of content, the valorization of graphs, logic, industry (where autobiographic determination plays a role, given Venet's place of birth, his father's and brothers' professions, and his first exhibits at Saint-Auban, which conferred both scientific and artistic legitimacy), and discipline (which even more strongly points to his system of values). On the level of enunciation, he declares his conceptual program (a personal development which closely follows the evolution of scientific ideas), but he also (performatively) proclaims a more general evolution that includes the entire age. Expressing this as the well-known figure of progress ("development can only come about through logic"), he gives us to understand that the question here pertains more to development than to the structure of language. Finally, on the level of the artistic subject, the modality is that of belief ("I think [...] everything can be reduced to graphs"), which here pertains to a sort of universal characteristic.

At the very moment Venet affirms his appreciable withdrawal as an artist, the notion of "discipline" reintroduces the organization and politics of the body. Advancing the triumphant objectivity of scientific language, he

simultaneously avows its self-proclaimed character. He can only valorize science through its technological manifestations (graphs, industry); he does not betray the uncertainty of the artistic enterprise, or his religious *naiveté*, the vague remains of belief. The normative evaluation which, as we have just seen, privileges graphic tools, logical-scientific language and the stance of the artist, and which aestheticizes a new form of art, takes place according to the four modalities of knowing that Philippe Hamon has discussed: how to do (*savoir-faire*), how to speak (*savoir-dire*), how to be (*savoir-être*), and how to enjoy (*savoir-jouir*).[35] The quadruple normative system here presiding over the valorization of science exceeds the limits of science itself, and there hence is nothing scientific about it. It is, instead, part of what Hamon has also identified as the "ideology effect" (*effet-idéologie*) of a text.

PERFORMANCE

In the 1977 Beaubourg exhibition catalogue devoted to the art scene in Nice, Ben reports the following incident:

Bernard (sic) was doing his military service. One day when he had a pass, he came to see Ben at his store, and said,

"You know, Ben, I'm the fastest painter in the world. Is that new?"

"Yes, but how do you do it?"

"I take five canvases, lay them down side by side on the ground, take my brush, dip it in paint, and spatter all five in a tenth of a second with a single sweep of my arm. That makes two one hundredths of a second for each one. Nobody's faster than I am!"[36]

To my knowledge, the act illustrated here has never been otherwise documented; van der Marck simply cites it, adding that he sees a "touch of perfidy" in Ben's story. The story does emphasize a trait that appears more subtly elsewhere, the aspect of "performance," in both senses of the word. In June 1967, having returned to France from the United States, where he had begun his conceptual program, Venet gave an interview to a local journalist. One of the journalist's statements, made in his own words, sounds as if it could have been originally made by Venet himself. It is marked with the same taste for performance: "From the industrial domain, Bernar Venet moved on to science. And thus he is the only painter in the world now exploiting a new style."[37]

We can refuse to believe what Ben and the local journalist report, or attribute the statements to youthful impulse.[38] Later however, when Venet turned to sculpture, we see once more the performative aspect of his work. Photographs of sculptures under production in his workshop on the whole presuppose physical and technical exploits.[39] Take, for example, the 1989 book prefaced by Jean-Louis Schefer which contains photographs by André Morain depicting scenes of the fabrication process for Venet's sculptures in the Marioni ateliers in Rozières-sur-Mouzon in the Vosges, which evoke the image of Vulcan's forge and portray the artist as demiurge (reminding us of Calder). The accidents from 1966, which look like a gigantic game of pick-up-sticks, are all the more impressive because of the immense weight of the metal bars involved. The monumental scale of certain civic projects are equally impressive, such as the "*L'Arc majeur*" conceived for the A6 autoroute in France, while other projects seemingly surpass all measure, like the idea of the "Grand oblique" which would virtually have linked Paris to Hong Kong. ·

When Venet himself uses the word "performance" he certainly does not refer to what goes on in his workshop, as I have just done here. He uses it retrospectively to designate his early work in garbage bins or the more recent display of pick-up-sticks with massive iron bars. In other words, he uses it to designate a genre (like the installation) familiar in contemporary art. The fact is, there are two registers to a performance: the explicit, which includes the claim to belong to a certain artistic genre; and the implicit, which develops from pragmatic concerns. On the pragmatic level, the artist is engaged, he has certain competences, he carries out his actions in the framework of an exhibition; he transmits artistic messages; he addresses a public near or far away. The artistic act thus is charged with all its pathos; it is not a purified, decontextualized statement, completely purged of inter-subjective rapport.

AUTOBIOGRAPHY

Venet has always been concerned about the written history of his work, and the importance of clarifying events, explaining different develop-ments, and rectifying possible misunderstandings. The publication of cata-logs has contributed to the constant revision of the authorized version of "the life and work of the artist" in several ways, adding new material neces-

sary to keep the biography updated, revising former episodes, and even unearthing incidents formerly shrouded in silence. As Jean-Marc Poinsot has written of Yves Klein, "The retrospective look at the past is obviously the motivation behind any successful biography, where facts are selected and arranged to conform to a desired outcome, an 'ending consciously attained.'"[40] There is, however, one important difference between Venet and other artists in this respect: while Klein, for example, deliberately constructs his artistic self-image with no concern for the facts, and Boltanski plays on the ambiguity between fiction and reality, the image of the artist Venet creates actually corresponds to his own person. As such, it is always patterned after the truth.

In 1974, Venet added his period in Nice to his *curriculum vitae*, thus amending prior, more antiseptic versions. There are no contradictions between the most recent biographical update, Anne Hindry's *Bernar Venet '61 -'96/ L'Équation Majeure* (1997)[41] and the anecdotes and clarifications in Jan van der Marck's important monograph on the artist (1988).[42] Both contain precious information about Venet's career as well as his personal life: the youngest of a family of four boys, Venet was brought up in the working-class town of Péchiney (Saint-Auban, near Château-Arnoux in the lower Alps); afflicted by chronic asthma whose treatment prevented him from attending school, at the age of ten or eleven he was encouraged by his mother to pursue his talent for drawing and painting; when he was fourteen, he lost his father, a school teacher turned chemist (one of his brothers is a chemical engineer, another an industrial draftsman); in 1958-59, after his entrance to the School of Decorative Arts in Nice was refused, he followed preparatory classes at the municipal school, followed by work as set designer at the Nice Opera; his earliest paintings attest to diverse influences; in 1958, he began to frequent Ben's shop on the *rue de l'Escarène*, where he heard talk of Klein, Arman, César, and the Zero group in Dusseldorf.

The period beginning with his military service is rich in works and anecdotes, the essentials of which can be found in Venet's interview with Catherine Millet. These include his time in the barracks at Tarascon, where a workshop was put at his disposal. It was there he met Martial Raysse, had himself photographed in garbage bins, spread out in the middle of the refuse, and took to action painting, including a series of works in tar painted with his feet. Venet's work in 1963 featured paintings in tar on newspa-

per and canvas, photographs of tar, piles of gravel and tar, and a drawing for a project in which the surface of a painting would gradually be covered over. From 1963-1965, he worked with industrial paints on cardboard constructions. In 1966, he first came to New York, sculpted tubes in Bakelite; participated in an exhibit at Céret where he presented an industrial drawing of a tube, exhibited with the tube itself and began his conceptual work (industrial design and mathematical equations).

Venet's publications all tend to sweep aside prior readings, and so illustrate how the construction of his biography overrides the direct transmission of information that characterizes monosemic documents. We can examine this process by beginning with the way the gravel piles he worked with in 1963 were integrated into his biography in 1974, where they were presented in relation to European tradition and as a prefiguration of "antiform" as well. "[These pieces] had the property of being outside the European constructivist tradition (the arrangement of volumes in relations to other volumes) and of 'having no specific form.' They are closely tied to what has recently been called 'antiform'".

Here, the first implicit reference is to Frank Stella's famous declaration in 1964, when he proclaimed that the non-relational character of this work differentiated it from all European geometric painting.[43] The second is to a concept by Robert Morris, published in an article in April 1968.[44] (In October of the same year, Morris presented "Earthworks", a mound of dirt mixed with other materials and objects.)[45] Venet does not mention these artists by name, and the implicit historiographical competence of his argument, as well as his readers' knowledge, gives credence to its assertion, transforming it into an authoritative account. This argument secretly reverses the usual historiographical process (presenting Morris's act as a reaction to Minimalism) in favor of a biographical account where the amorphous pile precedes the rigorous reductionism of the conceptual period. It is, however, more important to date facts and events correctly than to furnish a coherent explanation based on the biography, even if this means breaking up the narrative or even dismembering it to examine the facts piece by piece.[46]

Two types of documentation relate to Venet's work with piles. The first, reproduced in the 1974 monograph, are photographs dating from 1963. One shows the artist next to a pile, with a wheelbarrow serving as accessory. A second shot, an over-view of another pile in the street next to

a sidewalk, bears the inscription "Sculpture"— *volume composé de gravier mélangé à du goudron, sans dimensions spécifiques*, 1963" ["Sculpture"—volume composed of gravel mixed with tar, without specific dimensions, 1963"]. The second type of document, found in the La Jolla catalog (1976) and elsewhere, consists of photographs of installations of coal piles taken in 1975. This is not what is said in the 1976 catalogue description, "Charcoal Sculpture Without Specific Shape", 1963," or in van der Marck's monograph, which nevertheless does clarify the place: "work […] from 1963 […] coal pile […] installation at the Daniel Templon Gallery." The "Coal Pile", which according to the description dates from 1963, implicitly refers back to the piles of gravel and tar, and constitutes a series retrospectively. As Venet explains, he was unable to realize such work in a gallery:

> At the time I was making mounds of gravel mixed with tar. It would be possible to confuse these pieces, such as I photographed them, with ready-made works. To prevent this, it would have sufficed to reconstitute them in an exhibition space to show that they were not prefabricated pieces. I wanted to do this at the time, but the galleries showed so little interest in my work that I didn't have the opportunity.

Van der Marck explains that the pile was found in a street, and describes it as a "modified ready-made" piece that was "forcibly short-lived." He adds that, "despite appearances, the formless pile of tar and gravel did not belong to Presentational art, as Pierre Restany would describe the work of Arman, which is based in quantity. It was, instead, a radical act […]."

The constant shifts in terminology are striking. Should we seek a single truth, and try to establish the specific genre to which the piles of tar belong? Should we ask whether this is performance, photographic souvenirs, Ready-made art, or Presentational art? Instead, it seems more important to notice the game of generic naming that is here occurring—the game itself, not content, taking first importance—in relation to the future reconstruction of Venet's biography. This retrospective process of periodic renewal is certainly not unique to Venet alone, but pertains to a more general law that is certainly valid for most of Conceptual art, where "gaps always exist between the biographical narrative and the artist's production. Initially, there are always a few works and a public showing in order to establish dates," but the majority of the production takes place afterwards.

With Venet, however, once we put all the reported facts and biographical contributions together, we discover they always come out on the side of truthfulness, explanation, or even justification. Such a "mythography" is less deliberately constructed than a first person narrative where the artist and his image are inseparable. Venet's case, unlike that of other artists, does not offer this kind of disjunction. The biographical narrative does not read like a work of fiction (the sort of thing to which artists' stances have accustomed the public). Venet's mythography is realistic. The absence of this disjunction has its corollary in the existence of a subject whose presence behind the narrative influences it all the more importantly.

Todestriebe

Van der Marck's biography, in addition to insisting on the industrial background of the artist's childhood, also reports a fact (which the artist himself attributes to "legend") at the origin of the transformation of "Bernard" to "Bernar." Venet's mother, who already had three boys, was hoping for a girl for whom she had already chosen the name "Bernadette." Presented with her fourth baby boy, she masculinized the name, but at the age of two he still was wearing a ribbon in his hair (which was not necessarily a mark of feminization, but a custom at the time). Venet is said to have dropped the last letter of his given name because it reminded him of the feminine suffix in "Bernadette."

Van der Marck finds this explanation doubtful, and thinks that Venet was probably following Arman's example, hoping to become known under the single name of "Bernar." (Ben and César also come to mind.) However, in putting together information about the child's fragile health and the role attributed to his mother, van der Marck nevertheless does describes a set of personal circumstances for Venet which, to borrow an expression, "turned him into an artist." The most curious thing about it, to go a bit further in the psychological vein, is that to masculinize his given name, Venet cut off the only letter that stuck up in the air! The story of Venet's childhood has been constructed and reconstructed retrospectively with a view to elucidating his artistic creations and their *raison d'être*, and if we read this narrative as works on the artist's life invite us to, it is possible to discover something quite other than the explanation of how his family milieu and

industrial setting determined his vocation, or how he cooked up a name for himself destined for the world of art.

It is interesting to examine the few available documents that concern Venet's beginnings as an artist. On February 18, 1961, just before he left for the army, the young man still called Bernard Venet had his first exhibition on the second floor of the Recreation Center at Saint-Auban. An advance review appeared in the local newspaper, *Le Méridional*, written by a journalist who claimed to have recently singled out the work of the young artist at the painting exhibition at Péchiney.[48] There are two photos of the painter: in one, he is standing in front of a self-portrait holding a palette; in the other, he is bending over "a work entitled *Vie* [Life]," which is described as being "in a completely different style from the one that he is currently using" and depicts symbolic beings arranged in space in a manner reminiscent of Paul Klee.[49] Another advance review bears a photograph of the artist before a different self-portrait. This time, the head is not realistic, but made up of signs and surrounded by concentric circles against a checked background. (Klee's influence is still present.)[50] The article states his "painting [is] inspired by death, or at least the painting that is most important to him, which he has titled *La vie est une permission de la mort* (Life is a Permission from Death)."[51] The article on the exhibit in *Nice-Matin* featured a photograph of *"Inspiration en rouge"* [Inspiration in Red], "where the artist has brought together many symbols" (still in the manner of Klee):

> His pre-figurative paintings often represent tombs and death, and feature a little stylized man, lying or standing, sometimes surrounded by rays of glory, sometimes in a bright light symbolizing life … which the artist has nevertheless outlined in black […][52]

Reproductions of work from this early period, which we could somewhat superficially label "modernist-symbolist," do not appear until 1988, doubtlessly because, by that time, Venet's biography and his own directions for reading it were well enough established for him not to worry about the confusion he might create by revealing an existential side to his work where anguish about death mixes with visions of pantheistic fusion. This dark background is masked by his preemptory declarations on the future of art as reformed by the virtues of science, or the thundering affirmation of univocal meaning and the clarity of signs. The brown silhouette

of the little man on a golden background, outlined in black and flanked by two lances, reproduced in 1988 as *"La vie est une permission de la mort"* is a figurative version of what Kentzel detected in the logic of neutrality—Freud's theory of *Todestriebe*, the death instinct, which recalls the latent desire for primordial oneness, for an indiscriminate state of being. Venet's title forcibly recalls the words of Freud's text: " [...] death is the end towards which all life leans," and inversely, "non-being precedes being."[53]

Self-Portrait

In 1965, a curious article in *Le Patriot* bearing the inscription "Bernar Venet and Baudelaire" contained an extract of Baudelaire's prose poem *"Le Joujou du pauvre"* (The Pauper's Plaything).[54] The extract, of which neither the title nor the origin was identified, appeared between two (uncaptioned) photographs: one was a cardboard construction painted with industrial paint, and the other a picture of the artist "lying in army garbage bins."[55] Outside of the pre-conceptual period, this photograph only seems to have taken on importance much later. It does not appear in the initial publications which "recuperate" the Nice period of the artist's work (Catherine Millet's book, which appeared in 1974; the volume *Hubschmid* published in 1975 featuring Thierry Kuntzel's text on the neutral; the La Jolla Museum catalogue of 1976, etc.). It seems to have first reappeared in 1988, when it was published under the following caption by Jan van der Marck: *Performance: hommage à Arman, 1961. Bernar Venet dans les poubelles de l'armée"* (*Performance: Homage to Arman, 1961. Bernar Venet in army garbage bins"*).

As so it is that this photograph, dating back to the Tarascon barracks, takes its place in the artist's biography alongside his work with coal piles to inaugurate the period in Nice when Venet went on to paint his cardboard constructions. Its title has undergone alteration since the photograph was first republished in 1988. The reference to Arman disappeared in Hindry (1996) to become *Performance dans les détritus* (Performance in the refuse); a more recent title brings together qualities descriptive of the artist's other works as well: *"À propos de: sobriété, pauvreté, abandon, simplicité, austérité, sévérité, rigueur, rudesse, dépouillement, ordinaire. Performance"* (Concerning: Sobriety, Poverty, Abandon, Simplicity, Austerity, Severity,

Rigor, Harshness, Divestment, Ordinariness. Performance) (Venet 1977). In the *Nouveau Musée* exhibition at Villeurbanne in 1997, the photograph changed categories, going from a documentary photograph that had been reproduced in publications to a numbered photographic work measuring 125 by 155 cm and displayed on the museum wall.[56]

Whatever the title may be, it tricks us about the source of the image, which is far less likely to be found in Arman's garbage cans, with which it is contemporary, than in the photograph of Yves Klein's famous leap into space, "*Un homme dans l'espace! Le peintre de l'espace se jette dans le vide!*" (A Man in Space! The Painter of Space Leaps into the Void!).[57] Published the previous year in *Dimanche*, a journal Klein created, this photograph appeared on November 27, 1960, the date of the one and only issue ever to appear, along with an article on the "Theater of the Void." In the case of each photograph, the artist's body is both prop and agent to mythography. Venet's work, however, differs from Klein's on two essential points: it is not a *photomontage*, and the artist's body is seen from a foreshortened angle.

The character of Venet's photograph is opposed to the famous, somewhat unrealistic photograph of Klein, for in Venet the effect of reality is accentuated by the fact that the viewer is made to adopt the angle from which it is taken—that of the artist's head or feet, according to the two known versions. As such, it adopts the scenic composition of certain self-portraits by Courbet, notably that of "*L'Homme blessé*" (The Wounded Man) in the *Musée d'Orsay*, whose position, as Michael Fried has shown, works to reduce "the vertiginous gulf between model and spectator."[58] Citing Merleau-Ponty's *Phenomenology of Perception*, Fried emphasizes that the painter's stretched out body is in the best position to provoke the feeling of "primordial essence," the experience of the painter's own feeling of "incarnation." The arrangement of the scene and exposed flesh (in Courbet, the hands; in Venet, the naked torso and arms) communicate this existential feeling, creating a rapport between the body represented and the world outside the frame where we ourselves are spectators and indicating incarnation through the representation of flesh itself.

Venet was unable to relocate the photographer and recover his photographs until 1988. In 1976, Venet's own copy, which had been published in *le Patriot*, had been loaned to Arman, who integrated it under Plexiglas with other objects from Venet's environment to create a "*Portrait robot de*

Bernar Venet" (Profile of Bernar Venet), in the style of portraits he'd made of other people.[59] Arman made no mistake when he took this document to be a self-portrait! The successive titles that attempt to convey the significance of such an image cannot do justice to the emotion it conveys. Though it is generically described as a performance and conventionally called a homage, its subjectivity shines through.

Syncope

In 1970, at an exhibit of his work at *Studio Santandrea* in Milan, Bernar Venet announced he had stopped producing works of art. Ironically commenting on this occasion, Pierre Restany remarked: "In 1970, at the age of 29, Bernar Venet announced he had achieved his life's work. What would he do to insure its survival?"[60] Although this hiatus lasted only five years before Venet began producing work again, the interruption is an important sign, important in and of itself. Referring to "the verbal" on many occasions, the artist himself explains the need he felt at the time to define his previous conceptual work more precisely. His justification is no more singular than the hiatus in his work that occurs between 1970 and 1976. It is well known that other artists have also ceased producing work: examples famously include Michael Parmentier, who stopped in 1968, and the lesser-known example of François Guinochet. In all three cases, a halt announced as definitive turned out to be a temporary stop, and the artists found themselves facing a difficulty similar to the problem that Restany points out: the need to produce a unified narrative in order recuperate the interruption.

Venet's solution to this problem is, however, quite original: rather than advancing a political justification, he maintains that a period of theorization logically followed his conceptual phase. This solution is advanced through the same declarations about "logical" deduction and the importance of "rationality" as narratives about other aspects of his work, so that the hiatus continues, but on another level—the absolute syntax of the years 1966 to 1970. "[The] logical character of this halt [is the] consequence of the extreme rationalization of my work [...]".

Venet has stated that his theorization was meant to correct interpretation, the errors in the critical understanding of his work:

I noted the damage that critics who depended on comfortable cul-

tural notions had provoked in their writing on my work. They were trying to demonstrate a logical continuity between my work and historical precedents, whereas I was aiming to break with all of that. [...] I thus had to define more precisely the level of the originality and interest of my conceptual work.

[...] The advantage of this kind of analysis is that it permitted me to clarify the true meaning of my work, to define its latent content.

Such an enterprise of rectification is close to the "mechanism for denouncing subjective discrepancies" (*la machine á dénoncer les écarts subjectifs*) published during the same period in *"Index 01 and 02"* (1972) in which *Art & Language* classified its members' texts according to their respective compatibility, incompatibility, or eccentricity in relation to internal orthodoxy.[61] On this point, Venet and Art & Language share the same concern for the veracity of interpretation, a taste then well to the liking of the times, which furthermore recalls the case for a just line in which artistic and political groups were involved. Univocal meaning, posited on a semiotic and formal level, here spills over into alethic considerations. Although it is not one and the same thing to distinguish enunciations according to their monosemy or polysemy, and to qualify them as being true or false, Venet treats these oppositions as homologous and passes from one to the other without difficulty. He defines the content of this truth as "latent content", a term which, as paradoxical as it may seem, he actually borrows from Freud, whom he cites as a source:[62]

> Psychoanalysis is one of the most useful disciplines which bring us nearer to the true meaning of works of art, for it is directly opposed to the theological idealization which encourages the public to worship works of art and treat them as if they were quasi-divine. It submits artistic works to the principle of demystification, and exposes the excesses of fetishism.
>
> The purpose is to render intelligible the "troubling" and "fascinating" aspects that Freud discusses in *The Purpose of Psychoanalysis*. Apart from aesthetic evaluation, the purpose is to reach better appreciation through better understanding.
>
> We must encourage art lovers to develop a rational and analytic point of view.

[A citation from Freud concerning the divergence of opinions in matters of art follows, with a citation from Sarah Kofman on a phase of scientific maturity which, taken out of context, seems to support Venet's main tenets.]

Other misinterpretations of this Freudian text are certainly not rare (and it is true that the text itself dates from 1913). We know that Freud will question the reality of the primal scene and its accessibility through memory, will acknowledge that psychoanalysis "discovers" a reconstruction, and that the analysand's feeling of truth is tied to the analytical process itself (the transfer). Venet, to the contrary, thinks that manifest content demystifies latent content; he believes in the existence of unvarnished truth. Venet affirms his strong mastery over truth, a mastery that controls the meaning of the hiatus in his work from 1970 to 1976 and (retrospectively) determines that of his former work, and yet we detect he is pasting the pieces back together, suturing the gap that followed his withdrawal from artistic production. From 1970 on, what appears to be a metatheory reflecting the conceptual period is certainly in a metadiscursive position. This, however, is more than an epistemological discourse for constructing models of scientific discourse, for Venet aims to establish the transparency and alethic omnipotence of this metatheory itself. The "desire" for truth and transparency here prevails over truth as content.

Self-effacement

"Notes by Bernar Venet" (B.V. 71 c), published in the 1971 catalogue of his exhibition at the New York Cultural Center, takes the form of a series of statements. The second page constitutes a manifesto of sorts against artistic subjectivity:

My work is a manifesto against the expression of the individual's personality. In my work, the last manifestation of my personality, my last decision, will have been to opt for objectivity (i.e., the presentation of objective knowledge).
I have never been presenting Works of Art [...]
I have never been presenting my own work [...]

> I myself never selected the works presented [...]
> In the work that was shown, my role was completely neutral.

In an interview in English reported by Ursula Meyer that also took place in 1971, Venet declares yet again that the work he presents is not art, but "pure knowledge as such," and adds the following performative statement:

> My proposition is: *Cultivez-vous, Exploitez-vous, Éliminez-vous.*
> [Educate yourself, Exploit yourself, eliminate yourself.] I have set myself a four-year work schedule, which is coming to an end. Then I have to stop my work as an artist. I have no other choice in the matter.

This is a surprising proposition, in which the second and third imperative, in French, evoke in spite of themselves references foreign to the worlds of art and science. "Exploit yourself" doubtlessly does not refer to man's exploitation of man, which would be a capitalist credo; instead, the injunction simply lacks a proper object (exploit your knowledge), but the formulation is all the same unfortunate. As for "eliminate yourself," the violence of the verb, which conjures up images of suicide, exceeds the simple affirmation of the artist's self-effacement. The genre of the "statement", well known in the milieu of art, as well as the performative mode, contradict the artist's explicitly declared intention to present only "pure knowledge as such." Venet here adds, "I have no other choice in the matter," obliged to explain how his halt in 1970 logically relates to his preceding activity. Despite himself, his lack of "choice" suggests a situation where the speaker is constrained or backed into a corner.

It is true that Bernar Venet set up a whole series of procedures to neutralize his role (a saga reported by Thierry Kunzel, as described above). During his conceptual period, he went so far as to delegate the choice of the scientific themes in his work to specialists in each of the disciplines included in his program. Nevertheless, the artist's strategic self-effacement (which results from a deliberate artistic strategy) cannot manage to contain his subjectivity, which everywhere makes its presence known.

We have already seen the care Venet has taken to reconstruct his biography. Numerous photographs of the artist illustrate his catalogs, many showing him in his workshop (painting with tar, for example).[63] The open-

ing page of the Saint-Etienne catalogue shows him in his loft in SoHo. His texts and interviews published in *artpress* in1978 and 1981 are adorned with his face looking straight at the reader, mouth partially open, with buildings on West Broadway in the background. The 1971 catalog begins with a photograph of a lecture at the American Cultural Center in Tokyo. The caption, rather than describing the event as a lecture, identifies the artist instead, "Bernar Venet (right) giving a lecture [...]", and thus refutes the self-effacement for which Venet himself is arguing at that very moment. Venet's research in Conceptual art did not include the effort to construct an unconventional image of the artist. (Joseph Kosuth, for example, insisted on being photographed sitting at a desk, or as a tourist in exotic places.)

The paratexts Venet has authored have certainly enriched his work: the list of his texts and declarations in the bibliography of the current study is far from exhaustive. Taken as a whole, these paratexts are characterized by instances of personal utterance and subjectivity which supplement the principle text, which is intended to masterfully predetermine or "fix" the sense of a work, and announce the author's self-effacement and voluntary disappearance. (Venet does not fail to cite Barthes' famous text on the death of the author.) The presence of this "subjectivity working through language" (to paraphrase Benveniste) continually interrupts the discourse of absolute syntax.

Reflexive Doubling

As we have seen, 1970 to 1976 was a deliberate period of theoretical reflection for Venet. Considering the general logic of his work, it was not an actual "hiatus", as we have qualified it elsewhere in this work. As shown above, this period functioned much like the titles of his works from 1966-1967, for example, or those incorporated after 1976. It thus relates to the rest of his work like an index, and acts to anchor it. If, at a certain point, the syncope of the reflective years interrupts the continuity of the general text, Venet nevertheless fills the gap by taking up the same text in a metadiscourse, and makes statements about it on another level which simultaneously affect all of his work, and give it a measure of heterogeneity. This is a case of "demonstrated heterogeneity" (*hétérogénéité montrée*), in the sense that Jacqueline Authier-Revez uses the term.[64]

These metaenunciative forms in Venet's work act as doubles to the metatextual forms discussed above. All lend opacity to the purely denotative, transparent and transitive language that the ideal of absolute syntax announced in his conceptual years—an ideal that in many ways remains active in Venet's work today. The future unity which absolute syntax supposes is undermined by the same internal necessity that motivates the artist to reaffirm this ideal, for there is always a difference or gap between metalinguistic reaffirmation and simple assertion. At the heart of his discourse, Venet readdresses those elements that are elsewhere signified in his work—monosemy, the scientific domain, the absence of artistic intention, neutrality, etc.—and thus creates an entire self-referential corpus.[65]

It is important to understand the doubling that takes place between an element of an enunciation and its simultaneous commentary. "Doubling the use of a term in a reflexive commentary on the use of that same term renders its use more opaque by temporarily suspending the absolute, unquestioned, obvious character of the term in question, the idea that the standard, transparent use of words "goes without saying."[66] Such acts of reflexive doubling, or "*boucles réflexives*," Authier-Revuz continues, "pertain to the domain of self-reception, which is one of the dialogic forms Bakhtin proposes." This amounts to saying that reflexive doubling reveals a "shared" subject—a subject which is inhabited by another—for in such instances, the enunciating artist splits off into two: the enunciator as author and the enunciator as judicator of his own words.

Thematically, the relinquishment of the self found in Venet recalls the work of Jean-Marc Ponsot, who has examined the doubling between the artist-figure and his authority that has taken place over the past thirty or forty years. According to Poinsot, certain artists have discovered "the strategies necessary to discourage the belief that the figure represents the empirical subject." His analysis is valuable in showing how the authorized narrative largely derives from manipulating knowledge in a communicative framework where those who address (artists) transmit valuable objects to addressees (viewers). Nevertheless, we have seen how little Venet's construction of his image as artist differs from his personal biography. Furthermore, why stop with a view of the subject in its plenitude, sheltered by it's own aloofness?

If Venet's discursive heterogeneity manifests his subjective presence in language, it doubtlessly does so in spite of the artist himself. Here the

subject is no longer full and transparent, endowed with the project and clear intentions that absolute syntax presupposed; it is opaque, split, out of sink with itself. Certainly, we can describe all these "precautionary" operations which "differentiate specific meanings [...] in terms of strategies of 'communication,'" but, as Authier-Revuz argues:

> they [also] reveal, in a mode that has nothing to do with intention, the obligation for all speakers to take into consideration many facts that fundamentally go against their words. This "negotiation" consists in making statements that make a show of recognizing the disjunction, but do so by "denigrating" the way it has been presented, be it as an accident or an isolated error [(i.e., the critics misunderstood]. Such a tactic preserves and even reaffirms the fantasy of coincidence, i.e., of the necessary 'unity' of the speaking subject, on the very grounds that have called it into question.[67]

Following Authier-Revuz step by step, we see that "the forms of demonstrated heterogeneity principally function through 'rupturing-suturing,'" as the continual doubling of enunciator as metaenunciator places him, "in a fantasized position of over-arching dominance."[68] In this respect, Bernar Venet resembles those logicians who, seeking to translate everyday language into the terms of logical syntax, continually clarify, and even rectify, their theory.

The heterogeneity of texts and the opacity of enunciation that I have here discussed are definitely always forms of reflexivity. But as Jakobson reminds us, reflexivity is the very sign of the poetic. Reflexive forms most certainly contradict the stated meaning of a purely denotative art, of transparent, logically pure language. But they are necessary, for they provide the stage for this language and institute it as poetic. Without such forms we would remain uniquely in the domain of science, but whoever believed that Venet's art transported us to this realm only? The heterogeneity that animates its every part would threaten to undermine its foundations, were it also not constitutive of his poetics. If Venet is most definitively the author of such a poetics, it is because the "reflexive doubling", the *boucle réflexive* he relied on absolute syntax to eliminate, remains alive and active in his work, just as it does in all enunciations. And in this lies the paradox: for absolute syntax to reach the level of poetry, it is necessary to believe in its virtues, convey the myth, and thus declare null and void all enunciative posi-

tions, all traces of subjectivity; but it is also simultaneously necessary for a subjective presence to take charge of this absolute, to work on it and subtly undermine it. The obscurity of reflexive doubling must necessarily accompany the transitive arrow of transparency.

Such is Venet's strange poetics, outstanding for its uniqueness in the landscape of conceptual art and even fields beyond. Venet is the only artist working in this genre to consecrate himself with such determination to the exposition of a transparent language, to the quest for an absolute, entirely scientific language that willingly concedes nothing to art, and thus entirely assumes the denegation of its own poetics.

In this consists his heroism.

Notes

1. Lucy R. Lippard, *Six Years: The Dematerialization of the Art Object from 1966 to 1972* (New York: Praegers, 1973; London: Studio Vista, 1973).

2. Roman Jakobson, "Closing Statements: Linguistics and Poetics," *Style in Language*, ed. Th. A. Sebeok (New York: 1960). For French see Roman Jakobson, "Linguistique et poétique," *Essais de linguistique générale*, trans. N. Ruwet (Paris: Minuit, 1963) 209-230.

3. For a discussion of Venet's work in terms of information theory, see Wieslaw Borowski and Andrzej Turowsksi, A propos [de] 'potentiel sémantique des oeuvres d'art et leur degré d'abstraction, *Bernar Venet* (Warsaw: Folksal Gallery, 1974) 23-24 [catalogue].

4. Tzvetan Todorov, "Problèmes de l'énonciation," *Languages* 17 (March 1970).

5. Jacques Bertin, *La sémiologie graphique. Les diagrammes. Les réseaux. Les Cartes* (Paris: Mouton; La Haye: Gauthier-Villars, 1967).

6. Jacques Bertin, "La graphique," *Communication* 15 (1970). According to Jan van der Marck (op. cit.), this was the article that first brought Bertin's work to Venet's attention.

7. Jakobson, *op. Cit.*

8. Roland Barthes, "De la science à la littérature," [1974], *Essais critiques IV, Le bruissement de la langue* (Paris: Le Seuil, 1984) 13-20.

9. François Recanti, *La transparence et l'énonciation* (Paris: Le Seuil, 1979) 15-47.

10. René Wellek and Austin Warren, "The Nature of Literature," *Theory of Literature* (New Haven, 1948). For French see "Nature de la littérature," *La Théorie Littéraire* , trans. Jean-Pierre Audigier and Jean Gattégno (Paris: Le Seuil, 1971) 29-38. Translator's note: All English texts cited in French for the purposes of this study have been retranslated into English. All English translations of French or German authors are my own.

11. Jean Cohen, *Structure du language poétique* (Paris: Flammarion, 1976). A discussion of zero degree rhetoric can be found in Paul Ricoeur, *La métaphore vive* (Paris: Le Seuil, 1973) 173 ff.

12. Roland Barthes, *Le degré zéro de l'écriture* (Paris: Le Seuil, 1953).

13. Roland Barthes, *Les lettres nouvelles* (May 1953); cited in Bernard Comment, *Roland Barthes, vers le neutre* (Pairs: Bourgois, 1991) 142.

14. Comment, *op. cit.*

15. The articles on *Begriffsschrift* and *Sinn und Bedeuting* were published in 1882 and 1892, respectively. Cited in French in: Frege, *Écrits logiques et philosophiques*, Paris, 1971.

16. Introduction, *Manifeste du Cercle de Vienne et autres écrits* (Paris: PUF, 1985). The source of the expression "absolute syntax (*la syntaxique absolue*), cited in A. Soulez, is Jean Cavaillès, *Sur la logique et la théorie de la science* (Paris: PUF, 1960; 1st edition, 1942; 2nd edition, 1947). I was unable to locate the passage. On Frege, Russell and the Vienna Circle, see also Jean-Francois Malherbe, "La quête du language parfait," *Épistémologies anglo-saxonnes* (Namur: Presses universitaires de Namur; Paris: PUF, 1981) 13-66; Pierre Jacob, *L'empirisme logique* (Paris: Minuit) 31-117.

17. Thierry Kuntzel, "Bernar Venet; logique du neutre," in Bernar Venet, *Mathématiques* [...] (Paris: Arthur Hubschmind, 1975).

18. Sigmund Freud, *Beyond the Pleasure Principle*, 1920.

19. Jean Baudrillard, *Pour une critique de l'économie politique du sign* (Paris: Gallimard) 100.

20. Ruth Amossy, *Les idées reçues. Sémiologie du stéréotype* (Paris: Nathan) 30. See also Amossy and Elisheva Rosen, *Les discours du cliché* (Paris: CDU-SEDES, 1982).

21. Jean-Louis Dufays, *Stéréotype et lecture* (Liège: Pierre Mardaga, 1994) 170.

22. Umberto Eco, *La Structtura assente* (Milan: Bompiani & C.S.p.A., 1968). For French see *La Structure absente—Introduction à la recherche sémiotique*, trans. Uccio Esposito-Torrigiana (Paris: Mercure de France, 1972) 93. Catherine Kerbrat-Orecchioni is similar to Eco in making the connection with stereotype, but does not discuss the role of hyponymy in lexical connotation. See Kerbrat-Orecchioni's *La Connotation* (Lyon: Presses universitaires de Lyon, 1977).

23. "On Referring," *Mind* 59 (1950). For French see P.F. Strawson, *Études de logique et de linguistique*, trans. Judith Milner (Paris: Le Seuil, 1977) 9-38

24. L.A., "Cinq minutes avec Bernar Venet, peintre saint-aubannais, établis á New York," non-identified newspaper article (June 22, 1967). Clipping provided by the artist with handwritten date. My emphasis.

25. Roman Jakobson, "La dominante" [1935]; For French see Roman Jakobson, *Questions de poétique* (Paris: Le Seuil, 1973) 145-151.

26. Jean-Michel Adam, *Les texts: types et prototypes. Récit, description, argumentation, explication et dialogue.* (Paris: Nathan, 1997)11-43 and passim.

27. Venet has remarked that he is not responsible for some of these arrangements because they had been delegated to other people . These marks of artistic arrangement are nevertheless present for the viewer, and in such a case their author's identity is of no importance.

28. I have previously discussed the context and neutralization of the blank page in: "L'exposition et son lieu"[Conference Proceedings, Montpellier, 1985], *L'object expose le lieu* (Paris, Expo: Média, 1986); "Le souci du contexte" [extracts, exhibi-

tion catalogue], *Face à l'histoire* (Paris: Centre Georges Pompidou, 1996); and "La peinture chez elle nulle part. Supports/Surfaces et la neutralization du contexte" [Conference Proceedings, Paris, 1988], *Autour de Supports/Surfaces* (Paris: Galérie nationale du Jeu de Paume, 1999).

29. This is the well-known idea formulated in Joseph Kosuth's *Art after Philosophy* (London: Studio International, 1969). "The 'value' of particular artists after Duchamp can be weighed according to how much they questioned the nature of art; which is another way of saying 'what they *added* to the conception of art' or what wasn't there before they started. Artists question the nature of art, presenting new propositions as to art's nature."

30. Oswald Ducrot, *Dire et ne pas dire. Principe de sémantique linguistique* (Paris: Hermann, Savoir, 1972).

31. On authorized narratives, see Jean-Marc Poinsot, *Quand l'oeuvre a lieu. L'art exposé et ses récits autorisés* (Geneva: Mamco, 1999) 135 ff. (Numbers refer to page proofs of this work.)

32. Jean-Pierre Dupry, *Ordre et désordre* (Paris: Le Seuil, 1982) 120-21.

33. See Herman Parret, ed., *Le sens et ses hétérogénéités* (Paris: CNRS, 1991).

34. Bernar Venet insists on this point today (B.V. 99).

35. Philippe Hamon, *Texte et idéologie* (Paris: 1984) 24 and passim.

36. As cited in *A propos de Nice* (Paris: Centre national d'art et de culture Georges Pompidou, 1977) 15.

37. L.A., *op. cit.*

38. Today Venet finds neither Ben's statement nor those reported by the journalist to be credible (B.V. 99).

39. Examples include reproductions in the following personal catalogs: the Templon Gallery, Paris (1984); the commemoration of the 750th anniversary of Berlin (1985); The Vosages Departmental Museum at Épinal (1985); the Castelli Gallery in New York/ Elizabeth Franck, Knokke-le-Zoute (1986).

40. *Op. cit.*, 179. As Poinsot also points out, "[This] narrative intervenes *a posteriori* to add new elements to an existing story. An autobiographical narrative, like history, has a paradoxical function; writing or reading an autobiography assumes complicity, the collaboration and interest of the historian." Regarding the a *posteriori* aspect of autobiography, Poinsot states: "it is in this sense it is a *Rückblick* [a backward glance], according to Kandinsky's use of the term."

41. Ann Hindry, *Bernar Venet '61 -'96/ L'Équation Majeure* (Paris: Flammarion, 1997). Published in conjunction with the artist's exhibitions at the Musée de Grenoble (9 January to 17 February 1997), The Nouveau Musée/Institut in Villeurbanne (13 March to 31 May, 1997) and at the Musée d'Art moderne de Saint-Étienne (4 June to 20 September, 1997).

42. van der Marck, *Bernar Venet (op. cit.)*

43. Bruce Glaser, "Questions to Stella and Judd," radio program (WBAI-FM, New York, February 1964). Transcription in *Art News* (September 1966).

44. Robert Morris, "Antiform," *Artforum* (April 1968).

45. *Earthworks* was also the title of the exhibition in question (Dwan Gallery, New York, October 1968). This title was derived from Robert Smithson's *Earthprojects*.

46. As Jean-Marc Pinsot (*op. cit.*) points out in his remarks on the importance of dating works by Yves Klein, in any given series, it is possible to create works retrospectively, or after the fact (*après coup*).

47. Poinsot, *op. cit.*, 181.

48. "Surprising, troubling, varied. The young painter from Saint-Auban, Bernard Vernet (sic) takes us with him into a world of colors." *Le Méridional*, (Tuesday, 31 January 1961). Clipping furnished by the artist, handwritten date.

49. See also L.A., *op cit.*, who states having seen at the Péchiney Salon "a painting by the young Bernard Venet that drew a lot of attention at the time in Saint-Auban. It was a highly symbolic *Crucified Christ*, with a black forehead and a solid background."

50. "In a region known for chemistry and technical knowledge, a young painter from Saint-Auban prepares his first exhibition." Non-identified newspaper furnished by the artist.

51. Reproduced in van der Marck, 49. Translator's note: The title of this work carries the connotation of a military "permission" or pass, as in being "on leave" from death.

52. "Will he be a prophet in his own country? Bernard Venet, a young painter from Saint-Auban, gives us the happy impression this is the case in his first exhibition at the Recreational Center." *Nice-Matin*. Undated press clipping furnished by the artist.

53. Freud, *op. cit.*, Chapter 5.

54. *Le Patriot de Nice et du Sud-Est* (12 February 1965): 7. The title, "Le rictus et le cactus s'aiment d'un amour tendre" ("Rictus and cactus share a tender love") remains enigmatic.

55. The identification is by van Der Marck, *op.cit.*

56. Two versions exist, taken from different angles.

57. For the story behind Yves Klein's photograph, see Thomas McEvilley, "Yves Klein conquistador du vide," *Yves Klein* (Paris: Centre Georges Pompidou, 1983) 50-53 [catalogue]; "Yves Klein Messenger of the Age of Space," *Artforum* 20 (January 1982): 38.

58. Michael Fried, *Courbet's Realism* (Chicago: University of Chicago Press, 1990). French translation by Michel Gautier (Paris: Gallimard, 1993) p. 60.

59. Translator's note: A "*portrait robot*" corresponds to the sketch of a suspect police make-up based on eye-witness descriptions.

60. Pierre Restany, "Bernar Venet. La Poursuite de l'analyse jusqu'au dépassement du moi," *Domus* (October 1970).

61. Cited in Jean-Marc Poinsot, *op. cit.*, p. 212.

62. See also B.V. 75: "L'interesse di questo genere di analisi è che essa dà il vero senso, niente deve restare enigmatico, lo scopo ricercato è di mettere in evidennza il senso manifesto, il contenuto latente."

63. See, for example, the catalogues of the Foksal Gallery, *op. cit.*, 25 and La Jolla, *op. cit.*, 21.

64. Jacqueline Authier-Revez, "Hétérogénéité et ruptures. Quelques repères dans le champ énonciatif," *Le sens et ses heterogeneities*, ed. Herman Parret (Paris: CNRS, 1991) 139-151. See also Authier-Revez's *Ces mots qui ne vont pas de soi: boucles réflexives et non-coïncidence du dire* (Paris: Larousse, 1995). Authier-Revez's analyses strictly pertain to language. I here apply some of her concepts to the semiotic field.

65. Authier-Revez (*op.cit.*) also discusses autonymy, thus making a connection with the problems of embedding addressed above. For commentary on this subject, see Chapter 5, "Niveaux logiques et hiérarchies enchevêtrées" in Daniel Bougnoux, *Vice et vertus des circles. L'autoréférence en poétique et pragmatique* (Paris: La Découverte, 1989) 163-219.

66. Authier-Revez, *Ibid.*

67. *Ibid.*

68. *Ibid.*

PHOTO CREDITS

André Morain: p. 112
Georges Poncet: p. 14
Muriel Anssens: p. 187
François Fernandez: p. 218, back cover
Philippe Bompuis: p. 128
Chac Mool Gallery: p. 170
Jean-Pierre Quarez: p. 185
Xavier Vraigrandsart: p. 242
Tom Powel: p. 247
Benar Venet Studio Archives: pp. 23, 36, 44, 96, 114, 131, 134, 183, 190, 199, 232